PAINTING YOUR GARDEN

Lesley E Hollands

THE CROWOOD PRESS

First published in 2010 by
The Crowood Press Ltd
Ramsbury, Marlborough
Wiltshire SN8 2HR

www.crowood.com

British Library Cataloguing-in-Publication Data
A catalogue record for this book is available from the British Library.

ISBN 978 1 84797 227 9

Typeset by Sharon Kemmett, Isis Design, Stroud
Printed and bound in India by Replika Press Pvt Ltd

PAINTING YOUR GARDEN

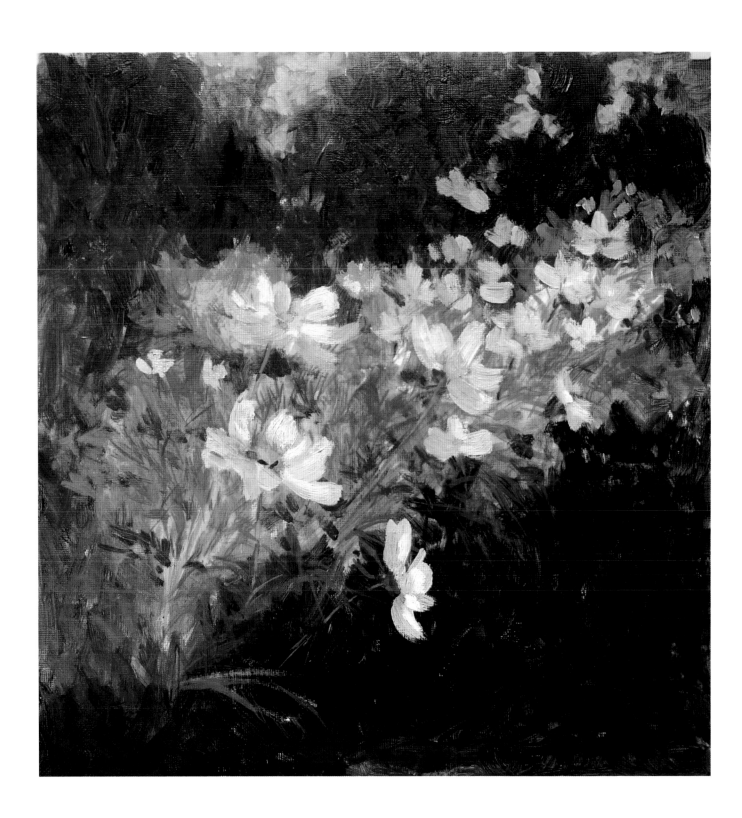

CONTENTS

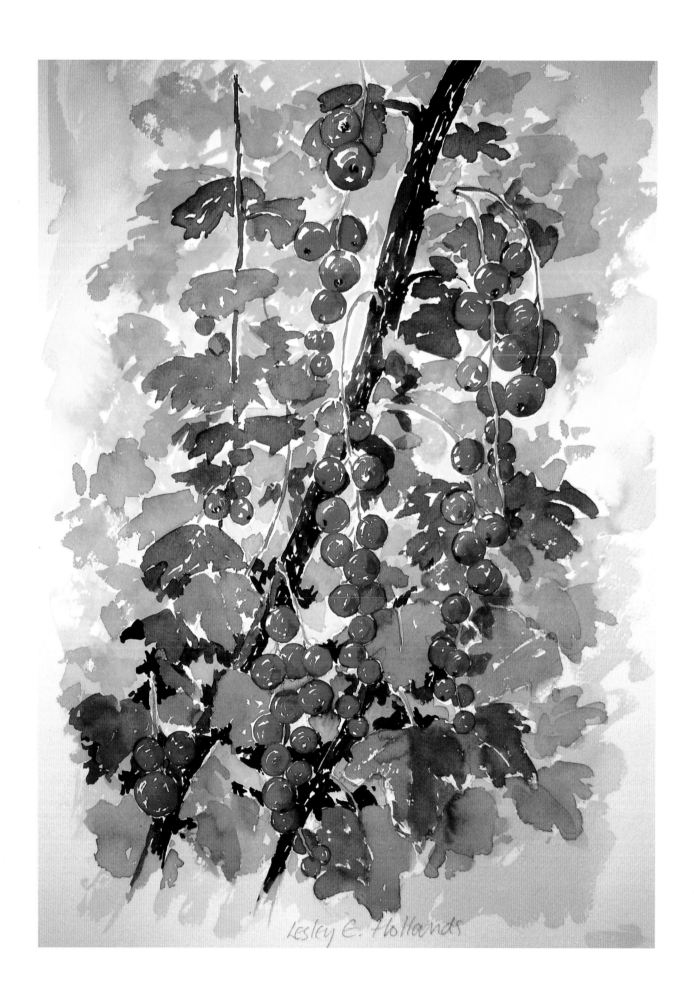

Lesley E. Hollands

ACKNOWLEDGEMENTS

I would like to thank Dr Jeremy Shaw for all his help and advice on spelling, grammar and punctuation and the time he spent putting them right. I would also like to thank my daughter, Saskia Gooding, who came all the way from Denmark to put her expert knowledge of digital photography to good use with the illustrations. Thanks also to Mary and Bill Bevington for the loan of the gnomes and to Ann Haussauer for her photographs of the watermill. Thanks also to Sissinghurst Garden for their permission to take photographs there on a magical summer's day.

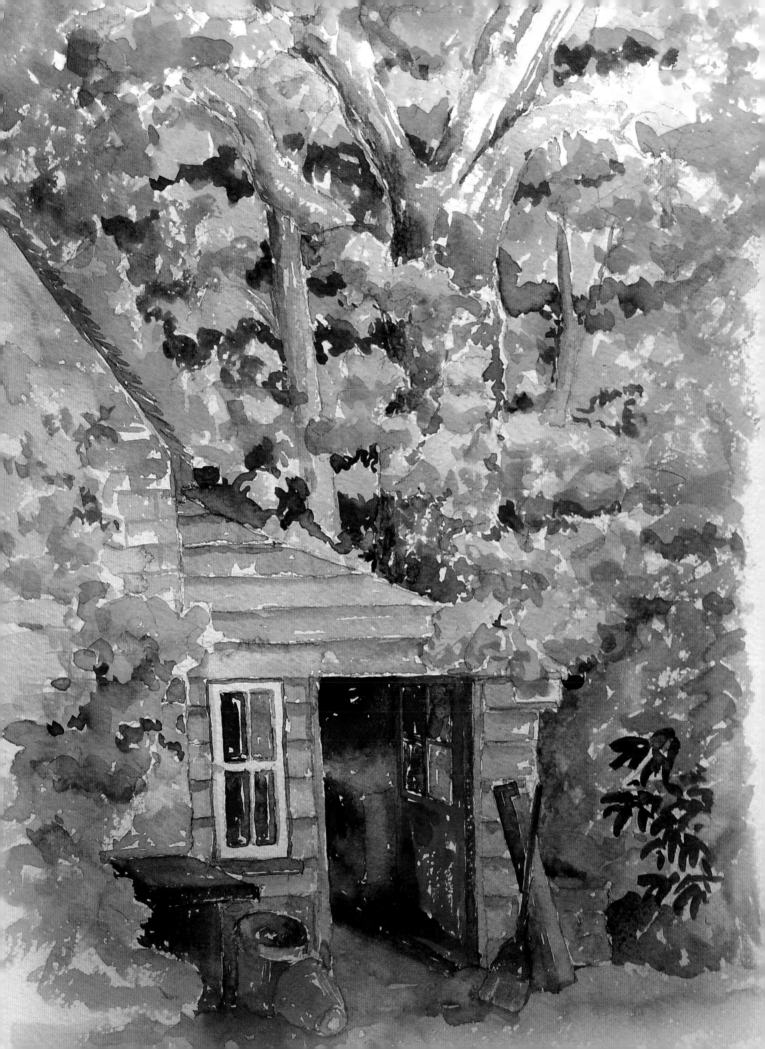

INTRODUCTION

To paint a garden is both a challenge and a delight. The ever-changing light during each day and on through the seasons of the year gives endless subjects for paintings. The various patterns of growth, range of colours, weather conditions and of course what you have chosen to plant and nurture in your garden can all provide inspiration. Even in the depth of winter when it is far too cold to work outside there are still lots of garden related subjects to inspire you to paint.

Looking at the work of other artists can give you new ideas, not only for what to paint but also what to plant in your garden. J.S. Sargent, Bonnard, Monet, Helen Allingham, Adrian Berg, Patrick Heron, Ivon Hitchens and Matisse are just a few of the painters whose work is worth exploring in this context.

This book aims to inspire you to use your own garden, and the many gardens that are open to the public across the country, as subjects for painting. It will include quiet corners, quirky ornaments, unusual planting, courtyards, cottage gardens and seaside borders, as well as the more formal layouts that go with the larger house. Living creatures will also be included to show that even the humblest and possibly not the most welcome visitor to your garden can be interesting to paint. It is not only flowers and foliage that make good subject matter but vegetables, fruits, sheds, tools and even seed packets.

The effects of light and shade on the simplest objects can stir you to paint. Dappled shade beneath an old apple tree, cast on a picnic table laid for an al fresco lunch; a blue shadow cast by a white *Magnolia stellata* onto a whitewashed wall in spring sunshine; long shadows of evening or early morning; the soft glow of Autumn and the strong light of high summer can all give a different slant on an everyday subject. The same subject painted at different times of day can make an interesting project; just think of Monet and all the series of paintings that he did. The same composition painted in oil instead of watercolour can also give you a very different approach and help you to see things in another way.

Working directly from the composition that you have chosen can give you a fresh and lively painting but this is not always possible; weather conditions may not be right; you may not have the time or the light is changing too rapidly; there may be too many other people around for you to feel comfortable; or you may feel that the subject would work best in oils which might require too much equipment for outdoor work. In these circumstances a camera and a sketch book can be invaluable. A quick sketch of whatever has caught your eye, with some notes about colour and light, accompanied by a photo, can enable you to go home with the idea and work at your leisure. A digital photo has the advantage of making it easy to manipulate an image by cropping, enlarging or just homing in on a small section that seems interesting. When working from a photo it is useful to print it off in as large a size as you can manage; this helps to prevent your painting becoming too fussy and tight, especially when working in watercolour.

LEFT: **The garden shed.**

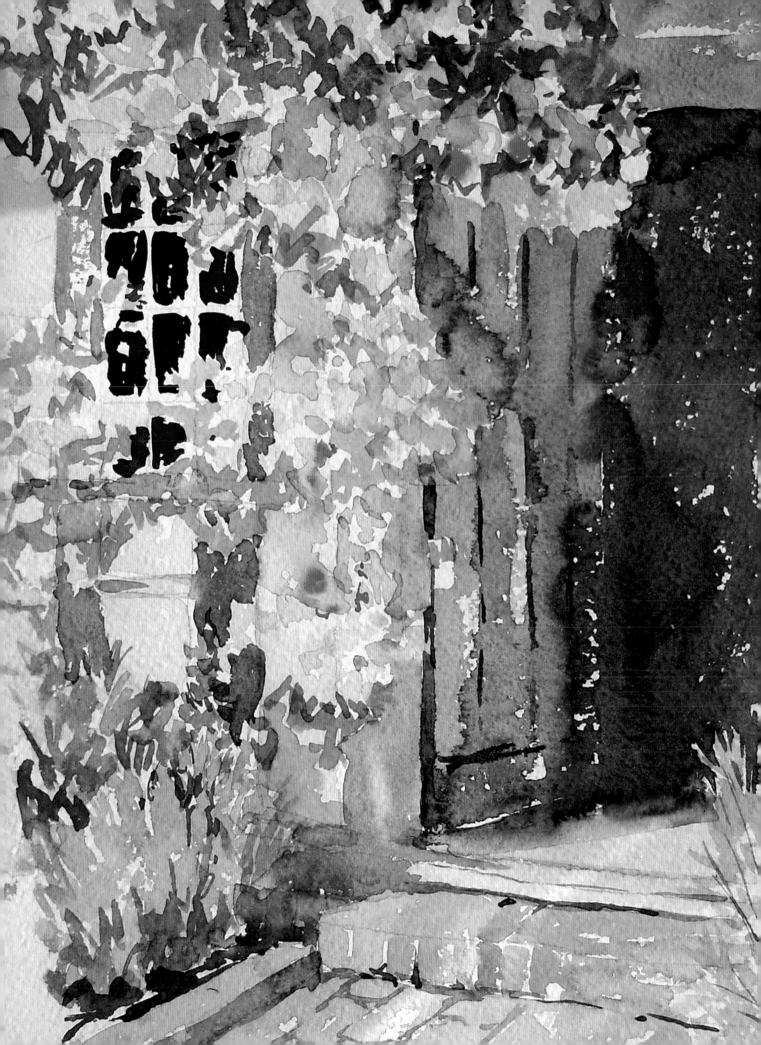

MATERIALS AND EQUIPMENT

WATERCOLOUR

Watercolours are ideal for using when painting outside as they are easily transportable and dry quickly. If you use pans of paint rather than tubes, your whole palette is accessible immediately so you don't even have to decide which colours to put out before you begin and the lid of your box can be used to mix on. A number of travelling watercolour boxes are available, some of which include an integral water container, which are useful if

Easy-to-carry paints.

LEFT: **The old cottage doorway.**

you are working away from home in someone else's garden. The drawback to these is that they are often so compact that you can only really work on very small-scale sketches. If you are painting in your own garden, a very portable set is not needed and you can take out a large bowl or bucket of water to replenish your jam jar at regular intervals, thus keeping your colours clean and fresh.

One of the advantages of watercolour is also a drawback and that is the speed at which the paint dries. If you are working on a hot day and trying to paint some loose areas of flowers or foliage it can be very annoying if the paint has dried before you have achieved the effect you are aiming for. Wetting the paper first can help and having a fine spray bottle to mist water across the paper can also help. Working under a sun umbrella or in the shade of a tree can also make life easier.

Paints

There are two qualities of watercolour, Artists' and Student. The Artists' Watercolours are a higher quality and have more pigment in them, which gives a richer colour, and they tend to flow better. The Student colours are cheaper but you tend to need to use more to get a really intense colour. If you are just starting out and are not sure if watercolours are for you or not, buy a few colours in a Student range then, if you find you are enjoying the medium, gradually replace them with Artists' colours. You do not have to spend a lot of money to get started and of course you have now solved the problem of birthday and Christmas presents, at least for a while to come.

Watercolours come in tubes and pans. Which you choose is

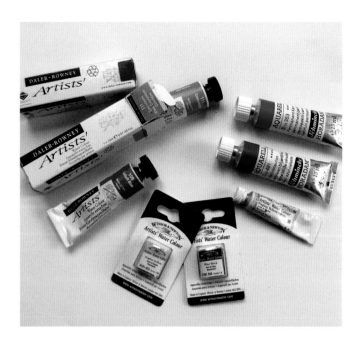

A selection of tubes of watercolour.

a matter of personal preference but the choice can be influenced by how large a scale you work at. A tin of pans is ideal for small scale work (anything up to A3) as the colours are all readily to hand and you can mix up a wash from the pans to cover any area that you need to without difficulty. If you enjoy working on larger paintings, up to A1 possibly, then tubes are much easier to deal with as you can put out a good quantity of pigment on your mixing palette and mix enough colour to cover a large area with ease.

Having both is the ideal solution.

Brushes

It is useful to have a minimum of three sizes of brush to start with, a number 10, a number 8 and a number 6. If you can only have two then choose the larger sizes and buy ones that come to a good fine point. You can do so much more with a large brush with a fine tip than you can with a small one. A large brush can give you a flowing line ranging from very broad to pencil thin with all the sizes between but a small brush can only give you the thin line.

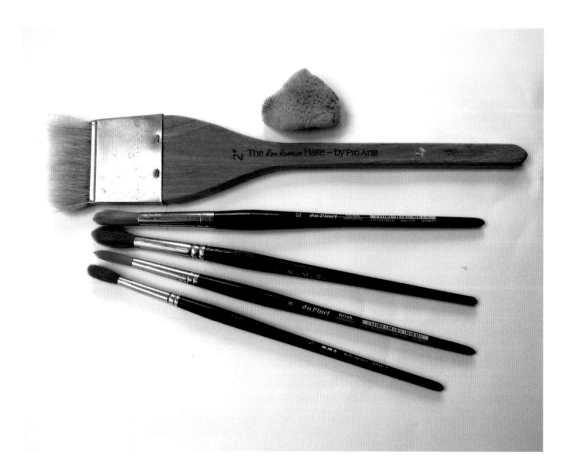

A range of useful brushes.

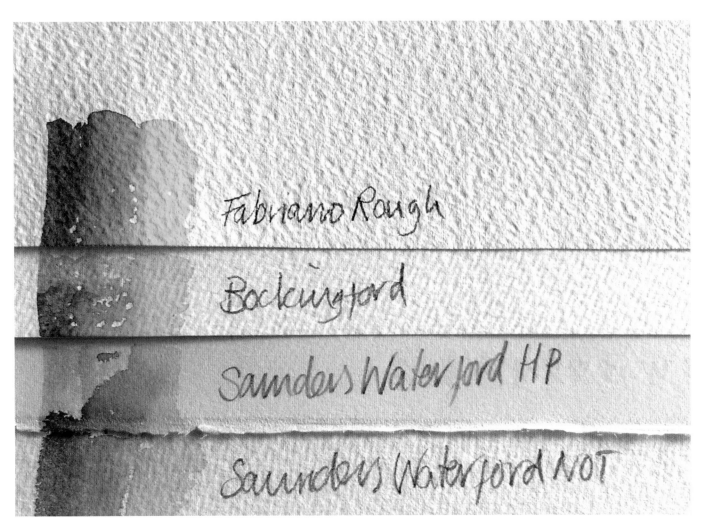

Paper textures from Hot Pressed to Rough.

BRUSH SHAPES

The most useful shape for watercolour is the round brush which comes to a point, in either synthetic or sable or a mix of the two. This shape is versatile and can be used to give a wide range of effects including fine lines, broad flat or broken washes, soft-edged areas and detail.

Other brushes that are available include those intended mainly for applying washes; these are usually made from squirrel or ox hair and are larger, softer and can hold a great deal of water. However, they are not so useful for finer lines and the chisel, or flat-ended, style of brush gives you a more precise mark but again is not so flexible or as useful as the round variety.

Paper

There is a very wide range of papers available to choose from for watercolour paintings, which vary in weight, surface and colour.

The weights go from 200gsm (meaning grams per square metre) which is quite a lightweight paper, through to 300gsm, which is a good weight for all but the wettest methods of working and on to 425gsm which is almost like card and will take the wettest of techniques. There are other weights in between these but the three mentioned above are the most usual. The heavier weight papers have less need of being stretched.

The surface of the paper varies according to how it is made and finished.

- Smooth (HP) is a hot pressed paper with a very smooth surface suitable for finely detailed work such as botanical painting.
- Fine Grain (NOT) has a light texture which is suitable for most painting techniques. The NOT means not hot pressed.
- Coarse Grain or Rough, which has a more heavily-textured surface ideal for loose, free styles of painting.

Most watercolour paper is white or off-white but various manufacturers have produced ranges of coloured papers. These are more suitable for use with opaque paints as the colour of the paper can change the shade of the paint that you have put

Sketch books are useful for working outside.

down. It also means that there is no white paper to shine through and give you highlights. Any white needed in a composition would have to be added using Titanium or Chinese White.

The type of paper you choose is very much dependent on the subject matter of the painting and personal preference.

Paper comes in sheets, usually A1 or pads or blocks in a wide range of sizes. The blocks, which have been glued on all four sides, are very useful as you do not need to stretch them and the paper is instantly available for use. When your painting is finished you just peel off the top sheet by running a palette knife or something similar through the glue to release it. Always buy paper a little bigger than you think you will need as it gives you flexibility when working to expand your composition and not become cramped and tight. Any paper left over can be used for testing out colours so it is not wasted.

Sketch books are also available in a range of sizes and choice of paper. If you are going to use a sketch book for watercolour then make sure the paper is suitable. Cartridge paper, which is ideal for drawing, does not take watercolour particularly well.

OTHER EQUIPMENT

Palettes and water pots

There is a wide range of palettes sold for use with watercolour but an old white plate works perfectly well and has the advantage that it can go through the dishwasher for a thorough clean every now and again.

There are a number of commercially made water pots available with various features such as brush supports or collapsibility but a couple of jam jars work perfectly well and a jar with a broad base is less likely to topple over if you are working outside.

WHICH COLOURS?

Painting your garden is inevitably going to need a range of greens as well as some good clear shades appropriate for flowers. Although most colours can be mixed if you have a range of primary colours to choose from, it can be simpler and more

The start of a colour chart.

convenient to have some ready-made colours to hand. Having three or four greens in your paint collection can help to keep your colours fresh and clear and give a base line to work from. Permanent Sap Green, Olive Green and Hooker's Green Dark are all useful shades and can be darkened with the addition of various blues or lightened with a range of yellows. Add red to the green and a range of warm brown shades can also be achieved.

The purple shades often necessary when painting flowers are also available in a ready-made range. Permanent Mauve and Ultramarine Violet are useful both on their own and mixed with other colours such as Permanent Rose and French Ultramarine.

A basic palette could include three blues: Indigo, French Ultramarine and Cobalt; three yellows: Indian Yellow, Winsor Yellow and Yellow Ochre; and three reds: Permanent Rose, Winsor Red and Carmine or Permanent Alizarin Crimson. Add Burnt Umber and Burnt Sienna and possibly Sepia and you should be able to mix any colour that you want to.

There are a number of excellent watercolour makes on the market and the choice is a matter of personal preference. It is worth trying the products from different makers as their colours do vary both in shade and richness of pigment. For instance Sap Green looks quite different when made by Winsor and Newton as opposed to Daler Rowney and different again when it comes from Schmincke.

Oil painting canvas and paper.

A selection of oil paints in tubes and bars.

Whichever make you choose, take time to get to know your palette and what can be made by mixing the various colours together in different combinations. If you have time, make a colour chart that is personal to you. It is quite a soothing thing to do on a rainy afternoon with a good program on the radio and can enhance your painting because you will be able to mix a wider range of subtle colours and make full use of your choice of pigments.

OILS

Supports

A support is any surface that you use for painting on. There is a wide range of ready-made supports available, which are very convenient and can save a lot of time. These include stretched and primed cotton or linen canvas in a multitude of sizes; canvas board, which comes in round and oval shapes as well as the more usual formats; plywood and MDF panels and various weights of primed papers which can also be bought on a roll allowing you to cut pieces to any size that you need. You can of course buy canvas by the metre and make your own frames out of lengths of wood and stretch and prime the canvas yourself. By doing it this way you can ensure that you have exactly the size and shape that you want for a particular piece of work but it can be very time-consuming. A simpler and cheaper way is to use sheets of hardboard, which are easy to cut with a saw and then prime with matt household emulsion or PVA glue. If you choose to buy ready-made canvases it is useful to have a variety of sizes to choose from so you can select one that is appropriate for the composition that you are going to work on.

Oil paints

As with watercolour, there is a wide range of manufacturers with differing ranges of colours. A number of companies make a Student and an Artist version of their colours, which are available in different-sized tubes. Some colours are also available in tins or tubs, which is ideal if you are working on a large scale. Oil paints are also available in a quick drying version called Alkyd, made by Winsor and Newton, who also produce a range of water-mixable oil colours called Artisan, which is useful if you do not like the smell of turpentine or white spirit. You can also

A good-sized palette gives plenty of room for mixing, which helps keep colours clean.

buy solid sticks of oil colour (sometimes known as oil pastels), which are very convenient for drawing with and for working outside with the minimum of equipment. The sticks can be overlaid and thinned with turpentine to give a wide range of effects. It is worth trying out one or two different makes and types of colour to see which ones you prefer.

Brushes

Brushes for oil painting are made from bristle or hog hair, sable and synthetic fibres and come in a range of shapes and sizes. The shapes include Round, Long Flat, Short Flat, and Filbert or Cat Tongue plus one or two more specialist shapes such as Fan and Rigger. It is useful to have two or three sizes of each of the basic shapes. A wider range of brushes is needed for oil painting to avoid constantly washing out your brush when changing colour, which can be both time-consuming and wasteful.

Good brushes are expensive and it is worth taking time when you have finished painting for the day to clean them thoroughly. Wipe any surplus paint off with a rag or newspaper then wash them in the white spirit or turpentine that you have been using to paint with. Finish off by dipping them in clean white spirit, then reshape them with a clean rag and store them heads uppermost in a jar. By doing this your brushes will last for years. If they do get gummed up with dried-on paint you can use a paint stripper, but not too often or the brushes will deteriorate.

Palette knives

Palette knives are useful both for mixing paint and for applying it. They are made from flexible steel and come in a wide range of shapes some of which are intended for painting with and others for cleaning your palette and mixing paint.

Palettes

Palettes can be bought purpose-made from wood with a hole to put your thumb through (which makes it comfortable to hold), or from a block of coated paper which means the minimum of clearing up as you just tear off the used sheet and throw it away.

You could also make your own from a piece of plywood or hardboard primed with emulsion paint or just use a sheet of thick glass which is very easy to scrape down at the end of the day and keep clean.

Painting mediums

Mediums are the various gels, varnishes and oils that are available to change the way in which the paint behaves. Liquin, for instance, can be added to paint to vastly speed up the drying time, thin the paint for glazing and increase the gloss; Liquin Impasto will thicken the paint for when you want the pigment to stand out in relief on the surface of the painting; Linseed Oil will slow the drying time and can be used when building up layers of paint, working from lean (thinned oil paint) to fat (thicker and more oil rich paint). However, for the most part you can probably manage perfectly well without any extras.

There are many different mediums on the market made by a wide range of companies but you can probably manage quite well without any of them.

Varnishes protect the finished painting and can also be used when painting, mixed with turpentine or white spirit, to speed up the drying time of the paint and create a 'glaze'. Varnish can also bring back the gloss to a painting and lift the colour where it has sunk. Matt varnishes are also available. Permanent varnishes should be used with care as they are very difficult to remove and if applied in a damp atmosphere a white bloom can appear on the surface. Always make sure your painting is completely dry and dust free before applying the varnish with even brush strokes while the work is lying flat.

EASELS

An easel is an expensive piece of equipment and you can probably manage quite well without one to begin with by working flat on a table or by having your canvas propped up with a couple of books or something similar. If you find that you enjoy working with oil paints and if you want to work on a larger scale than can be accommodated on a table then it is worth investing in an easel. Find a good sturdy one – it is very annoying if your easel falls over under the slightest pressure from a paint brush and make sure it is one that you can adjust to the height and angle that you require without risk of injury to yourself. The better studio easels are made from wood but have the disadvantage of being quite heavy and more difficult to transport if you are working outside. There are lightweight sketching easels available made in both wood and metal. It is well worth looking in your local paper for a second-hand one, or even advertising that you are looking for one.

COLOURS

As with watercolour, most of the colours that you need can be mixed from three pure primary colours, but it is much more enjoyable, and far less hard work, to use a wider range of colours. Unlike watercolour, which uses the white of the paper as the lightest area and water to dilute and lighten the paint, oil paints need white to lighten them and create tints of colour. Some oil paints are transparent and some are opaque – most manufacturers have a code that tells you not only how transparent or opaque the colour is but how permanent it is. Colour and consistency varies between makes even when the colour has been given the same name.

When putting out paints on your mixing palette it is worth devising a system of some sort that works for you and then sticking to it. By always putting your paints out in the same order you can quickly pick up the colour you need without having to think twice about which one it is. Some artists prefer to order their colours by whether they are cool or warm; others put them out according to which primary colour range they fall into. Whichever way you choose, always arrange them along the edge of the palette furthest away from you so that you have the maximum amount of space on which to mix colours and are less likely to smear them all over your arm if you are holding the palette while mixing.

When you have chosen your paints spend some time getting to know what they will do for you: try mixing Payne's Grey and Cadmium Yellow Pale to create an Olive Green; experiment with different combinations to find the clearest oranges and purples; find out which of your colours are transparent and experiment with glazing by applying thin layers of colour; find out what happens when you mix white or black with a colour.

WHICH COLOURS SHOULD I HAVE?	
A useful basic palette could include the following:	Alizarin Crimson
French Ultramarine	Magenta
Indigo or Prussian Blue	Permanent Mauve
Cobalt Blue	Sap Green
Cerulean Blue	Burnt Umber
Cadmium Yellow Deep	Burnt Sienna
Cadmium Yellow Pale or	Payne's Grey
Winsor Yellow	Ivory Black and Titanium
Yellow Ochre	White.
Cadmium Red Light	
Cadmium Red Deep or	You could also add Raw Umber, Raw Sienna and Olive Green.

Oil paints are a very versatile medium and can be used in a wide range of ways. There are a few rules that are perhaps worth following loosely, especially when you are first starting out.

Work from thin layers of paint up to thicker layers to avoid the thin top layer drying more quickly than the layers below it and then cracking. This is sometimes referred to as working from lean to fat.

Work from dark to light. Although much oil paint is opaque unless thinned, you will find that the light colours formed by the addition of white have a greater covering power than the dark colours.

Keep your thickest paint for the highlights as this will make them further stand out. Use thinner paint for darker background areas as this will help those areas recede.

You are now ready to start painting.

THE SEASONS

There is much in a garden to inspire a painter at all times of the year. The new growth of spring with its tender green shoots and the first, most welcome, flowers makes an artist itch to put paint to paper or canvas.

Spring starts with the small steps of snowdrops, crocuses and daffodils and gains momentum daily until there is an explosion of blossom on the trees. This ranges from the exuberant froth of cherries and apples to the delicate, almost ethereal blooms of *Magnolia stellata*.

Summer comes with clusters of roses and neat rows of vegetables, deep shadows and clear blue skies, bright borders and comfortable deckchairs, which all provide subjects for painting. Autumn follows with the wonderful blaze of colour from the changing foliage, the drift of smoke from a bonfire, the harvest of not only fruits and vegetables but seeds and seed heads and plants for drying for use during the winter months.

The quiet of winter rounds off the year with crisp, cold mornings in which frost outlines the remaining seed heads and the structure of the garden is laid bare.

Then it is seed catalogues by the fire and plans for next year. There are many ways of capturing these images, ranging from careful, almost botanical, studies of the first spring flowers through to an exuberant, free-flowing approach more appropriate to the explosion of blossom in the late spring. The quiet shady corners of the summer garden need a different approach again; as does the movement and colour of autumn leaves blowing in the wind. Then, finally, there is the stillness of a frosty morning and the almost abstract pattern of bare branch-es seen against a cold blue sky. Weather conditions generally can add another element to your subject matter by changing the mood of a painting and how the colours appear.

There is so much to paint and only a lifetime to do it in.

Spring

SPRING TULIPS

The first painting of this chapter gives an example of an approach to a group of spring flowers planted in earthenware pots. The bulbs were growing at West Dean College near Chichester in West Sussex, where their wonderful gardens are open all year round. The pots were sitting outside one of the big greenhouses on shelves of different heights and were catching the afternoon sun on this mild spring day. The colours were wonderful, ranging from the deepest purple through pinks to orange. In the foreground was a row of smaller pots with a variety of pansies in colours that complemented the tulips. The white painted, wooden window frames created some useful structural lines and the reflections and shadows in the glass gave a feeling of depth.

To use the whole of the composition seemed a little daunting and the slats of the shelving were too dominant since the pots were well spaced out. If this group was at home they could

LEFT: **A blowy day in early autumn.**

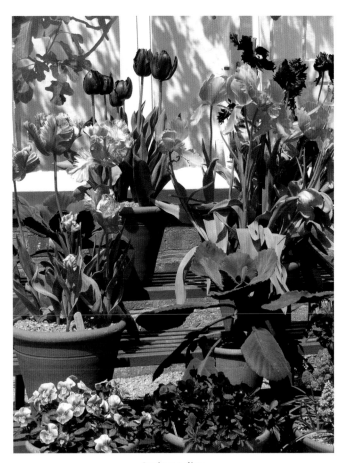

Spring tulips.

that could be extracted from the photos; for instance the row of shallow pots in the foreground containing violas and grape hyacinths would make a charming composition, as would a combination of these with some of the pots of tulips in the background.

A large brush, number 12 or 14, which comes to a fine point, is needed for a painting of this style. The brush allows plenty of paint to be held so that bold sweeping brush strokes can be made and the fine point allows delicate drawing and thin lines all within the same mark.

The dark tulips are put in first. If you are not confident enough to put such a dark colour down directly then either draw in some guidelines or practise first on a scrap piece of paper. The colour is made by mixing Winsor Violet with Indigo, which gives a wonderfully deep, rich shade. A second colour is mixed ready for use from Winsor Violet and Carmine. Do not tone down either colour and make it lighter or you will lose some of the drama of the composition. It is best to lay down the colour as it is rather than build it up in layers because this risks the loss of the all-important flecks of white, which stop the colour from looking too heavy. Using too many layers can also lose the transparency of the paint, making it look dead and lifeless.

The brush is dragged in areas where the flowers are catching the light and the second shade is also used to give some variety to the colour of the tulips. Before these first marks are quite dry, a second layer is put on where the flowers are in shadow. By adding this layer before the paint is dry the colours blend together and do not leave hard edges where they are not wanted.

The pink tulips are painted in using Permanent Rose in different degrees of intensity. Permanent Rose is, as its name implies, very permanent and once it is dry will not move or blend. The paper could be wetted first to keep the paint moving for longer or more water could be added to the pigment. Either way the paint needs to go where you want it before it has time to dry. A second layer of colour using Permanent Rose and Carmine is added to suggest the shadows.

The stems and leaves go in next. The green needed for this part of the painting is a soft shade made by mixing Yellow Ochre with Cobalt Blue plus some Sap Green. You will need a range of shades so try out various combinations and proportions until you have a useful selection. The large brush is also useful here as it can give you a broad stroke for the wider part of the leaf by pressing down on the brush and a finer line for the tip by lifting the brush up. Drag the brush where there is light on the leaf and leave some small areas of white paper.

The stems vary in colour, with some of them being quite red near to the flower. Mix some Carmine with the green to get this shade. Run a line of darker green down one side of the stem while the first shade is still damp to indicate the shadow and make the stems look round.

have been rearranged but, as the gardeners at West Dean would probably not have appreciated their display being tampered with, some artistic licence was used and a bit of redesigning on paper took place back in the studio.

It was decided that a fairly loose approach would suit this particular composition so an A3 sheet of Fabriano Artistico 300gsm paper was selected to work on. The paper was on a glued pad, which meant that it did not need to be stretched even though a fair amount of water was going to be used. The following watercolours were laid out on two large dinner plates: Permanent Rose, Carmine, Indigo, French Ultramarine, Cobalt Blue, Winsor Violet, Sepia, Sap Green, Hooker's Green Dark, Winsor Yellow, Yellow Ochre and Indian Yellow. Two plates were used so that there was plenty of room to mix colours and still keep them from becoming muddy. The yellows and greens went on one plate and the reds, blues and violets went on the other.

To keep the painting loose and free a planning drawing was made first on cartridge paper. The design was adapted from the photographs taken in the garden, and not only were the pots moved but the viewpoint was also changed. This gave a more interesting and bolder composition with the tulips becoming the main focus of the painting. There are a number of paintings

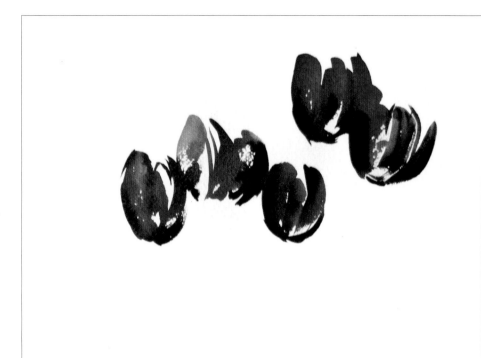

First stage.

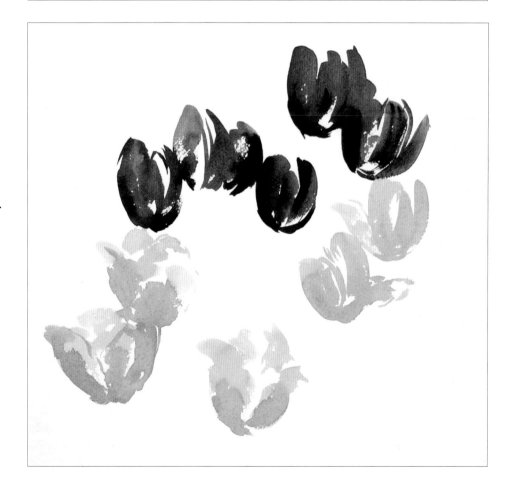

Pinks are added.

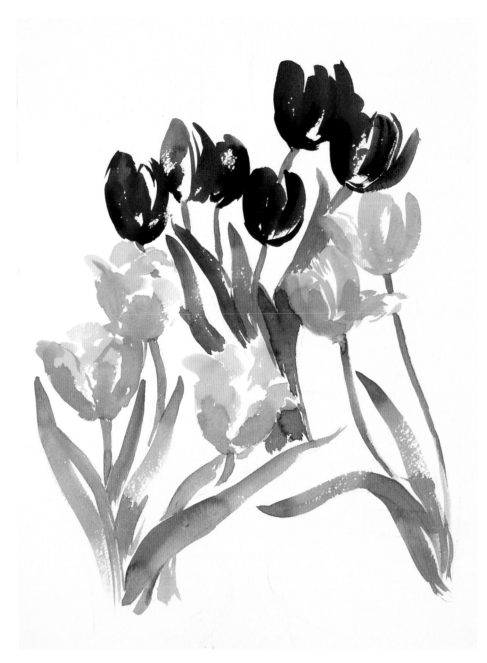

Stems and leaves go in next.

Behind the group of flowers was a greenhouse. The window bar provides a useful straight line, which anchors the composition and the reflections of the plants in the glass adds another dimension without being too intrusive.

Paint in the window bar using some very dilute French Ultramarine. It does not need to be a perfectly straight, continuous line as this would contrast too much with the fluid lines of the plants, so do not use a ruler. The reflections in the glass are suggested by dragging the brush diagonally with some dilute Cobalt Blue and French Ultramarine. Run the brush over the edges of the dark tulips and let them run into the background. By doing this you will connect the flowers with their setting and push them further back in the composition.

The terracotta flower pots are painted next using a variety of close shades of warm browns. The pots are painted in quite freely and in some places just suggested. The pots are large but they are only playing a supporting role in the composition so must not be allowed to become too dominant.

Sepia and French Ultramarine mixed makes a rich brown, which is warmed by the addition of Carmine and can be lightened by adding Yellow Ochre. Draw in the ellipses if you need to but do not fill them in too carefully. Use the side of the brush to drag the colour in places and let the edges dissolve and blur into the background. The earth in the flower pots has been covered with gravel to help keep the moisture in and the weeds out. The gravel is light in tone and has a hint of green in places,

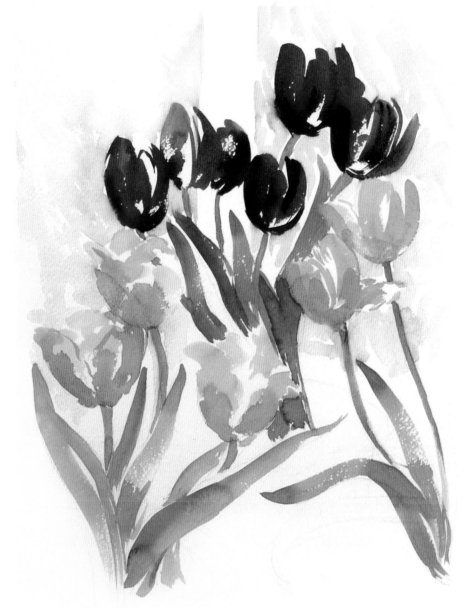

A suggestion of background adds depth to the composition.

which links up with the leaves rather well. A broken wash of colour suggests the uneven surface and the texture of the gravel and some darker areas around the base of the leaves help to anchor the plants in the pots and suggest shadows cast.

The line of the window bar stands out too much because it is completely white. A line of deeper blue, run down one side with a corresponding but narrower line on the other side,

shows that the wooden bar is three-dimensional, breaks up the edge and pushes it into the background. A suggestion of the cross bars lower down, behind the pots, is indicated by another blue line.

The finishing touch is to put in one or two of the dark stamens in the pink tulips at the front, which takes your eye to them first and then leads you in to the rest of the composition.

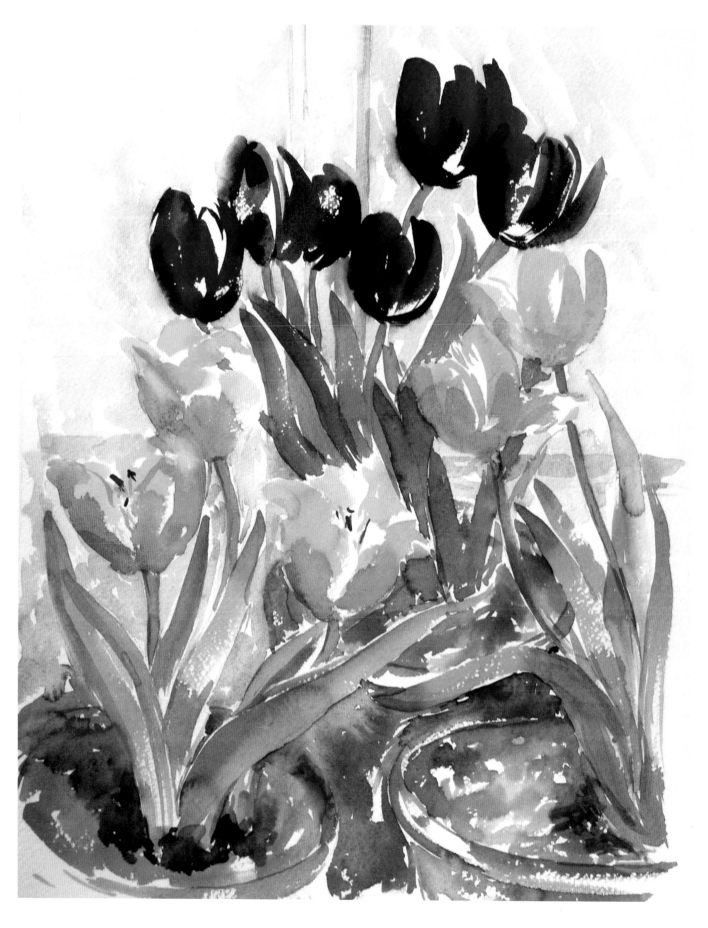

APPLE BLOSSOM IN THE SPRING

This is a quick sketch in oil, which attempts to capture the fragility of the apple blossom. It is painted on a piece of ready-prepared canvas board and the composition is not drawn first, but painted directly onto the white surface. By working in this way the brush marks are kept fresh and direct and overworking is avoided.

The following Alkyd Oil paints were used: Permanent Rose, Alizarin Crimson, French Ultramarine, Yellow Ochre, Cadmium Yellow, Sap Green, Hooker's Green Dark and Titanium White. Alkyd colours were used because they dry quickly, so allowing for speedy over-painting and, since the apple blossom does not last long, this seemed an important factor.

The buds have a deep pink colour, which fades as the flowers open to become the palest pink and then eventually white. Permanent Rose is used for the pink and the deepest areas of colour are put in first, allowing the composition to be seen easily against the white board. Where the open petals are in shadow they become a delicate shade of mauve and these areas are put in next. Care is taken to get the shapes of the flowers right and the spaces between the buds, open flowers and the individual petals. The lightest areas are put in next with some deliberate brush strokes laid in to avoid disturbing the paint already there.

The flowers are seen entirely against the leaves, which frame the blossom and give a sense of depth and light and shade. A range of shades of green is needed to give the impression of the overlapping leaves and these are mixed by using combinations of the ready-mixed greens plus blues to darken them and yellows to lighten them. Combinations of blue and yellow are also used with the addition of red to darken and soften the colour. The foliage around the flowers is painted in with some care and the shapes of the leaves are drawn in with the brush. By doing this the more detailed leaves look nearer and the remaining foliage can then be suggested by using shades of green and broken shapes which give the appearance of distance and depth.

The leaves, being darker than the flowers, can be used to redraw the petals if needed. There is a small space between the petals at the centre of the flowers where the green background shows through, which it is important not to miss.

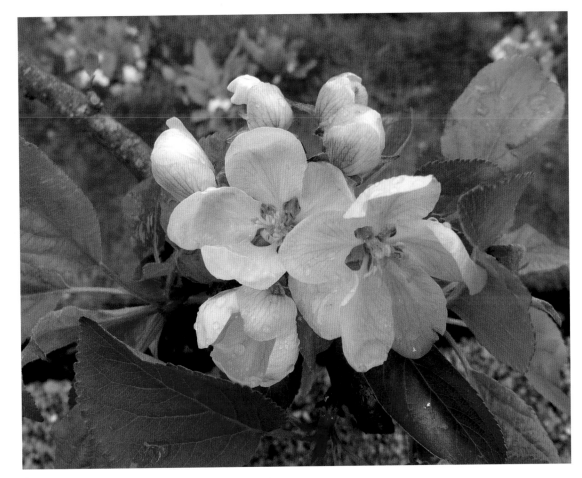

Apple blossom.

LEFT: **The dark of the earth gives a good contrast to the bright colours of the flowers.**

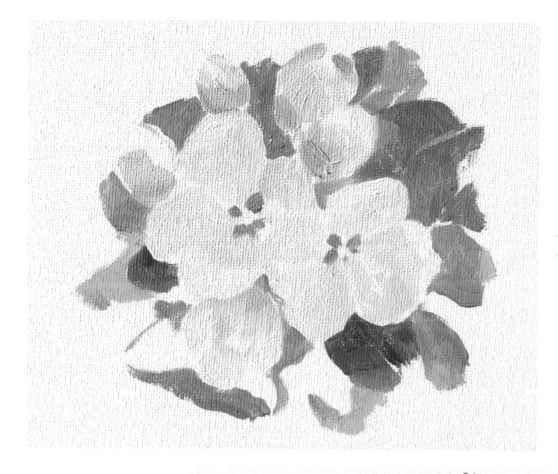

The delicate flowers are outlined by the leaves.

Added darks in the background make the flowers appear more fragile.

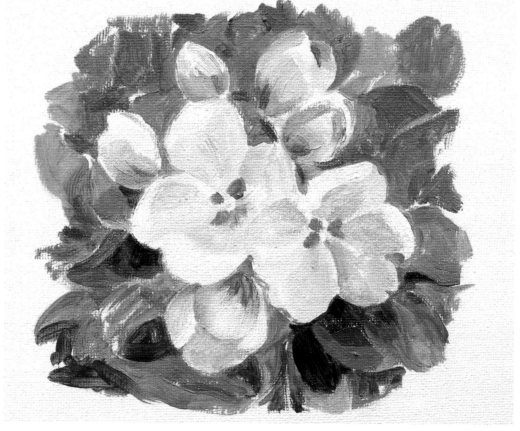

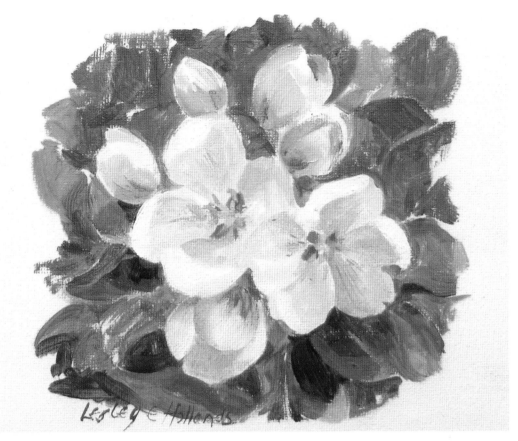

The finished painting.

The centre of the blossoms has yellow stamens that range in shade from a Lemon Yellow through to Cadmium and then to Ochre. These tiny details bring the painting of the flowers to life. At this stage the painting can be left to dry, which with Alkyd paint under the right conditions of warmth and dry surrounding, can be as little as twenty-four hours. The final stage is, where necessary, to highlight areas of the blossoms with white and to darken parts of the background to push areas further away in the painting.

This is a small painting that captures the fleeting fragility of spring blossom.

Summer

THE WASHING LINE

The smell of clean clothes dried by a summer breeze is uplifting. Watching the freshly laundered garments gently blowing in the wind inspired a painting which, although relatively simple in composition, was very rewarding to paint.

The trees on either side of the washing line threw some dappled shade and the taller growth at the back of the garden gave some dark areas, which set off the line of light-coloured washing very well. Photographs were taken to hold the movement in the fabric as the breeze caught it but the rest of the painting was done on the spot.

Fabriano Artistico Rough 140lb/300gsm was used with the following watercolours: Sap Green, Hooker's Green, Olive Green, Winsor Yellow, Indian Yellow, Yellow Ochre, Cobalt Blue, French Ultramarine, Burnt Sienna and Burnt Umber. The paper was on a block to avoid having to stretch it, glued on all sides apart from one small section to allow a palette knife to slide in and remove the sheet.

The composition was roughly drawn in and the washing line and clothes prop protected with masking fluid. Schmincke make a blue masking fluid in a tube with a fine nib, which makes drawing thin lines very easy and also saves brushes being clogged up and spoiled by dried on fluid. The white washing could also have been protected but it forms relatively large areas that are easy to paint round. Over-use of masking fluid can make for a rather stiff painting so it is best kept for fine detail that would otherwise be difficult to leave as white paper or paint in afterwards.

A broad, dragged wash of a light, bright green was laid in first using a mixture of Sap Green and Winsor Yellow. The dragging leaves flecks of white paper showing, which suggest the slight sheen along with the light and shade that you get on

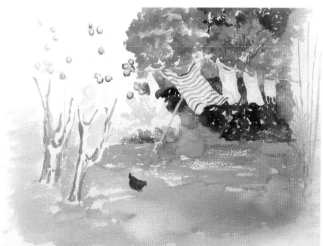

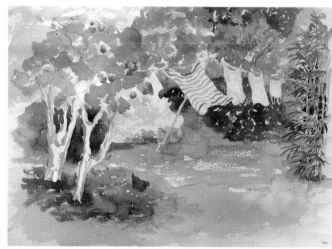

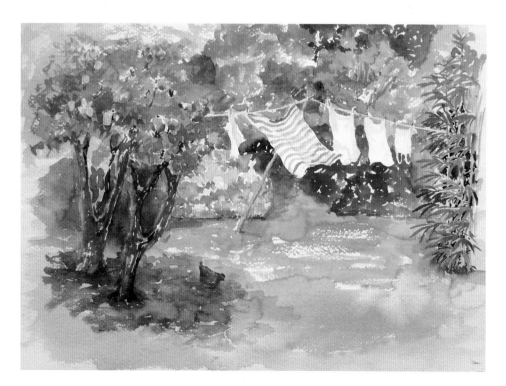

TOP LEFT
Washing drying in the sun.

TOP RIGHT:
The grass is suggested with a dragged wash.

MIDDLE LEFT:
Trees and washing are added.

MIDDLE RIGHT:
The bamboo gives some contrasting uprights.

LEFT:
The finished painting captures the movement of the washing.

grass. Dragging works best on a rough surface. A deeper shade of green is then laid in with a broken wash to suggest some of the trees in the background.

The tree to the left in the foreground is an old apple tree of an early variety called Katy and it is laden with ripening red and gold fruit. The apples are painted in using shades of reds and yellows and when the paint is completely dry they are covered with masking fluid. By doing this the branches and foliage can be painted in quite freely without worrying about losing the fruit. A touch of red against all the greens in a landscape helps to bring the painting to life. The main branches of the tree were indicated using Olive Green with a touch of Sap Green added for some of the lighter areas. The bark of the tree was quite rough and had lots of lichen growing on it that glowed in the sunlight.

On the right hand side of the foreground is a clump of bamboo, which gives a pleasing contrast to the rest of the foliage due to its upright habit. The main stems are just suggested here as a reminder of where the plant is going to go.

The washing is painted in next, keeping it quite simple with mostly just the shadows being painted. The striped cloth was made of very lightweight cotton, which lifted and blew in the breeze beautifully, and the stripes followed the curves in the cloth, which made it even easier to give the impression of movement.

At this point a chicken wandered across the grass and was quickly sketched in and then painted using Raw Sienna with a touch of Burnt Sienna.

More greens were then put into the background with the area immediately behind the washing made quite dark in order to set the washing off. Some softer greens, mixed by combining Yellow Ochre with Cobalt Blue, were also painted into the background, giving a greater degree of interest and suggest depth and distance.

There is some lovely dappled shade underneath the apple tree, which is put in next using Sap Green mixed with French Ultramarine. The wash is varied so that quite a lot of the first layer of paint is left showing through; this helps to give the dappled impression. Around the base of the tree the shadow is darker and also has some earth showing through, which was suggested by adding some Burnt Sienna to the colours already used. These darker shades help to bring the foreground towards you.

The bamboo is worked on next with the clear green leaves put in with single brush strokes. The stems and leaves are made to stand out by putting some much darker greens between them. The spikier growth adds further contrast and interest to the foreground.

There is a flowerbed behind the apple tree with roses and lobelia growing in it. This is just suggested, with very little detail. The colour is needed there but too much would interfere

with the line of washing, which is the focal point of the composition.

More colour is added to the apple tree foliage before the masking fluid is removed from the apples, the washing line and clothes prop. The branches and trunk are darkened with a mixture of Burnt Sienna and Sap Green and more detail is added to the chicken.

The apple tree and the bamboo now frame the washing line and the chicken helps to take your eye into the composition.

Autumn

A BLOWY DAY IN EARLY AUTUMN

The leaves were just beginning to turn and there was a smell of autumn in the air when a breeze got up and blew the first fragile leaves from the group of silver birches growing at the bottom of the garden. The trees swayed in the wind giving a graceful feeling of movement accentuated by the leaves flying up into the air. The silver trunks of the birches stood out sharply against the clump of dark-leaved holly growing behind. Dry grass at the foot of the trees accentuated and complemented the orange and yellow in the sky, balancing the composition.

A quick sketch was made *in situ* and photographs taken for further reference, as it was too cold and windy to sit outside comfortably.

The first stage was to draw out the overall composition without much detail. The trees were then marked out with masking fluid so that their light shapes against the dark background were not lost.

Fabriano Artistico Rough 300gsm paper was used for this painting on a glued block. The rough texture of the painting helps to keep the work loose and free with the flecks of white left showing accentuating the movement in the trees.

The following watercolours were used: Indian Yellow, Winsor Yellow, Carmine, Cobalt Blue, Indigo and Sap Green.

This is a relatively simple painting, completed quickly in order not to overwork the composition and retain the feeling of the fresh, windy day.

The sky was washed in first using a mixture of the two yellows and the carmine in various combinations and proportions. Lots of broken areas of white were left showing, which help to suggest movement in a subtle way. The bottom edge of this wash was left ragged and paler than the rest to make putting in the foliage behind the trees easier.

Before the sky was completely dry a broken wash of shades of light green was added. It is broken to represent the leaves of the silver birch trees and a light shade is used to suggest the leaves furthest away. Once this wash is completely dry some darker leaves are added to suggest the nearer foliage.

In the distance behind the holly is a line of shrubs with lighter green leaves. This is washed in next and then the dark areas of holly are added. It is important to get this area dark enough first go in order that the silver birches really stand out clearly and the dark green does not become too heavy and solid. Indigo and Sap Green are used, with a little Indian Yellow, to achieve the rich deep tones of the holly leaves.

When all of this is quite dry, the masking fluid is removed. You may well find that some areas will need to be further filled in and paint brought up to the edges of the trees. Some detail is also put into the trunks using Cobalt Blue and Indian Yellow, which mixes to a silvery grey shade.

The foreground is dealt with next using some of the sky

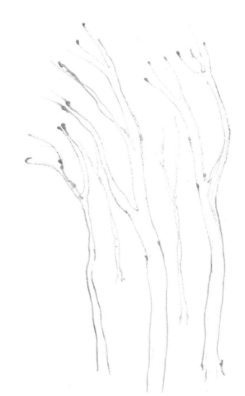

The masking fluid protects the light areas.

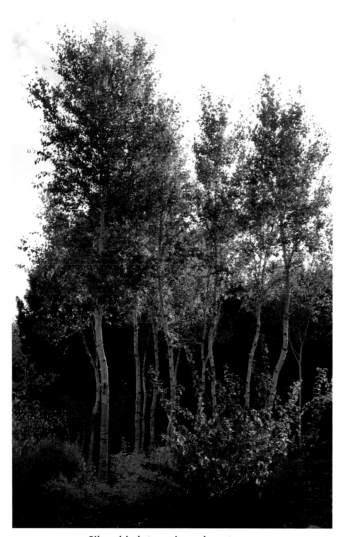

Silver birch trees in early autumn.

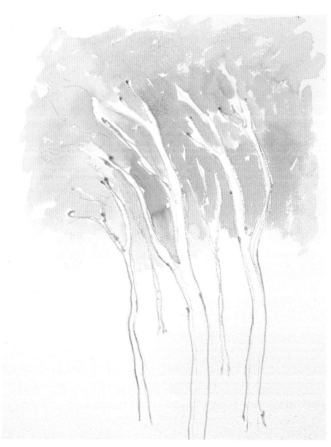

Warm colours are washed in for the sky.

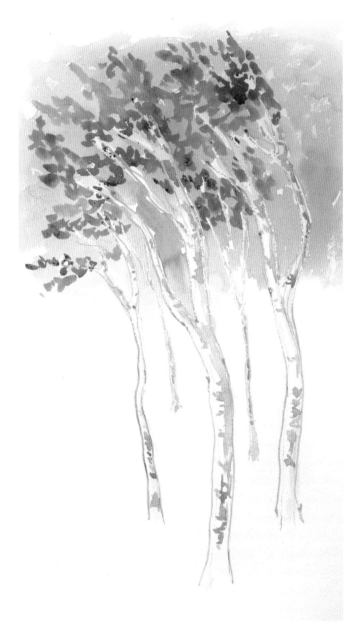

Leaves are added.

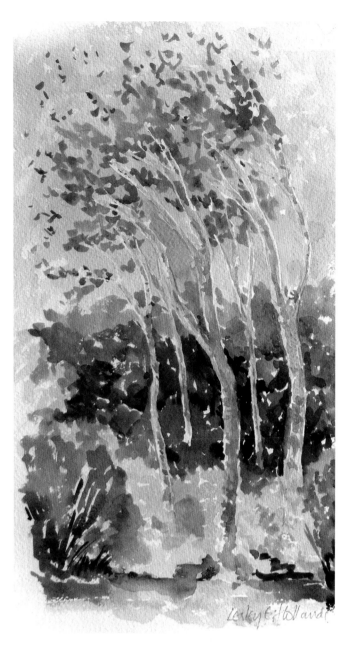

Dark foliage in the foreground and behind the trees completes the composition.

colour to suggest the mass of dry long grass which has grown up underneath the grove of trees. By using this colour here the composition is balanced and a feeling of light is suggested.

There are some dark shrubs in the foreground with a stronger upright growth, which give contrast and structure to the front of the composition. Then finally the wind-blown leaves are painted in using deeper shades of the sky with added red to give the suggestion of the autumn colours.

The finished painting, although relatively simple, has movement and warmth and captures the feeling of the early autumn.

Stained canvas with drawing.

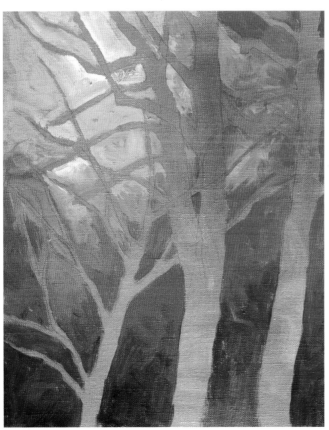

Background painted showing up the tree shapes.

AUTUMN COLOUR, THE LAST LEAVES

It is late autumn and most of the leaves have fallen but there are still a few hanging onto branches. The trees are sharp against the evening sky, which is reminiscent of the colours of the leaves still lying at their feet, then a sudden gust of wind shakes the branches and the remaining leaves are lifted and blown up in the air, swirling away into the distance. The overlapping branches become almost abstract in their shapes and patterns and the whole composition lends itself to some dramatic use of colour. It is difficult, but not impossible, to paint autumn colour without it looking over bright and extravagant. Here the strong structure of the tree skeletons gives a strength and boldness to the composition, counterbalancing the brilliant colours in the sky behind; while the dancing leaves give life and movement to what might otherwise have been a rather static painting.

Oil paint seemed the most appropriate medium for this painting as it can be layered with ease, giving a luminosity and depth to the finished work. Canvas has been used for the support with a thin, uneven stain of Burnt Sienna removing the whiteness. Burnt Sienna is a sympathetic colour to use as a ground as it adds warmth and depth to the composition without being intrusive. A white background would have shown up too much through the rich autumnal colours of the composition and care would have been needed to ensure it was all covered by the layers of paint.

Once the stain was dry, the trees were drawn onto the canvas with a pencil, although a brush could just as easily have been used, and the background was painted in.

The following oil colours were used: Cadmium Yellow Deep, Lemon Yellow, Yellow Ochre, Cadmium Red Deep, Winsor Red, Permanent Rose, Burnt Umber, Burnt Sienna, Titanium White and Payne's Grey.

The spaces created by the overlapping branches were varied and interesting and were painted in almost as though they were pieces of a jigsaw. A good range of subtle colours was used and even the smallest space had a variety of shades in it. To give a greater feeling of depth and distance darker shades were used at the bottom of the composition and lighter tones towards the top. This gave the impression of undergrowth at the bottom and the light of the sky shining through the trees at the top. To avoid the painting looking too much as though it was a 'painting by numbers' piece, care was taken to avoid stopping one colour at one side of a branch and then starting another colour on the other side. By continuing the colour behind the branch a greater suggestion of distance was given and the sky was pushed behind the trees.

Once the sky was complete the trees were painted in using all of the reds, plus Burnt Umber, Burnt Sienna and Payne's Grey. The trees also needed to be painted with subtlety using a

range of colours. A suggestion of light and shade, which also gives a feeling of three dimensions, was achieved by varying the colour on each branch. Again the painting is generally darker in the lower part of the composition and lighter towards the top left giving the impression of the sun going down.

When the trees were complete, the painting was left to dry thoroughly before the leaves were painted in.

The leaves were a wide range of shades of red, yellow and brown and they varied in size from tiny – where they had blown some distance away – to quite large where they were close. The shapes of the leaves also varied as they were being viewed from different angles. It is important to capture this variety in colour and size or the painting will look stiff and stilted and lack the feeling of movement and lightness that the moving leaves give against the weight and strength of the bare trees.

This is a small painting, relatively simple in composition, but due to the intensity and contrast of the colour and the movement in the falling leaves, it has a great feeling of drama.

Winter

THE FIRST SNOW

This painting uses part of the same group of trees that border the garden as are in the previous picture. This time it is late afternoon in deep winter and the snow has started to fall. The sky has gone the curious shade of yellow that sometimes appears with this type of weather and the flakes of snow are falling large and softly, not yet settling on the trees but with the promise of a deep blanket by morning. The trees are very stark against the sky and it is difficult to tell just what colour they are. They are more than just black and on looking closely a subtle range of shades can just about be made out. The undergrowth is spiky and also dark against the glow of the evening and the falling snow.

While watching the snow and thinking about how to paint it, various things come to the fore. The flakes are various sizes, partly because of perspective but also because that is the way they are. The distant snow seems to blur and fall more quickly than the nearer snow, again probably an optical illusion but a useful thing to observe. The snow is not all the same colour, with the nearest seeming much whiter than the distant. Further away the colours appear a soft blue/grey with even a tinge of yellow.

All of these observations will be put to good use in the

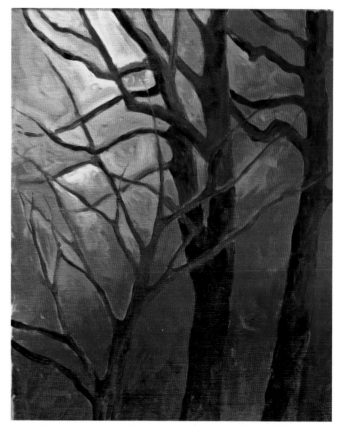

Trees painted with more colour in the background.

Finished painting with leaves blowing in the wind.

Background colour.

Completed painting with more snow and greater detail in the trees.

Trees and first stage of snow.

painting.

A ready-primed canvas board is used for this painting and as with the previous work the whiteness is taken off with a stain of Burnt Sienna. The trees are drawn onto the board, using a slightly different part of the group of trees that border the garden in order to vary the composition. The following Alkyd Oil Paints are used: Cadmium Yellow, Lemon Yellow, Yellow Ochre, Burnt Umber, French Ultramarine, Alizarin Crimson, Cadmium Red and Titanium White.

The spaces between the branches are painted first using all three of the yellows plus some white. Each section has a range of shades in it to give that subtle suggestion of distance and movement.

The trees are painted in using a mixture of Burnt Umber, French Ultramarine and Alizarin Crimson in varying proportions. Some lighter areas are added with a little Yellow Ochre. The bottom of the composition is covered with some spiky undergrowth, which looks very dark in the evening light. This area does not want to look too heavy and solid so the paint is scrubbed on with a hog hair brush and then lifted and manipulated with some dry kitchen roll. You may find that too much comes off to begin with but it is easy to repaint and try again. When the undergrowth looks suitably prickly, leave the painting to dry completely before attempting to paint the snow. By allowing the paint to dry you will then be able to keep the

snowflakes looking white and pristine and you also have the advantage of being able to remove the snow if it does not look right and have another go.

The smallest snowflakes are painted first using Titanium White mixed with a very small amount of Cobalt Blue for some and Titanium White mixed with Cadmium Yellow for others. The flakes vary in size and shape even when they are small and further away. Larger flakes of snow are painted with pure white, overlapping some of the smaller flakes and the trees. Snow has begun to settle on the ground and in the shadows looks quite blue. Broader, horizontal brush strokes are used for the lying snow and some of the undergrowth has been left showing.

The finished painting has caught the feeling of quiet that often comes when snow falls and gives a peaceful, cold impression.

BONFIRE IN THE SNOW

We had a late afternoon, end-of-year clear up of the garden rubbish one cold afternoon, with a cheerful bonfire as reward, and then it started to snow. The fire was big enough to withstand the soft flakes and continued burning as the surrounding areas turned white. The sky had a faintly mauve tinge, which made the snow where it settled on the tree branches and the ground seem even whiter, with blue shadows among the shrubs below the trees.

A photograph was not very successful so a quick sketch was executed with some colour notes written on it. It was too cold to stay outside so the wood burner was lit and a board prepared with a blue grey ground ready to start work as soon as the board was dry.

The following oil colours were used: Olive Green, Burnt Umber, Payne's Grey, French Ultramarine, Cobalt Blue, Cadmium Red Deep, Titanium White, Cadmium Yellow Deep, Yellow Ochre.

When the coloured ground was dry the sky was painted a pale mauve with areas of light blue and touches of pink. The bottom half of the painting was made darker using shades of cool mauve, violet and grey. By making the initial layer of colour quite dark the snow, when painted later, stands out more readily. An indistinct blending of the sky and the foreground was needed, so the paint was scumbled together with a stiff brush.

Misty, cold background.

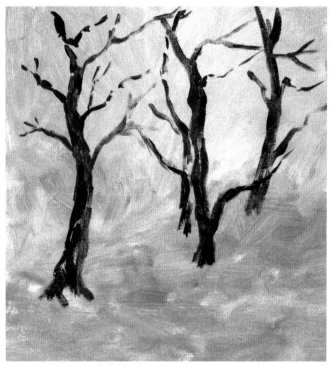

Tree painted in with broken brush marks.

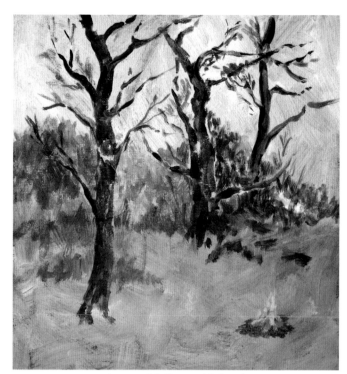

Background foliage with bonfire.

Scumbling is traditionally applied with a circular motion of the brush but the effect can be achieved with dabs, stipples, streaks or any other mark of the brush that allows the under layer to stay visible and does not form a flat skin of paint. Without doing this the composition would have been split in two and the sense of distance lost.

The paint was left to dry and then the trees were painted in using shades of grey, green and brown. Fine broken lines were drawn in with a thin brush between the main branches and the trees were made to overlap and interlink with each other.

The undergrowth of scrubby shrubs beneath the trees was quite dark but broken with lines and patches of snow. Shades of soft green and grey with hints of blue were used here to keep the shrubs receding into the background. Lighter patches of snow were then added, again using a range of shades.

Snow was now painted on to the foreground using horizontal brush strokes to give the appearance of the flat area in front of the trees. Some white was used here but also lots of close shades of blue, pink and mauve. The more you look at snow as you try to paint it, the more colours there appear to be. Snow was also painted onto the tree branches where it had

begun to settle.

The next stage was the bonfire. This was quite tricky to paint as it dominated the composition to begin with because it was too large – repainting it on a smaller scale made it fit, but then it seemed too bright. Putting in the darker ring of melted snow and ashes around the fire helped here and softening the colours also improved it. The finishing touch was putting in the column of smoke, which drifted up in the still air almost completely vertically.

This was a challenging composition to paint – especially the bonfire – but the finished piece has caught the feeling of cold surrounding the warmth of the dying bonfire. It is good to try something new and give yourself something out of the ordinary to test your skills and help you to move forward.

Of course there are many paintings that could be put into this chapter with so many aspects of a garden being dictated by the seasons, but this is just a taster. Later in the book the idea of developing a series of works using the same subject matter but painted at different times of the year will be explored.

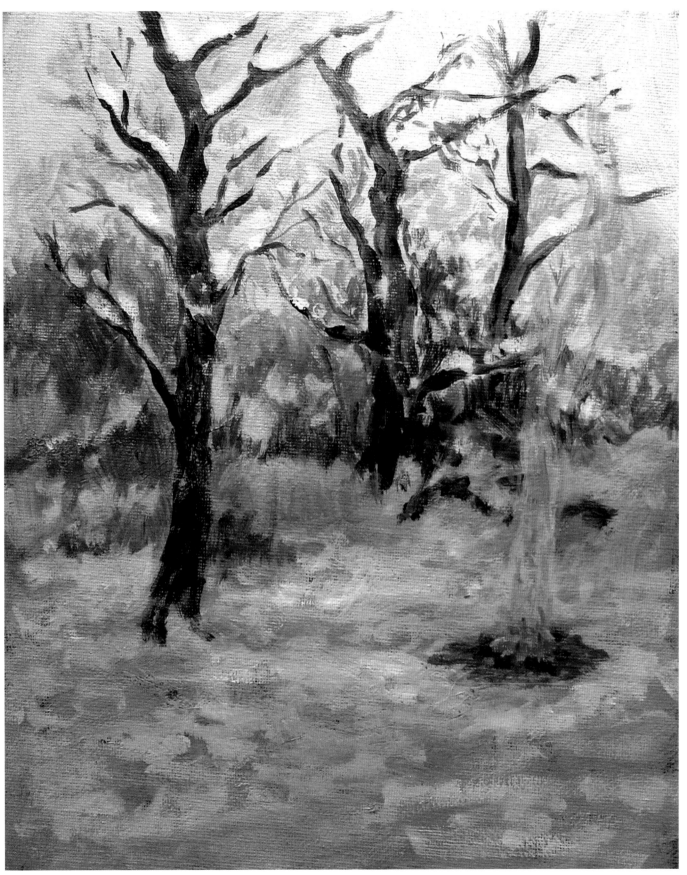

More detail in the trees and bonfire and added colour to the snow.

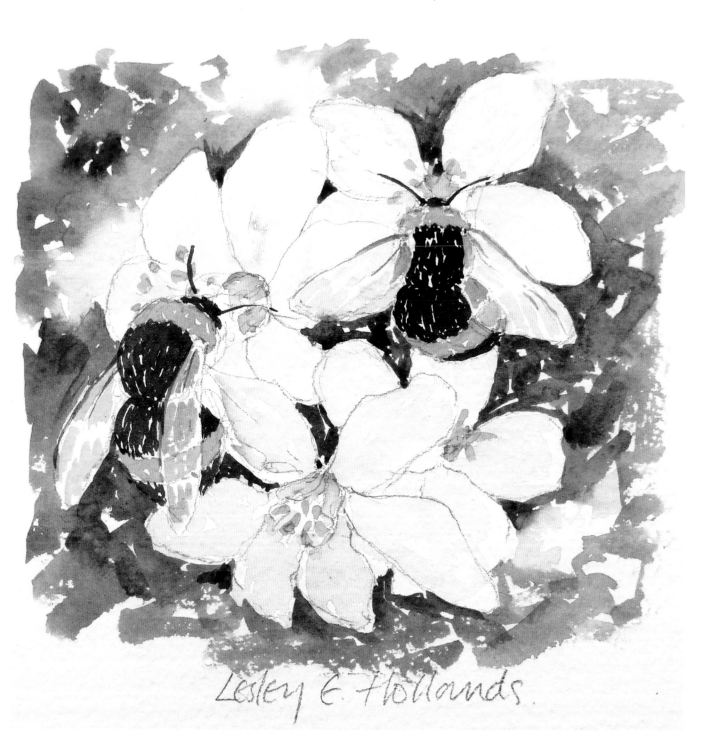

Bees on blossom.

ANIMALS, BIRDS AND OTHER LIFE

This chapter looks at the possibly less usual subject matter found in a garden. Insects of all sorts play a large part in a garden whether for good or bad and make excellent subjects for paintings – even if sometimes they are rather small. Many creatures need to be photographed as they move too fast to work from them directly in the garden. Some things, such as snails, are pests in the garden, so it is a bonus if they can earn their presence by posing for a while. Birds make good material for painting and can be photographed well if you have a good zoom lens on your camera or, alternatively, set up a bird feeder near a window and when they have got used to it you can sit quietly inside and get some great shots. Some birds, especially robins, are used so often on Christmas cards that it is a challenge to make a painting that is not sentimental.

The human figure is another feature of a garden, whether as the main part of a composition or just tucked away somewhere in the painting to give scale and movement. Figures will be looked at in this chapter and incorporated again in the chapter on Garden Scenes.

SNAILS

Perhaps snails are not everyone's idea of a subject for painting but they can make an interesting and amusing composition especially if you can find some of the stripy ones as well as the more common varieties. Collect them in a glass jar with a lid as they are remarkably fast moving and can quickly escape. It is a good idea to have your workspace and materials set up before you collect your snails so you are less likely to lose them before you begin. Place a sheet of white paper on your work surface and dampen it slightly so the snails will be more comfortable. Have a light ready to illuminate the sheet, or work by a window. Put out your colours on a mixing palette or use pans of paints and choose a couple of brushes with good points and a sharp pencil. This will be quite a small piece of work so an A4 sheet or an off-cut would be quite suitable.

When everything is set up put the snails out on the paper. It will take a moment or two for them to emerge from their shells and start moving. As soon as they make an interesting composition start drawing. You will probably have to keep repositioning them as they have no idea how to hold a pose! If they move too fast for you to draw them together, put all but one back in the jar and work on a single individual. You could even just use one snail and by drawing it in different positions on the sheet put together your own made-up composition. By keeping them in a glass jar they are still visible and available for you to refer to them.

Another way of dealing with the speed at which the snails move about is to take photos of them in a variety of positions and from different angles. A macro setting on a digital camera is very useful for this sort of photography.

Here two small paintings have been made. The first is a study of an individual snail chosen because of its rather attractive black stripes and the second is of a group of snails, which was composed on the paper rather than drawn as they were seen.

A small piece of Bockingford 300gsm was used for both paintings with the following watercolours: Burnt Sienna, Sepia, Burnt Umber, Blue Black, Raw Sienna, Cobalt Blue and French Ultramarine.

The first snail was drawn, trying to get a feeling of movement in the body and a suggestion of shine on the shell. A warm golden brown was mixed using Burnt Sienna and Raw Sienna.

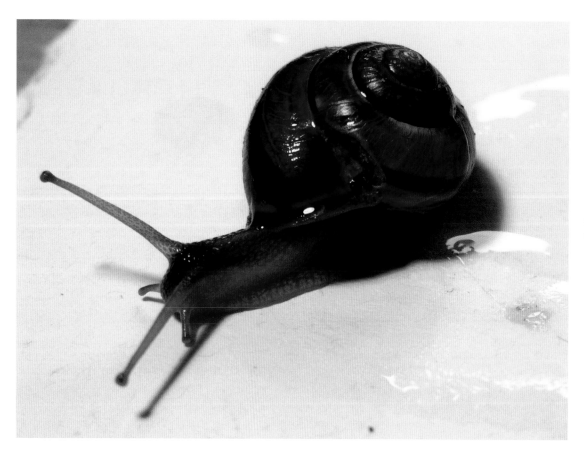

A not always
welcome guest.

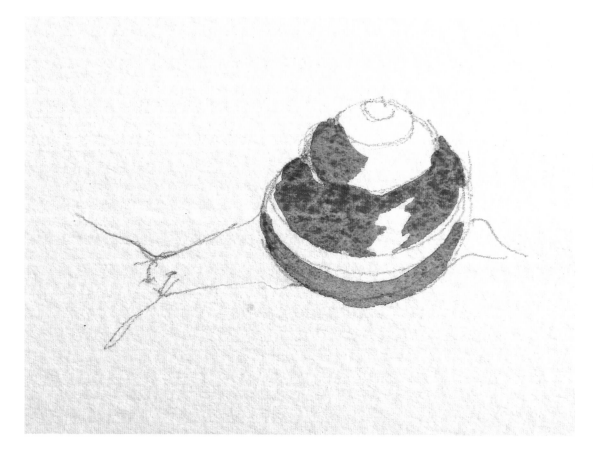

Gloss on the shell is
caught with a white
highlight.

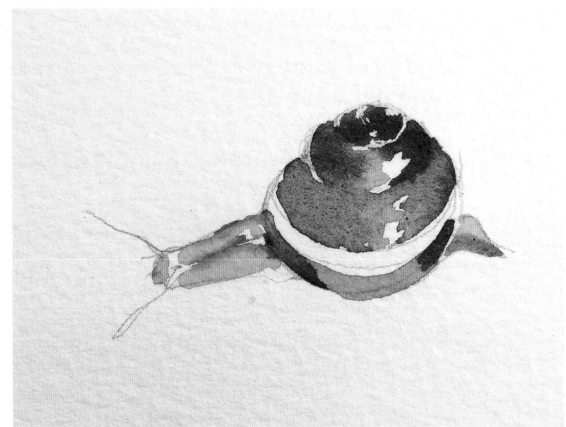

The body is added.

Antennae and shadows bring the snail to life.

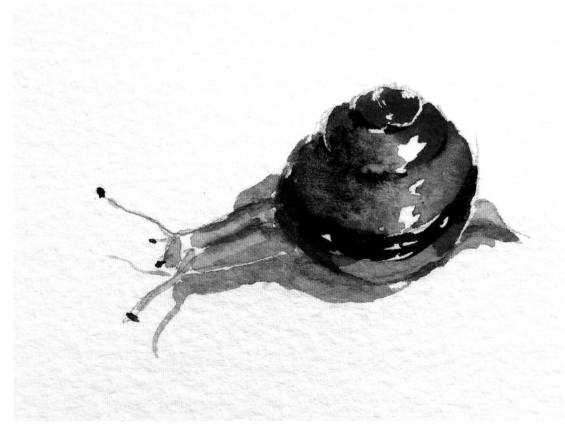

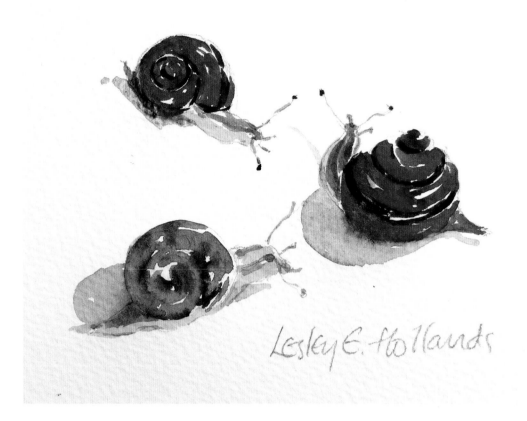

A gathering of snails.

This was dragged on, leaving a small area of white to show off the glossy shell. The body was put in next using a similar mixture but with more Raw Sienna and additional water to make the colour lighter. The feelers of the snail are important as they add movement and give a direction to the creature. The black dots at the end of the feelers are its eyes and give that little bit of extra definition and a full stop. Again flecks of white have been left showing in order to suggest the moistness of the body. When the first colours were dry the black stripes were painted in, making sure that they follow the shape of the shell, so helping to give its curved, spiral appearance. The final stage is to add some shadows using a mixture of the two blues to create a soft shade. The shadow cast is slightly darker immediately under the snail, which helps to anchor it to the surface that it is sitting on. Some shadow is put onto the shell and the soft body of the snail, making it appear more three-dimensional.

The next painting has used two live snails, but one of them has been painted twice in the same picture, so there appear to be three of them. The composition was arranged on the paper and the snails used for the observation of their shapes and sizes. The final painting has used a photograph of a large snail and a small snail, which look as though they are communicating with each other. The actual snails were kept in a glass jar so that the colour and shape would be accurate.

To make a fuller composition you could add other things, placing the snails on plants, flowerpots, pieces of wood and such like.

Snails make an unusual and amusing subject for a painting and it is surprising, perhaps, how popular they are with buyers. No snails were injured in the making of these paintings and all were released back into the wild once their 'portraits' were completed.

A ROBIN IN THE SNOW

This composition was suggested as a challenge to create a painting of a robin in the snow without making it look sentimental or Christmassy. You can judge for yourself whether the challenge has been met.

During a snowy period one January the robins were hungry and therefore relatively accommodating and posed for their photographs quite happily. It was difficult to get very close but after a number of attempts some useful shots were achieved. The one that has been chosen has the bonus of some winter

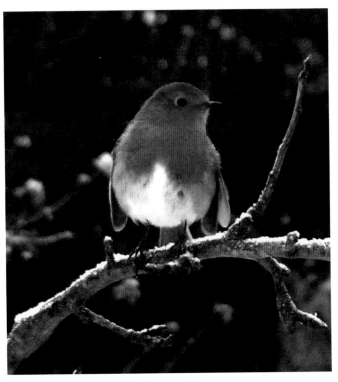

Winter robin.

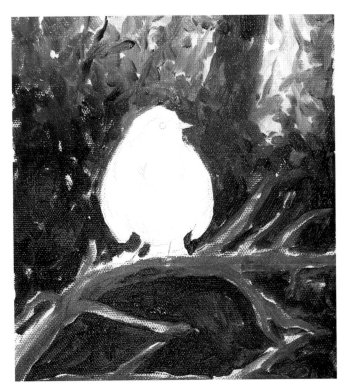

Background painted.

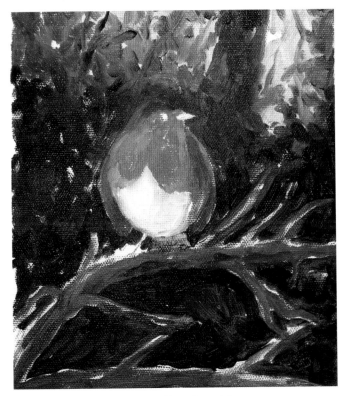

Some detail on the robin.

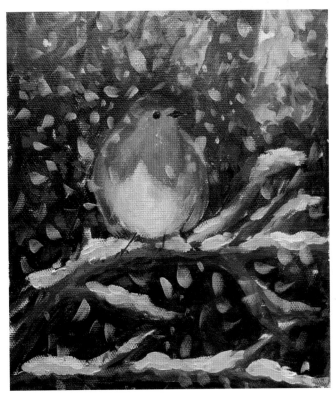

Robin complete with falling snow.

Daphne in the background, which picks up the warm colours in the robin rather well. The robin has become almost a ball shape with his feathers fluffed up against the snow, very different from his sleek springtime appearance.

This is a small painting, which used a ready prepared, white primed canvas with the following oil colours: Cadmium Red, Sap Green, Olive Green, Burnt Umber, French Ultramarine Blue and Titanium White.

The robin was drawn out on the canvas with a pencil and the branch he was sitting on sketched in. The light sky was painted in first using white with a little Ultramarine to give just a small amount of colour. Branches, tree trunk and broad areas of the holly foliage were put in on top while the sky was still wet. By working into a wet ground a very soft-edged appearance has been achieved, which keeps the background looking slightly out-of-focus and distant. All the shades of green and brown were used plus French Ultramarine for the very dark areas.

The robin is painted in next with the brilliant Cadmium Red of the breast gently fading into the grey below and then into the brown of the wings and head. Small brush marks are used to break up the outlines and give the appearance of fluffed-up feathers.

Light and shade are added to the small branches that the robin is sitting on; this detail brings the twigs into focus and keeps them in the foreground of the painting. The black eye of the robin is mixed from Olive Green and French Ultramarine,

which gives a rich dark colour. Shadow and light are added to the robin's body to increase the feeling of roundness.

Finally the Daphne blossom and the falling snow are added with settled snow on the branches that the robin is sitting on. The hint of pink in the background lifts the dark of that part of the painting and connects gently with the colour on the robin.

It is difficult to judge whether this painting has met the challenge or not; either way it was great fun to do and could be used as a Christmas card if necessary.

BEES

It would be very difficult indeed to paint a bee when it is flying around the garden enjoying the flowers; so a camera, preferably digital, is essential. Choose a flowering shrub or group of flowers in a good light so that there are lots of bees with plenty to keep them occupied. If you have a macro setting it can be quite useful – set your camera to its highest resolution so that if you have to enlarge your photographs they will still be crisp and full of detail. Take a few practice shots so you know roughly how far away you need to be in order to get a reasonable shot of the insects, then snap away. Fifteen or so shots were taken in preparation for this painting and only about four were useful. The bee always seemed to move just as the shutter went down so a lot

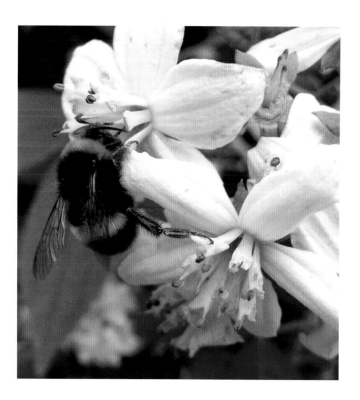

Busy bee.

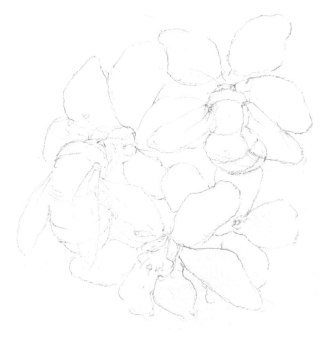

Composition drawn out.

of the images were out of focus or with only a bit of the bee in shot. If you cannot get quite as much detail as you feel necessary to paint the bee properly, look up pictures of bees in natural history books or on the internet.

Out of the few good photos two were chosen and then amalgamated to create one composition. Two bees on a group of flowers look more interesting than one.

The composition was drawn out first, trying to make the bees look as though they were seen from different angles. The main flowers were drawn in with some detail but the leaves and other flowers in the background were left out at this stage as they can be put in later with just a suggestion of variation in the colour.

The first thing to paint is the yellow on the bees; this is done so that it does not get lost and painted over by mistake. Winsor Yellow was used for the sunlit side and Indian Yellow for the shadow. The yellow in the centre of the flowers is also put in at this stage since it needs a similar shade. Permanent Rose in a very dilute form is used for the petals with just a hint of stronger colour towards the centre of the flowers. Some small areas of pink are put in to suggest that there are other blossoms in the background, slightly out of focus. At this stage the wings of the bees are not painted at all. In order to make the flowers and the bees stand out, the background needs to be quite dark but not too heavy. To achieve this, a broken wash of light green is put down first. To create a broken wash, drag your brush, using the

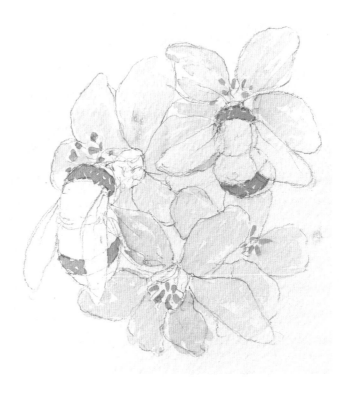

First suggestion of colour.

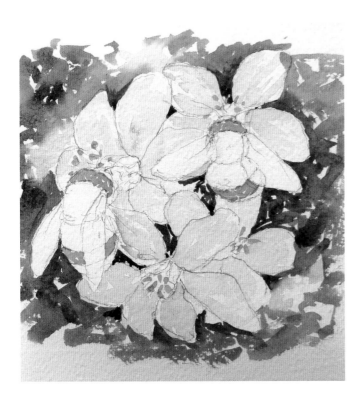

The dark background makes the flowers stand out well.

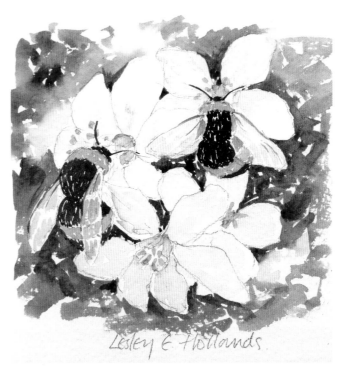

Detail on the bees and flowers, brings the painting to life.

side as well as the tip so that the paint catches the surface of the paper leaving small areas untouched. You need to get the right fluidity with your paint to achieve this effect – use too much water and it won't leave the flecks of white and if you use too little the result will be too dry, without any flow to the colour. If in doubt, practise on a spare piece of the same type of paper first. Sap Green and Winsor Yellow are used for the first wash.

While the first wash is still damp work into it with a deeper shade of green made by adding more Sap Green to the first mix. Keep some of the flecks of white across the composition. Finally mix another even darker shade of green, this time by adding French Ultramarine to the Sap Green. Use this colour to make the edges of some of the petals really stand out. Do not go round them all as this would have the effect of flattening the composition; by leaving a few petals with a softer edge it makes some flowers seem further back and the whole group of blooms seem more three-dimensional.

The last part to paint is the bees. Their bodies are furry and even though it is a small area of paint they do need to look soft and hairy. To achieve this use a brush with a fine point and, with paint that is not too wet, apply small marks that follow the shape of the bees' bodies. Indigo and Blue Black have been used to create the deep velvety colour needed. The wings need to look delicate and semi-transparent, which is a difficult effect to realize. If you look carefully, the colour seen through the wings is a slightly lighter version of what is behind them. The wings are also shiny and catch the light so tiny areas of white need to be left to give this effect. Put in as little as possible in order to keep the delicacy. Pause frequently to look at what you have and, as soon as they look like wings, stop painting.

This is a charming little composition and was fun to do, right from the first photographs through to the final painting of the wings.

BEES ON A LAVENDER BUSH

This clump of lavender was alive with the buzz of bees, busy finding nectar. They were even faster moving than the bees on the previous painting so more photographs were needed in order to get some useful images. The idea for this painting is to try and get the feeling of lots of bees moving through the flowers and foliage with wings moving so fast they are out of focus. This would be quite difficult to achieve with watercolour unless opaque colour were used, so oils were decided upon.

With oils, light colour can be put on top of dark, and fuzzy out-of-focus effects can be achieved more easily giving the option of sharpening up some and making them more defined when needed.

For this painting a ready-made canvas board was used with

the following Alkyd colours: French Ultramarine, Cobalt Blue, Cerulean Blue, Burnt Sienna, Magenta, Purple, Sap Green, Olive Green, Cadmium Yellow and Winsor Yellow. Alkyd paints were chosen as they dry much faster than ordinary oil paints so the building up of the layers could take place with far less waiting between the stages; an ideal choice for impatient people.

First of all a stain of Burnt Sienna was applied to the canvas to take off the whiteness. The stain was applied first with a brush using very thin paint and then rubbed with a cloth to give an uneven appearance. Removing the white was an advantage to this particular composition as the lavender blooms were seen against bright green stems with dark areas between. The red-brown stain recedes, allowing the blooms to really stand out and there is no competition between the lightest areas of the flowers and any of the original canvas, which may have been left unpainted if not stained first.

This painting is worked from dark to light so, once the stain is dry, shades of deep green are applied using Olive Green and Sap Green mixed with French Ultramarine. The brush marks are vigorous and sweep in from the right-hand side to give a feeling of the plant moving in the breeze. Lighter shades of green are created using Sap and Olive Green mixed with Cadmium

Sketched in background – bees on lavender.

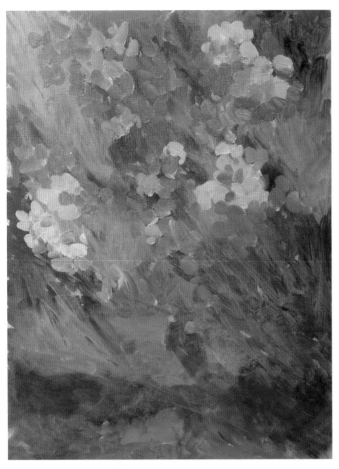
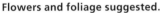

Flowers and foliage suggested.

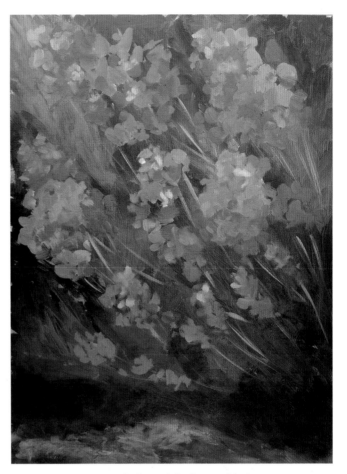

More darks and the bees added.

and Winsor Yellow. These brighter shades are painted on top of some of the darker areas again with loose and vigorous brush marks. To achieve a lively painting full of movement it is better to start quite freely and impressionistically and tighten up the work later rather than to be too precise too soon.

Once the greens are quite dry the lavender blossom can be laid in. The flowers have a remarkable range of colours in them going from deepest purple through to lightest mauve with all the shades between. Magenta, Purple, Cerulean, Cobalt and French Ultramarine Blue plus Titanium White were used in all the combinations possible to achieve the range of shades needed. Although the lavender spikes are made up of lots of tiny flowers, to begin with some broader areas of colour were laid in leaving brush marks that followed the angle at which the stems were growing. Areas of light and shade were used to make the groups of flower heads look three-dimensional. The whole painting is still quite loose at this stage.

Some structure is added next with the stems being painted in using a fine brush and shades of pale green. The stems help to show the movement in the plant and go through and behind

the flower heads and cross over each other. The main thing here is not to make them look too ordered and regimented by putting the stems into parallel lines.

Once the stems are in, some suggestion of the bees flying about comes next. The aim here is to give an impression of the movement of the bees so the minimum of detail is required. As the bees were right in among the flowers some insects were partly hidden. By varying the size of the insects slightly you can make some seem nearer to you and others further away, all of which add extra interest and variety to the composition.

The first attempt at painting the bees made them too large and they appeared to be stuck on and somehow lacking in movement. After propping the painting up and leaving it for a while it was decided to paint some of the background over the bees, thus making them smaller and at the same time less distinct. This approach greatly improved the effect. Reference books on natural history were used to get the bees' shape and colour right. Even though there is very little paint on the insects, what is there needs to be correct.

The final part was to put some smaller brush marks on the

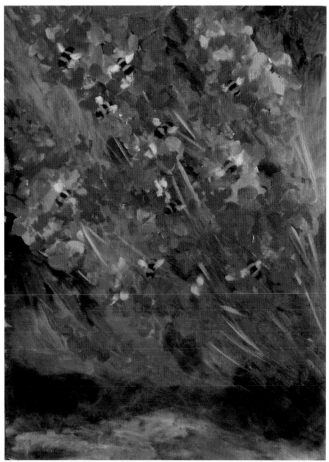

Finished painting with added colour in the flowers and more detail on the bees.

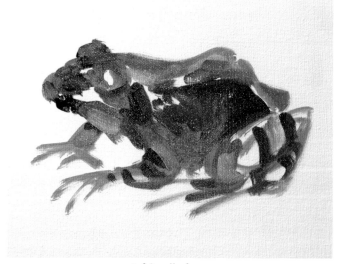

A friendly frog.

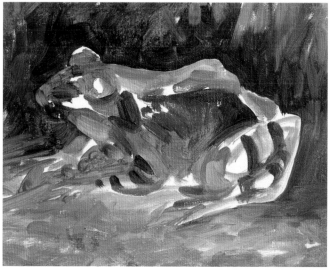

First stage of background.

flower heads to improve the shape of the spikes of lavender and make them just a little more detailed.

This was quite a challenging composition, especially painting the bees but also achieving the wide range of colours needed for the lavender.

A COMMON FROG

This frog had been living among a pile of stones in a damp spot near the pond. He was a handsome creature and did not seem to mind having his photo taken. It was a rather shady place so the photograph was not as clear as had been hoped but there was enough information, along with some help from a reference book, to make the painting.

A small piece of canvas-covered board was used for the painting, about A4 size, and the frog was sketched in freely using Yellow Ochre, Burnt Sienna and Sap Green.

A background was put in next using Olive Green, along

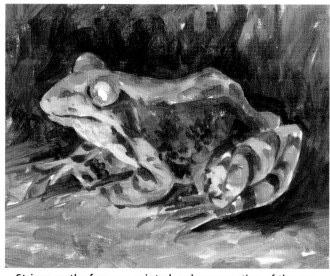

Stripes on the frog are painted and a suggestion of the eye.

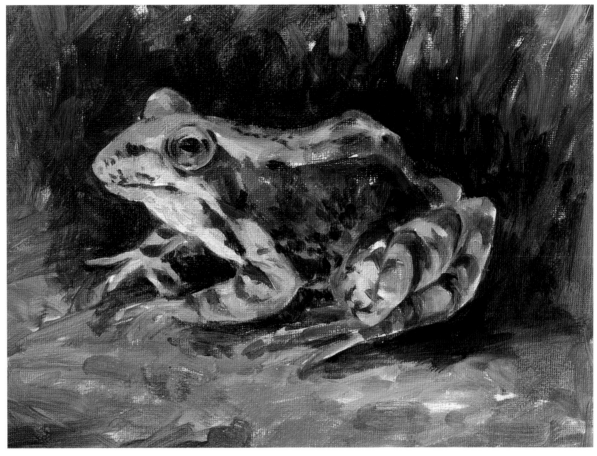

The shape of the frog has been improved and more colour added.

with the other colours already set out, to make some dark, rich tones. A suggestion of a cool grassy area seemed to set the frog off well so the direction of the brush marks used to give this impression were mostly vertical. The dark of the background was also used to redraw the body of the frog to give him a better shape.

Once the body of the frog looked about right more detail was added with the stripes on the legs and the speckles on the belly plus more drawing around the eye. The front of the frog was lightened using Naples Yellow and Titanium White and highlights of the same colour put onto the back and legs. More detail was then added to the eye, which begins to bring the frog to life.

At this stage the painting was propped up so that it could be assessed dispassionately. Questions asked were: does it look like a frog or is it a bit too much like a toad; does it look shiny and slippery; is the overall colour right and does the background look grassy enough?

It was decided that it did look too much like a toad and this was because the colours were too brown and there was not enough suggestion that the skin was wet and slippery. The nose was also not quite right and the nostril, although small was also not as it should be.

Bringing the background in and redrawing the nose area

improved the outline of the frog. A wash of Sap Green was applied to the whole body and was then gently wiped away in places to improve the colour; and the broader brushstrokes in the background, which did not really look like grass, were made narrower.

The finished frog looks as realistic as was wanted and has some character about it. It was great fun to do!

PEACOCK BUTTERFLY

This quick sketch of a peacock butterfly was painted on a piece of Bockingford 300gsm that happened to be to hand. The butterfly, which was one of many, was feeding on a buddleia bush in the sunshine. The insects were staying in one place just long enough for a painting to be completed from life. A box of paint pans was used for speed and convenience.

The outline of one butterfly was drawn in with some yellow paint. Yellow was chosen as it could then be incorporated into either the wings or the foliage behind without any difficulty. The blue eye on the wing was quickly placed with Cobalt Blue mixed with Cerulean. This is such a feature of the butterfly that it was important to put it in first so as not to lose it. A brilliant

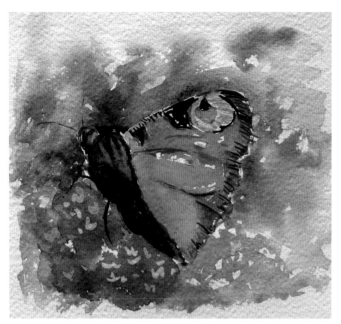

Peacock butterfly.

Pigeon in the snow.

red was mixed from Carmine and Indian Yellow and painted in freely around the blue eye, adding a little extra yellow to make some parts more of an orange shade. The bits of yellow along the edge of the wing were put in with a couple of brushstrokes.

By the time this was completed, the painting was dry and the black could be added without fear of it running into the more brilliant colours.

The butterfly flew away at that point, but all that was needed was some background foliage and a broken wash of purple for the buddleia. Finishing touches of antennae and legs were painted in using other butterflies as reference.

This was a very quick painting but captures fairly well the fragile nature and brilliant colour of the butterfly.

A FERAL PIGEON

During a particularly hard spell of weather, which culminated in some deep snow, this feral pigeon visited the garden. It looked rather as though it had got stuck and certainly stayed put long enough for this quick sketch to be taken through the window. Luckily paints and paper were to hand as there were only a few minutes in which to complete the painting. The purple sheen with touches of pink was quickly put down followed by a soft grey wash for the head. The curved blue/black stripe on the tail and wing feather helped to show the roundness of the puffed up shape of the bird. The details of red leg and eye went in as the bird flew away and the colour in the snow with a suggestion of shadow was put in after it had gone.

A quick sketch like this can often work well as there is no

time to fuss over it, only the bare essentials can be put down, and you can get to the essence of the subject.

FIGURES IN THE LANDSCAPE

Putting a figure into a composition adds scale and human interest but it can also be quite daunting to do. If you find the whole idea of painting people interesting but you feel it is beyond you then take it slowly and start small. Practise drawing figures, join a drawing class or get a friend or relative to sit for you and look first of all at the proportion of the human figure. If you are putting figures in the distance in a painting it is the general proportion that is more important than anything else. There are lots of excellent publications with good instructions on basic figure drawing, which can be very useful when you are just starting out.

Looking at other artists' paintings that include people, and observing how they do it, can be very helpful. Sometimes, when you look closely, it is just a couple of brush strokes that suggest a person somewhere in the painting. Constable, among many others, was very good at using a splash of red on a figure to bring life to a landscape. There may only have to be one or two brush marks, but unfortunately they have to be just the right ones. Although oil does have the advantage of being readily repainted, painting in either oils or watercolour is difficult; but do not let the problems put you off. The more you do, the better you will get.

THE GARDENER

This painting was worked from two photographs taken in West Dean College Gardens in the late summer. The gardener was busy dead-heading and generally clearing out the beds ready for the autumn and as it would not have been possible for her to stop work to pose, the photographs made a useful record of her position.

The first photograph made her look as though she did not have a head, which felt slightly uncomfortable, so a second was taken slightly closer. The advantage of the first image was that there was a good long shot of the flower borders with an old stone sundial at the end. To make a better composition the most useful elements were taken from the two photographs and combined to make a new arrangement.

An oil-painting board with a stain of green was used for this painting with the following oil colours: Yellow Ochre, Cadmium Yellow, Winsor Yellow, Permanent Rose, Winsor Red, Sap Green, Burnt Umber, Cobalt Blue and French Ultramarine.

The composition was drawn out with a brush, keeping the lines quite sketchy and free. It is very easy to alter a line drawn in this way and by not putting in extra detail too soon the whole composition is kept in a fluid state. Look at where the figure comes in relation to its surroundings, as this will help you get the all-important proportions right. Measure with the end of your brush or your fingers where the half-way mark comes in the figure, how the width compares to the height, at what angle the shoulders are sloping and the way the general stance of the figure appears. Do not worry if it does not look right immedi-

ately as the paint can be wiped off, repainted and generally moved around until things look about right.

When the drawing is complete start blocking in areas of colour. Small brush-strokes of Cobalt Blue and white are used for the sky and a blue/green tone for the distant trees. The groups of Michaelmas daisies form large and dramatic clumps all along the border and these are just suggested at this stage with some broad strokes of purple and mauve with smaller patches of light green among them. There is an old brick wall at the far end of the garden with a small statue standing in front of it; the path winding gently towards this feature gives a pleasing sense of distance to the composition. The path is a very fine gravel/sand mixture, which is painted in with a mixture of Yellow Ochre and Titanium White. There are shadow areas where a little blue is added to the mixture and some places along the edges which have been made green with moss and other tiny plants. All these discrepancies add subtle detail and richness to what might otherwise be a rather bland part of the painting.

The figure is roughly painted in, keeping fairly close to the colours of the clothes that she was wearing. The yellow bucket is also painted in with suggestions of light and shade both inside and outside.

At this stage the painting is put to one side not only to allow it to dry but also to assess the balance and colours of the composition.

A number of things do not feel comfortable: the yellow bucket is too intrusive and too large, the wall at the end of the path is too low, the gardener's sweater is too harsh a colour and the wheelbarrow looks clumsy. There is more work needed on

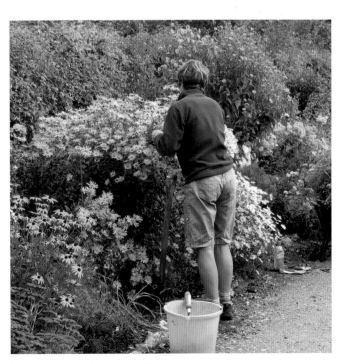

The gardener with the long border showing.

A better view of the figure but less garden showing.

Composition sketched in.

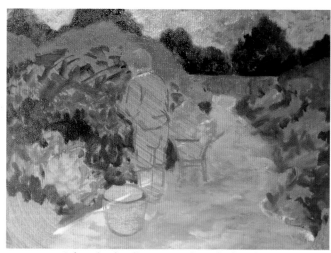

Colour in the distance and on the borders.

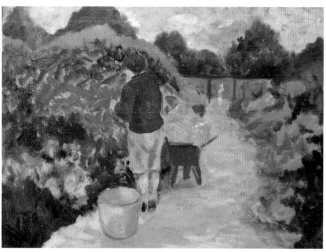

Gardener added with more detail in the borders.

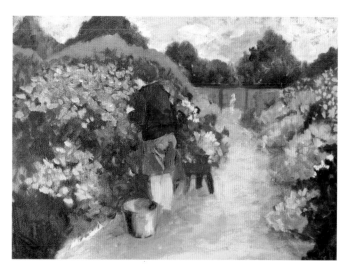

Flowers are given more emphasis and the gardener is improved.

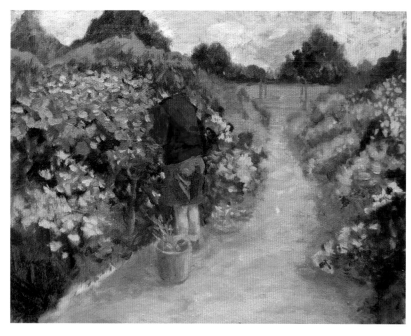

Wheelbarrow removed, bucket reduced in size and eye level taken up have all improved the composition.

the Michaelmas daisies and other foliage but that will come in as the other elements are put right.

The bucket is easily made smaller and changed from yellow to blue and the sweater is toned down and made into a deeper red. More colours are added to the daisies and the other yellow flowers in the border and some darker greens put in to make the flower colours stand out more. The little scene at the far end of the path is painted out and the wall moved up; the statue will be put in again when the paint is dry.

Once again the painting is propped up and looked at from a distance. It still does not feel right and after some consideration the wheelbarrow was painted out, the bucket made smaller again, changed to a much quieter colour and moved across slightly. The hand of the gardener was the wrong colour and stood out too much so this was darkened and made smaller. Her legs were also improved in shape and given a bit more definition and colour. More yellow was put into the flowers in the foreground on the left to help lead your eye into the composition and a little more colour added to the path. A suggestion of the statue at the end of the path was added plus two upright posts that were there.

The finishing touch was to put some clippings in the bucket and to add a barely visible spade in the border.

The composition works well as a painting of a gardener at work and has a sense of depth and distance, which is pleasing.

THE LONG BORDER

This second painting uses the same photographs as the previous one but the figure is used in a different way. This time it is the colourful border that is most important and the gardener, placed much further back in the composition, takes second place.

The same colours are used as before and the painting is worked on a piece of ready-primed oil painting paper, which has the advantage of being easily cut down if needed.

The composition is sketched in with a brush and any fairly neutral colour. The figure needs to be placed far enough down the pathway for it not to be the focal point but still near enough to play a useful part in the composition. Broad areas of greens and purples are blocked in and the trees and sky in the distance painted in soft tones of blue and blue-green.

The gardener's shorts are painted in and the foliage and flowers built up with more colour. To give more of an impression of sunshine, some stronger shadows are added to the plants on the right-hand side. This also helps to make the path, which was rather dominant, appear narrower and slot into the composition more comfortably. The left-hand border needs to

Composition sketched in with a brush.

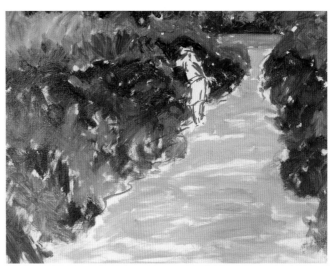

First stages of colour blocked in.

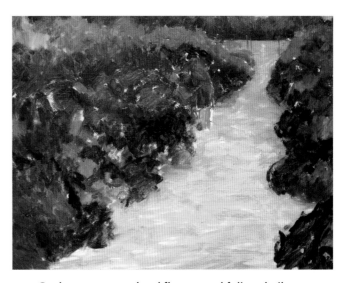

Gardener suggested and flowers and foliage built up.

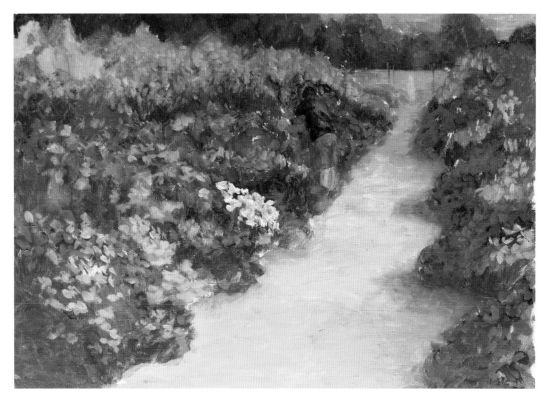

More colour in the flowers in the foreground give the painting greater depth.

be made more interesting so some yellow flowers are added and a wider range of mauve shades put into the Michaelmas daisies.

The gardener's sweater is painted in with a warm shade of red, which may need to be toned down when more of the composition is painted if it makes her stand out too much. The bucket standing next to her is put in.

The path is still too dominant, partly because it is all too light but also because it does not have enough subtlety of colour in it. Adding some slightly purple tones to the nearer part and darkening it in the distance will remedy this. The statue at the end of the path is made a little more visible with some very pale Yellow Ochre.

The painting is now put to one side and looked at from a distance to assess what still needs to be done. On looking at it with a fresh eye, it was decided that the flowerbed on the right still needed something else in it to make it more interesting; the gardener stands out a little bit too much and the right-hand flowers need just a touch more light on them.

The figure needs to be visible but not dominant so the red jumper is made darker and browner, the shorts have a suggestion of light and shade added, and a brush mark is added to indicate the boots. When it looks like a figure leaning into the flowerbed then it is probably best to leave it as it is.

Some white flowers have been added to the right-hand border to brighten it up and the addition of very pale mauve highlights on the Michaelmas daisies bring them to life. These small alterations help to lead your eye into the composition and make the figure a secondary part of the painting.

The finished painting works well, with the figure not being immediately noticeable but taking your eye down the border and into the composition.

CATERPILLAR

The last small painting for this chapter uses a summer visitor to the garden; a cinnabar moth caterpillar. This creature likes to feed on ragwort which, although it is poisonous and a pest on farmland, is worth having as a small clump in the garden to attract the wonderful red-winged, day-flying cinnabar moth and its offspring. By taking the flowers off before they set seed you can prevent the plant spreading to where it would be unwelcome.

This is a very quick painting using a scrap of Bockingford 300gsm, which happened to be to hand, with the following watercolours: Indian Yellow, Permanent Rose, Sap Green, French Ultramarine, Blue Black and Indigo.

The caterpillar was painted in first, using Indian Yellow mixed with Permanent Rose, which give a good clear orange. The paint was dragged in order to leave flecks of white along the caterpillar's back where it was catching the light. The stem was put in with a couple of brush strokes of light green, by which time the orange colour was dry.

Stripes are added, using Blue Black mixed with Indigo, mak-

ing the lines go around the body in uneven bands. A very out-of-focus background is added next using a range of greens, allowing the different shades to run into each other.

The caterpillar then has a touch of darker orange put down its side and when this is dry the tiny but all-important hairs are added. Some of the hairs appear white and other have a slightly yellow tinge to them. Titanium White is used because it is so opaque and a little Yellow Ochre is added to the white for the yellow hairs. Finally the eye is darkened and a little more black added to each strip to suggest the shadow. This is a small, very quick study, but it works.

There are many other living creatures that make excellent and slightly unusual subject matter for painting that can be found in most gardens; beetles for instance have a wide range of patterns, colours and sizes; lots of other birds can make attractive subjects; insects such as dragonflies, although challenging to paint, can look wonderful. So keep your eyes open and you will find that there is a whole other layer of things to paint in your garden.

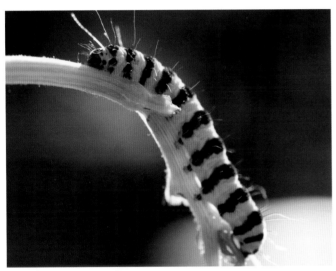

Cinnabar moth caterpillar.

Simple shapes sketched in.

A range of greens gives the background depth and interest.

Hairs, shadows and highlights on the caterpillar give it form and movement.

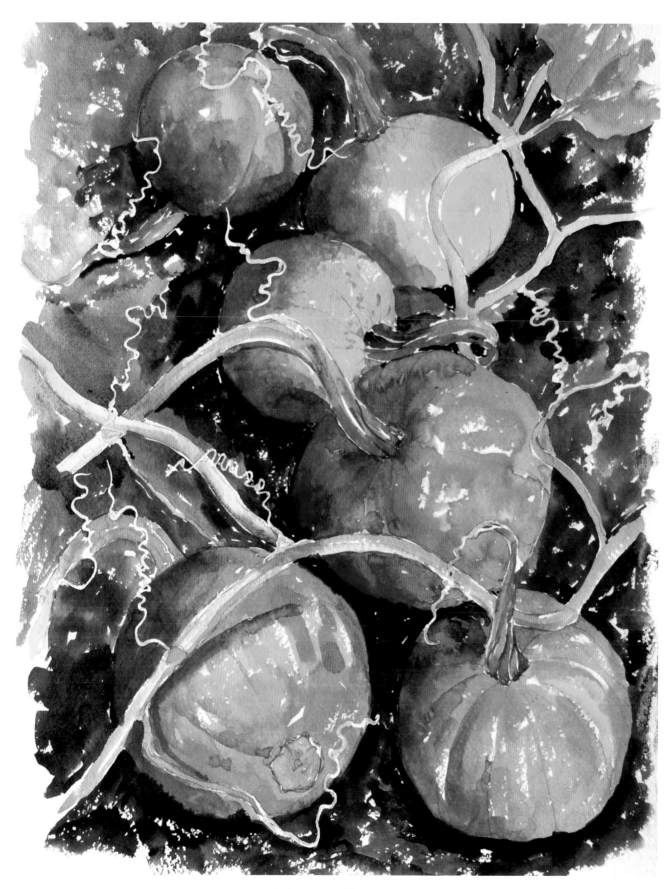

Autumn pumpkins.

FRUIT AND VEGETABLES, THE GARDEN'S HARVEST

The fruit and vegetables grown in the garden for eating make wonderful subjects for painting. In this chapter just a few are explored but there are many more that could be used. Onions, for instance, make stunning paintings with their long sinuous stems (which form as the onions dry) and wonderful colours ranging from pale gold to deep red. The wide range of pumpkins and squashes, which again come in such a wonderful range of shapes, colours and patterns, are worth growing just to paint. Looking closely at the strings of glossy blackcurrants and red currants, hanging from the plants, provides a new viewpoint which can make exciting compositions. Plums and apples growing on the tree or harvested into trugs and basins make sumptuous subjects. Globe artichokes with their thistle-like flowers and statuesque growth are quite sculptural and really lend themselves to being painted. Close-ups of peas in their pods, bunches of garlic, trusses of tomatoes at differing stages of ripeness; the list goes on and on.

These are just a very few of the fruits and vegetables that could be used in painting. It is well worth looking at things that you might grow as subject matter when you are planning your vegetable garden or you could just tuck a few ornamental edibles such as 'Swiss chard' in amongst your flowerbeds.

THE FIRST GOOSEBERRIES, A PAINTING FOR A COLD SPRING DAY

On a cool blustery day when there is more rain than sun, a delightful painting can be made from that first small picking of gooseberries. Their fresh green colour and slightly uneven shapes are a harbinger of bigger and better things to come. As there are not many of them they are poured into a cup with the few leaves that came with them left in to add some deeper notes of green. The cup has a green pattern on it and is an attractive, simple shape, which sets off the fruit very well. The cup is placed on a piece of folded, white kitchen towel, which gives a boundary to the composition and some extra shadow to add substance and further interest to the group.

A light is shone on the set up to suggest sunshine and bring out the colours on the fruit and in the shadows.

The first gooseberries.

Pencil drawing of the composition.

First greens are painted.

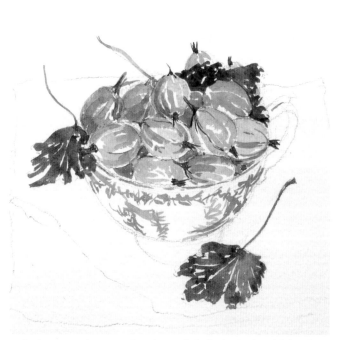

Red tops to the gooseberries and dark shadows add depth.

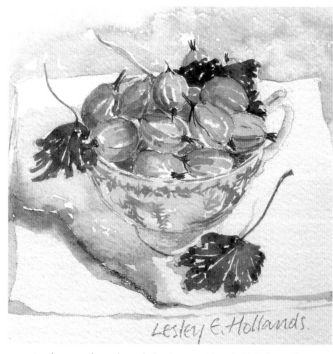

Background wash and shadow on the cloth brings the
composition together.

The first stage with this small painting is to draw it, ensuring that the ellipse of the cup is right and the fruit looks as though it is in the cup and piled on top of each other. Look at the spaces between things and observe the differences rather than the similarities of the gooseberries. Working in this way you will produce a more interesting drawing.

The paper used here is Fabriano Artistico Rough 300gsm and the watercolours are Sap Green, Hooker's Green, Winsor Yellow, French Ultramarine, Burnt Umber and Yellow Ochre.

The lightest green is applied first using Sap Green mixed with a little Winsor Yellow. The brush strokes follow the curved shapes of the gooseberries, which help to convey their plump roundness. Thin lines of white paper are left showing to enhance this effect. The pattern on the cup is painted using Hooker's Green with a little Sap Green added to lighten it. The design on the cup is not complicated so did not need to be drawn out first. By painting the pattern directly a much fresher result is achieved that is more in keeping with the whole spring-like feel of the composition.

The leaves are added next using a mixture of Sap Green and French Ultramarine. The paint is applied with dragged brush strokes, which leave flecks of white paper showing through. These small light areas prevent the dark of the leaves becoming too heavy and solid looking.

Each gooseberry has a small reddish brown sprout to it and at the opposite end a deeper green tail. The sprout is important as it gives the opportunity to add some complementary colour to the composition, which brings it to life. Constable would often put a small area of red into his greener landscapes to give this same effect. Burnt Umber is used for the basic colour, with a little French Ultramarine added where there is a shadow. The deeper green tails add another lively note with their curved shapes and the colour running down the side of the gooseberry in the form of fine lines.

When all this is dry the shadows are applied using French Ultramarine and a little of the green left on the palette. The mixture is diluted so that it is not too strong a colour and painted onto the fruit to give the impression of roundness and solidity. If the edges of the shadows become too hard, run a damp brush along them to soften them. A shadow on a curved surface fades out because it does not stop suddenly at an edge; so it is important to keep the shadows soft. The shadows between the fruits are quite dark and help to define the edges of the gooseberries and where they are in relation to each other and the cup. Add a little more blue to your mix to get this shade. The leaves have a touch of shadow on them, which helps to make them look curved and there is a line of darker colour down the edge of the stems.

The final area to tackle is the shadow on the cup and the cast shadows. A blue/green is again used for these areas with the edge of the shadow fading out softly as it goes around the cup.

There is an area of darker green shadow where the fallen leaf reflects green back onto the cup and another thin line of dark where the foot of the cup sits on the paper towel. The cast shadow follows the curve of the fold in the paper towel and fades away as it moves away from the cup into the background. The paper itself is casting a shadow and by putting this in along the front and the left-hand side you can define its edge without overstating it. The right- hand side is left to disappear into the light.

The finishing touch is to put a little Yellow Ochre along the back edge of the paper towel; bring the wash down gently with a faded and broken edge, which helps the colour stay in the background. The finished painting has a charming simplicity and with its fresh green colours is very spring-like.

The gooseberries can now be eaten for supper, perhaps with a little cream or homemade custard or baked in a cake giving a little tart edge to the sweetness.

REDCURRANTS

It is July and the redcurrants are hanging like long threads of scarlet jewels on the bushes. The brilliant red berries glow

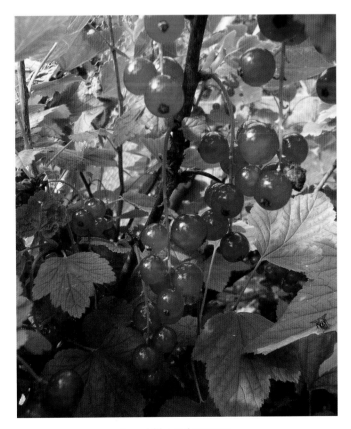

Jewel-like redcurrants.

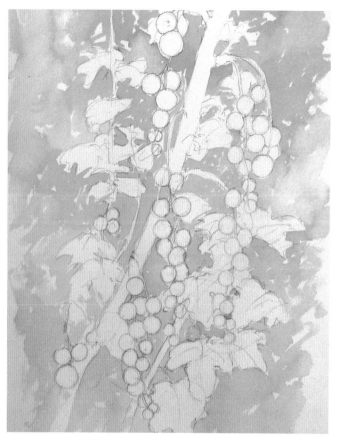

The first wash in the background.

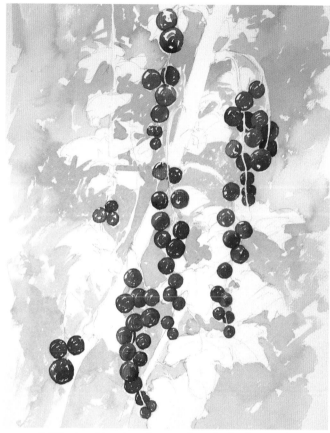

Brilliant red berries glow against the background.

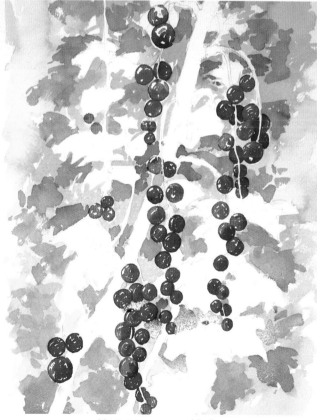

More greens are added.

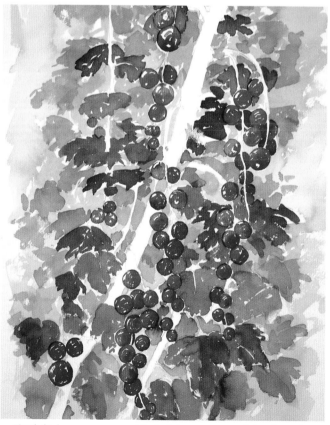

Final darks greens are added giving a sense of depth to the composition.

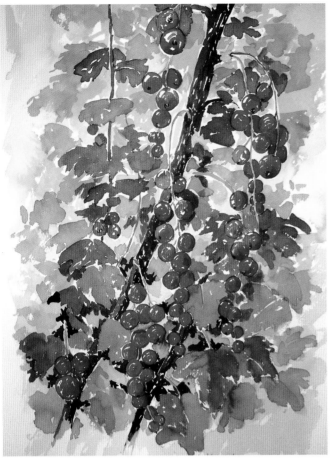

The dark stems add structure to the painting.

where the sun hits them through the leafy undergrowth and the woody stems of last year's growth gives an interesting contrast of straight lines. There is not enough room in the fruit cage to sit with the various bits of equipment needed to paint the redcurrants *in situ* so photographs are taken. It is interesting to push right in and under the bushes and become surrounded by the glowing fruits, giving an unusual viewpoint. There are lots of good compositions so a dozen or more shots were taken with the digital camera and one selected later when it had been viewed on the computer.

The chosen photograph has some long strands of berries hanging from a main stem, which cut across the composition diagonally. There are some smaller berries seen through the leaves, which add depth, and there are some very deep shadows at the bottom of the composition, which give a good contrast to the sunlit fruit and leaves, making the main strings of berries glow beautifully.

Fabriano Artistico 300gsm Rough was used for this painting with the following watercolours: Indian Yellow, Winsor Yellow, Sap Green, Hooker's Green Dark, Olive Green, Winsor Red, Carmine, French Ultramarine and Cobalt Blue.

The chosen composition was drawn out first, putting in the main strings of berries, the larger leaves and the two main stems. The other leaves and berries will be put in freely later on. An initial wash of a sharp, acidic green is laid in first, carefully going around the berries so that their brilliant colour is not compromised. The wash is broken and dragged, leaving areas of white paper showing, and the colour is varied by adding more or less yellow to the Sap Green.

When the first wash is dry the berries are painted in. The fruits are a brilliant colour and gleam in the sunlight, each with a little curved highlight which needs to be kept as white paper. You could put some masking fluid on to protect the highlight but with a decent brush with a good point this should not be necessary. Winsor Red is the basic colour used and this is lightened with the addition of either Winsor Yellow or Indian Yellow for where the light is catching the berries and turning the red to orange. Where the berries are in shadow a little Carmine is added to the Winsor Red to darken it.

When the berries are finished they are left to dry completely and then a second layer of darker green is put into the background. The next layer of green is suggesting leaves further back in the composition so while they do not need to be particularly precise they do need to look a little like redcurrant leaves. Take care to leave some of the white in the background as well as areas of the first acidic green. The white of the paper is your lightest shade and if this is lost then the whole painting is toned down and loses its sparkle and extreme of contrast. It is possible to put light back into a painting using Titanium White but it looks better if you do not have to.

The next stage is to paint in the leaves that are nearer to you. These need to have a more precise shape with added detail. Some of the veins can be left as a lighter shade of green and the correct shape of the leaf painted with its serrated edge. The leaves in the foreground also have light and shade on them and this can be painted using Hooker's Green Dark with a little French Ultramarine Blue added to darken it. Do not make the leaves over strong in either shape or colour as you do not want them to overshadow and dominate the berries, which are the main part of the composition. If you find that the leaves do stand out too much then take a damp brush and soften the edges and lift a little of the colour off.

The final part of the painting is to paint in the woody stems and put a last touch of shadow on the berries. The stems are a combination of Olive Green and Burnt Umber with a little French Ultramarine added where the colour needs to be darker. The stems are not smooth so small brush strokes are used to indicate the rough surface. Sun is shining on the stems in patches and these lighter areas are painted in using the addition of yellow to the basic mix. The berries now need to be made darker in places so that they look really round. By darkening some it will also make some of them look further back in the composition. French Ultramarine Blue is added to the Carmine to dark-

en it. Use just enough to deepen the colour without turning it purple. The berries that are further back will also benefit from having their edges softened and blurred slightly. It makes the composition more interesting if everything is not painted with the same degree of sharpness.

Prop the painting up now and leave it somewhere where you can see it from a distance. If after a day or two you are happy with it then it is finished.

This was a very enjoyable composition to paint and further paintings were done to create a series using some of the other photographs. The redcurrants won a prize at the local horticultural summer show and were then made into jelly and a redcurrant sauce ready for Christmas.

AUTUMN FRUITS

PUMPKINS

This group of pumpkins, lying on the ground and ripening in the sun, glowed in the autumn light. The fruits themselves were different shades of orange, some still with green on them but what made them particularly interesting were the dried tendrils still attached to the yellowing stems that crossed over the round pumpkins making some visually interesting contrasts.

The fruits were rearranged slightly to make a more pleasing composition with some laid on their sides and others left upright. Smaller fruits were put at the back to give a greater impression of depth. Excess dry and withered leaves were also removed so that the rounded shapes of the pumpkins and the straight lines of the stems could be seen to best advantage. The soil around the fruits was very dark which made an excellent contrast to the pumpkins and enhanced their brilliant colours still further.

The composition was drawn out first and the tendrils, which are an important part of the arrangement, were protected with a layer of masking fluid. By doing this the rest of the painting could be put in with free and confident brush marks which complement the bold arrangement and strong colours of the group. Fabriano Artistico Rough 300gsm paper was used for this painting with the following watercolours: Indian Yellow, Windsor Yellow, Windsor Red, Permanent Rose, Sap Green, Indigo, Cobalt Blue, French Ultramarine; Burnt Umber, Burnt Sienna and Sepia.

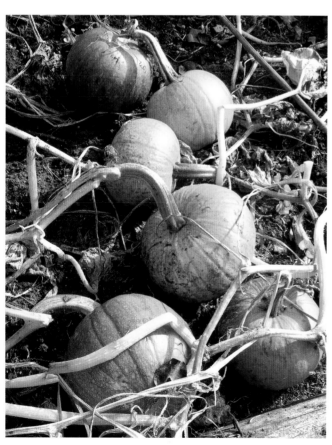

A harvest of pumpkins.

First stage of colour with the masking fluid.

Once the masking fluid was completely dry, the first wash of orange in different shades was applied to the pumpkins with a large, number 12 brush. Indian Yellow and or Winsor Yellow mixed with the Winsor Red or Permanent Rose in a variety of combinations and proportions gave a wide range of clear transparent shades. It is important to get some good strong colours so that the right colour can be put down first time. If you have to build up the colour with too many layers it can become rather heavy and dead looking. It is also far more difficult to keep the flecks of white paper showing and if you lose these then you have lost your lightest area and the whole painting will be dulled down a notch. The brush strokes were made to follow the form of the pumpkins, helping to accentuate their round shape. The brush was dragged across the paper in places to give broken areas of paint; this helps to prevent the strong colour becoming too heavy and flat and adds a sparkle to the painting. It is easier to drag paint on a rough paper although it is not impossible to do this on a smooth paper. If you find getting the dragged effect difficult, practise on a spare piece of the same type of paper first, and try using a fairly dry brush.

While the orange colour was still wet the greens of the unripe areas were added using a mixture of Sap Green and either French Ultramarine or Cobalt Blue. Once again the brush

Shadows on the pumpkins give them weight and form.

The stems create wonderful flowing shapes.

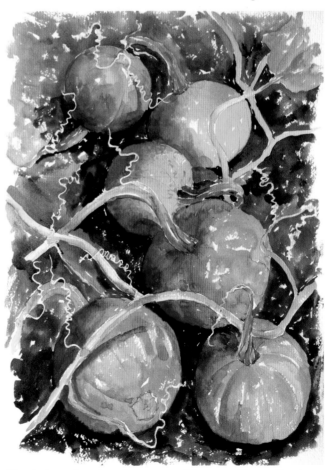

The dark earth makes the orange of the pumpkins really glow.

strokes followed the round shape of the fruits. Shadows cast by the stems also follow the curves of the pumpkins and these are put in using more of the green shades already used.

The stems go in next. These are quite sturdy so it is relatively easy to put in the light and shade and make them look three-dimensional. There is a pleasing range of colour in the stems going from deep green through pale greens and on to shades of ochre. One or two darker lines drawn in with a fine brush can further accentuate the twists and turns of the stems.

The next part of the composition is probably the most daunting. The dark earth, which is going to give the contrast to the pumpkins that makes the painting glow, must not be toned down. If you lose your nerve over this then the painting will be far less of a success than it could be. If in doubt, try mixing up the shades that you think you will need and paint them onto a spare piece of paper, preferably against an area of orange. Let the paint dry and then assess the effect. You want to avoid going over the same area several times as you will then lose the white highlights from the grain of the paper and the dark areas will end up looking heavy and dead. Use a variety of shades by mixing combinations of Sepia, Burnt Sienna, Burnt Umber and French Ultramarine. Some areas of dark green in among the browns also help. Make the shadows cast by the pumpkins the darkest part and bring the colour up and over the edges of the fruits so that they look as though they have sunk a little into the earth.

When the painting of the soil is complete take a well-earned break and let your work dry completely before taking off the masking fluid.

The removal of the masking fluid will leave quite stark white lines where the tendrils are. To leave them unpainted would look rather obvious but you need to take care when putting colour on them so that they don't get lost. A touch of very pale Yellow Ochre or Naples Yellow would work well.

When the tendrils are painted in prop the work up and leave it for a while before going back and deciding whether it needs any more doing to it. Questions you might ask yourself are: is the soil dark enough? Do the pumpkins look round and as if they are resting in the ground? Are the shadows describing the shapes? Does the whole composition glow or has the colour on the pumpkins sunk at all?

Remedy any of these areas if necessary and your painting will then be complete.

This was a very enjoyable composition to paint especially as much of it could be done directly while sitting on a chair in the garden enjoying the last warmth of the autumn sun. The pumpkins were then turned into soup, chutney and pie, which were much enjoyed.

PURPLE GRAPES

It had been a good enough summer for many bunches of grapes to have formed on the vine. Unfortunately the grapes are not pleasant to eat being mostly pip and skin but they make tasty jelly and the birds like them. The vine was planted mainly for its autumn colour, which is magnificent but it's a shame that some tasty grapes could not have been part of the equation.

The grape vine was supported by a series of thick ropes, which helped it to form a shady canopy that was very pleasant to sit under in the summer sun. The ropes are in the photograph but, because they look rather intrusive, they do not necessarily need to be in the painting.

Because the composition is quite intricate and because various parts needed to be altered and adjusted, a careful drawing was first made. The largest bunch of grapes was partly hidden by leaves, which looked awkward, so its position was changed slightly. The rope looked far too heavy and did not add to the overall composition so this was omitted. Some grapes were only just visible further back in the vine so, to give a feeling of depth and distance, these were made more noticeable.

A rough Bockingford paper was used for this painting with the following watercolours: Indian Yellow, Winsor Yellow, Winsor Red, Carmine, French Ultramarine, Cobalt Blue, Indigo, Sap Green and Winsor Violet.

Once the composition was worked out in the drawing, the first areas to paint were the warmer tones in the stems and branches and where the leaves were beginning to change into their autumn colours. The two reds and the two yellows made some basic warm orange shades and these were then deepened with the addition of either French Ultramarine or Indigo. The branches are quite red and being round have a distinct shadow on one side. Run the shadow colour in while the first shade is still damp, giving the grapes a well-rounded appearance. A suggestion of texture can be given by dragging the brush and keeping the paint on the dry side. The stems of the leaves have turned from the red that they were when new to a warm yellow.

Some sky can be seen between the leaves and a pale Cobalt Blue is used for these areas. By varying the shade of blue, even in the small spaces that are visible, a suggestion of distance and movement in the sky can be attained.

Shades of green are painted in next, making sure that there is a good range of shades and tones by using different combinations of the three blues, two yellows and the green. Because it is still only late summer and the autumn colours are not very far advanced, many leaves have both shades of orange and green on them. If, when you put green next to orange on a leaf, it looks too stark and abrupt, take a wet brush and run it over the line where the two colours meet and encourage the paint to run together.

The grapes are an important part of the composition and

Ripe grapes.

Drawing of the rearranged composition.

First stage of painting with sky behind and warm colours
in the branches.

Greens are built up.

Grapes with highlights to give shine.

Grapes hidden amongst the vine leaves with criss-crossing branches giving support to the composition.

being as dark as they are must be painted with care. This does not mean that they have to be over neat and tidy but they do need to look as though they are bunched together and rounded. They must also look as though they are growing in among the leaves and are not just stuck on.

Indigo, Winsor Violet and Carmine are used to make the rich deep colour of the grapes. To begin with each grape is painted individually, leaving small areas of white paper where the fruit is catching the light. The light areas may look too stark to begin with but can easily be toned down at a later stage

Where the grapes are in shadow they need to have the darkest shading at the bottom to make them look round. Some variety of colour is needed for artistic effect, even though the grapes themselves are pretty uniform.

The bunch of grapes growing further back among the leaves is made very slightly lighter and is less distinct than the bunch in the foreground. The grapes can be painted carefully to begin with and then the edges of some of them encouraged to run slightly, giving a softer, very slightly blurred effect, which helps them to recede.

Now that the darkest areas are in, the painting needs to be assessed in order to decide exactly where the last areas of dark green are going to go. Prop the work up and stand back from it so you can see it with a fresh eye. Ask yourself which of the remaining unpainted areas need to be dark and which need more of the light green and the autumnal tones. By not having enough dark in the composition the strength of colour in the grapes can make the painting out of balance. Some of the leaves near the bunches need to be quite dark while other areas would benefit from more of a middle tone.

The final touch is to soften the edges of some of the leaves in the background to make them appear further away and to put in any of the spiralling tendrils that the grape vine uses to attach itself as it grows.

The finished painting is colourful and has enough strength and contrast of tone to make it interesting.

GREENHOUSE STRAWBERRIES

These pots of strawberries were growing in one of the magnificent Victorian greenhouses in the gardens of West Dean College, near Chichester in West Sussex. They had been placed on a shelf at eye level, well out of reach of marauding slugs, birds and hungry small children. The plants were bursting with health and vigour and even though it was still early in the year the fruits were ripening and looked quite delicious.

A number of photographs were taken from different angles but, as is so often the case when things have been put together for growing purposes rather than for artistic reasons, the

combinations of pots was visually not quite right. The pots could not be moved and rearranged or the gardeners might have had something to say about it, so a new composition was sketched out on paper. As painting in the greenhouse would be difficult due to lack of space and other visitors needing to get past, the work was continued back in the studio.

Fabriano Artistico 300gsm extra white paper was used along with the following watercolours: Winsor Red, Permanent Carmine, Burnt Sienna, Burnt Umber, Cobalt Blue, French Ultramarine, Indigo, Sap Green, Winsor Yellow, Indian Yellow and Raw Sienna.

The quick sketch taken *in situ* was developed in the studio to make an interesting arrangement of the pots of strawberries against the greenhouse window. In the photographs the pots were seen from below but in the drawing this was altered so that some of the dark soil in the pots is visible. The deep brown compost sets off the leaves rather well and gives emphasis to the edge of the flowerpot.

The strawberries glowed in the sunshine and, as it is important to keep their brilliant colour from being muddied by surrounding areas of paint, they were painted first. Winsor Red is a useful shade for these strawberries with the addition of Winsor Yellow for where they are less ripe and Carmine for the riper areas and the shadows. The fruits are catching the light on their glossy surfaces and these highlights are kept as white paper. It is better to keep too many highlights rather than too few as they are easy to paint over but not so easy to put back. The unripe berries are quite an acidic green and this colour is obtained by mixing Winsor Yellow with Sap Green.

The leaves have a characteristic serrated edge and, because they are growing in pots, they are slightly more bunched together than usual. The lightest leaves are painted in first using a similar colour to that used for the unripe strawberries. When the first wash of green is dry the darker leaves are painted in using Sap Green mixed with French Ultramarine. If the light green leaves lack shape then it is easy to paint between them with the darker colour to give them more form and structure.

The flowerpots are made from terracotta so have more variety and interest than the plastic equivalent. They are darker at the bottom where the damp tends to collect and have a pleasing, subtly uneven colour. The colours needed for the pots can be mixed from various combinations of Burnt Sienna, Raw Sienna, Burnt Umber and French Ultramarine. Venetian Red could also be used here if you happen to have some in your paint box. There is a soft shadow on the right-hand side of each pot and some shadow cast by the hanging fruits. The damp bottom colour is made by mixing more of the French Ultramarine into the terracotta shades already mixed.

Paint around the strawberries with care so that they stand out, except for the ones hanging close against the surface of the pots. Here the edge of the fruit can be encouraged to run slight-

A row of strawberries.

Bright red berries.

Leaves added.

More detail in leaves and fruit.

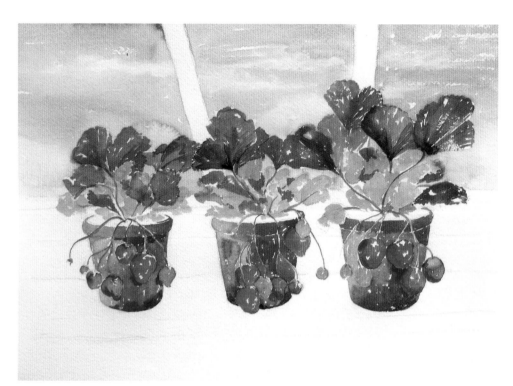

Pots and background.

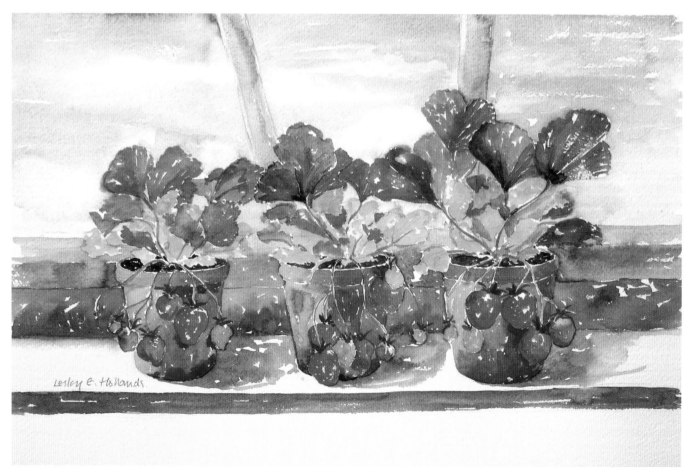

The finished work, looking good enough to eat.

ly and merge into the colour of the pot. By doing this the fruit will look more subtle and have a suggestion of depth.

Through the glass of the greenhouse a brilliant blue sky can be seen with just a few white clouds breaking it up. Using Cobalt Blue and not too wet a brush, the paint is dragged across the window areas and where the paper is left white clouds are suggested. If the wash goes on in rather a flat way then take a piece of kitchen paper and blot out areas to represent the clouds. Make the bottom of each cloud shape flat and the top more curved and uneven. Do not overdo this or it will stand out too much and detract from the rest of the composition.

The window bars are painted in using French Ultramarine with a tiny amount of Carmine added to make it tip slightly towards a mauve shade. It is painted so that the wash is uneven and quite light, again so that it does not become too dominant and intrusive. The horizontal line of window frame running behind the plants can be slightly darker as it is more in the shadow and broken up by the pots and plants standing in front of it. There were other things growing outside the greenhouse and these can just be seen through the lower part of the glass. Shades of light and dark green are used to suggest that something is there. The shadows cast by the pots on the shelf are shades of blue and mauve, slightly darker next to the pots and getting lighter as they move away.

Burnt Umber and Indigo make a rich dark brown for the compost in the pots which is painted in unevenly to suggest the crumbly surface of the soil.

The shadow on the edge of the shelf is darker than the shadows on the greenhouse window and is painted in using French Ultramarine with a little Sap Green added. A stronger colour will always come toward you and a lighter colour will recede.

The final touch is to put in the little sprigs on the strawberries where the stems connect to the fruit. If you cannot make these stand out because the green you are using is too transparent, then use a little Cadmium Yellow mixed with either French Ultramarine or Sap Green to make a more opaque paint.

The finished painting looks summery and fresh and the strawberries look as though they are ready to be picked and eaten.

APPLES AGAINST AN OLD WALL

This is another painting inspired by the gardens at West Dean College. The fan-trained apples were growing against an old brick wall, which had the most wonderful mellow colours in it. The mortar between the bricks had small flints embedded in them, which help to stop the lime mortar weathering away too quickly. The apples were nearly ripe and had a rosy glow, which gleamed in the sunshine. Some of the fruits were very close in

Apples against an old brick wall.

colour to the bricks and almost disappeared into their surroundings. It is a good thing not to have everything visible in a painting at first glance but to have aspects for the viewer to discover at a later time.

The leaves were just beginning to turn and their autumn shades connected the apples and the wall rather nicely.

This subject matter, with its rich colours and textures was ideal for a painting in oils. A piece of ready-prepared canvas was used with the following colours: Cadmium Red Deep, Cadmium Yellow Deep, Cadmium Yellow Pale, Yellow Ochre, Olive Green, Sap Green, Burnt Sienna, Burnt Umber, Cobalt Blue and Titanium White.

A ground of Burnt Sienna and Yellow Ochre was rubbed unevenly across the canvas and left to dry. The warmth of these tones gives a rich base for adding the subsequent colours.

The composition in the photograph leaves rather a large gap between the apples and their foliage at the top and the bottom. Although the wall is interesting it is the fruit tree that is the main subject of the composition so it was decided to move the two areas closer together. The main trunk and branches were painted in first using Burnt Umber mixed with Burnt Sienna. The brush marks were dragged to allow some of the ground colour

A warm stain on the canvas pulls the painting together.

Bricks are suggested along with the fruit.

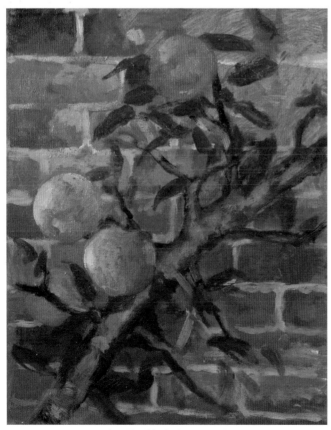

More detail added plus some leaves.

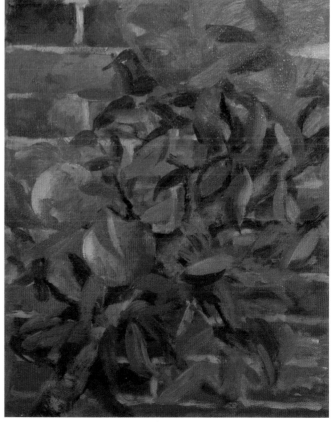

The fruit gently glows against the warm colour of the bricks.

to show through and suggest the uneven texture of the bark. The apples were suggested with some marks of Cadmium Red Deep and Yellow Ochre, as much to give their position as anything else. The brick wall to either side of the main trunk was a deeper shade and this was painted in, again roughly, with a mixture of the colour used for the bark and with some Cadmium Red Deep added. The bricks were suggested by putting in areas of red and Yellow Ochre. The whole painting was kept very loose and free at this stage with the idea of building up the composition in layers and tightening up some areas as the work progressed.

The first stage was left to dry for a while before more paint was applied. It is possible to continue while the paint is still very wet but care has to be taken to avoid disturbing the first layer of colour and mixing it into the second. Another advantage of letting the first stage dry is that it enables you to wipe off the subsequent paint if it goes wrong.

The mortar is suggested with some broken lines of white mixed with a small quantity of Yellow Ochre and Cobalt Blue. The lines need to be uneven in colour and width to keep them looking old and in the background. The main trunk now has some lighter tones applied using some of the colour mixed for the mortar plus small areas of Yellow Ochre mixed with white. The apples have some bolder colour added with Cadmium Yellow Deep and Cadmium Yellow Pale. With the addition of these colours the apples are already beginning to look round.

There are lots of subtle shades of red, orange, brown and blue/grey in the bricks. Additional pigment is added to the bricks to make them more interesting and richly coloured and the strips of mortar have more detail and variation put in.

The leaves come next and it is the darker ones that are painted in first as these are generally in shadow and nearer to the wall. The foliage faces in all directions with leaves of differing size, colour and shape; it is important not to overlook this aspect, or your painting will be less lively and interesting. Olive Green and Sap Green are useful ready-mixed shades, which can be lightened with the addition of any of the yellows on the palette and darkened with either of the blues. Other greens can be mixed with the blues and yellows and, by adding a little red, further shades can be made. Another subtle shade of green can be mixed from Winsor Yellow and Payne's Grey. There are lots to choose from and it is a good idea to mix a range of shades on your palette and have several brushes on the go at once so that the colours stay separate and do not get muddled together ending up as one green.

The apples now need more colour on them to make them begin to glow against the foliage. The skins have subtle streaks of colour ranging from deep red to bright yellow but do not put too much detail on the fruit at this stage; it is enough to get the tonal value right in relation to the rest of the painting and to

make the apples look round and solid.

Let the painting dry now; so that when you put on the lighter leaves the brush strokes do not pick up the colour underneath but stay clear and bright.

On the dry painting start adding more leaves, looking at the way they are grouped together and how they grow. By looking at the shapes of groups of leaves as well as the individual ones you will avoid the composition becoming too bitty. The more autumnal leaves are put in now, which link the leaf colour to the colours in the fruits. Stand back from your work at frequent intervals to assess how the leaves look and how the composition is pulling together. It is a delicate balance between the apples, the foliage and the brick wall and you need to be aware of how your painting is working as a whole. The painting is now very nearly finished but on standing back from it the balance of light and shade is not quite right. The tonal value of the wall and the apples is too close so the fruits disappear too much into the background. The leaves on the top right-hand corner look too sparse and need to be filled out more.

To make the apples stand out without losing the subtle colours and interesting paintwork in the wall a glaze of transparent colour can be used. This is a useful technique for this sort of situation as it enables you very delicately to change the colour and/or tone of an area in a controlled way. As long as the paint underneath is totally dry any further layer of paint that is put on can easily be wiped off completely with a rag dipped in white spirit. To check whether a colour is transparent or not take a small amount thinned with white spirit or turpentine and wash it onto a piece of white board. If the white shines through the paint is transparent and if it does not then it is opaque. Most paints will have this information printed on the tube but if it is covered or lost for some reason then technical information is available from the manufacturers or on line.

The wall has an almost purple tinge to it where it is in the shadow, so a mixture of purple and French Ultramarine is used to create this deeper tone. The tree branch is also glazed and the lighter central area then rubbed back to reveal the lighter colour it was originally painted. By doing it this way you avoid hard edges and make the branch blend gently with its surroundings. The space behind and around the apples is also darkened, which makes the fruit stand out more and glow against the rich colours of the old wall.

More leaves are added to the top right-hand corner, nearly hiding the apple there. There are four apples in the composition but only two of them are immediately visible, giving the viewer something to find on a second look.

The final touch is to put just a little more colour on the two most visible apples and add the dark indentation at the base of the fruit. The painting has a soft glow to it, which suggests the mellow fruitfulness of a late autumn day.

SWISS CHARD

Swiss chard is a useful vegetable to have in the garden as both the stems and the leaves can be eaten and it stands well through the winter months. The variety called 'Bright Lights' also has the advantage of being very colourful and would not look out of place grown in a flowerbed.

The brilliant stems used for this painting were growing in the late autumn and caught the low afternoon sunshine beautifully. The leaves are also quite varied in colour and have a wonderfully crinkly, glossy surface. The group here were mostly red-stemmed so a bit of artistic licence was used by moving one of the yellow-stemmed plants into the composition to add variety. The strong, overlapping stems give a bold and colourful structure to the painting, set off well by the dark leaves.

The chosen plants were drawn out first to make sure that the composition was as wanted. Bockingford 300gsm paper was used with the following watercolours: Permanent Rose, Carmine, Indian Yellow, Winsor Yellow and Sap Green.

The stems were painted first so that their brilliant colour would not be painted over by mistake.

Indian Yellow and Permanent Rose both worked well for the stems. Fine vertical lines of light were left to indicate the slightly ridged appearance of the stalk and the colour was taken up into the veins on the leaves, making the lines thinner as they reached the edges of a leaf.

The leaf colours are wonderfully varied with different colours appearing on the same plant. The leaves overlap so, in order for them not to lose their individuality and definition, the colours were organized so that light was put against dark and vice versa. The impression of the uneven surface of the leaf was achieved by dropping a slightly darker shade of whatever colour was being used for a leaf, into the first colour while it was still damp. By doing this before the original colour had dried a soft-edged change of colour in an uneven shape was achieved. The red/brown colour of some of the leaves was made by mixing Sap Green with Carmine and, where the colour is deeper, adding a little French Ultramarine. The leaves will look far more interesting if there is a range of shade and colour within each leaf.

When all of the leaves are complete the painting is left to dry before the background is put in.

There are some other things growing around the chard and quite a lot of soil is showing. Further behind the vegetable patch is a wooden slatted fence, which looks quite dark in the distance. However, the surroundings only need to be suggested because the chard is quite dramatic and interesting enough not to need anything else to support it in the composition. What is important is getting the colour and tonal value of the background right.

The green plant growing around the base of the chard (which is probably chickweed) has a sharp, light green colour and this is put in first. The surrounding soil is very dark and the area behind the vegetables only a little less so. The soil colour is mixed from a combination of Sepia and Indigo which makes a wonderfully rich dark brown. As the colour goes back into the composition and recedes behind the chard then some red and a little Sap Green is added to the original soil colour.

By making the surroundings good and dark the brilliant colours of the chard stems stand out really well. The final touch is to put a little more colour onto some of the stems making one side a deeper shade to indicate a shadow and suggest that the stems are three-dimensional.

The finished painting works well, with the dark leaves almost disappearing into the background in places and the brilliant pinks and yellows really standing out.

If it is too cold to paint outside but you still want a composition connected with your garden there are all sorts of still life groups that you could put together from garden produce. Even something as humble as a few root vegetables with soil still clinging to them, resting on a sheet of newspaper can make an interesting painting. Jars of homemade jam, with some of the fruit alongside, look colourful and appetizing. So keep an open mind and use your imagination and you will never be at a loss for what to paint.

Swiss chard.

The bright stems go in first.

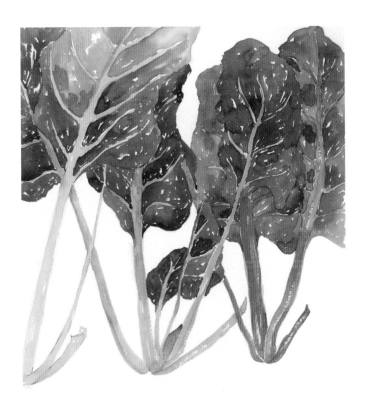

Leaves are built up with a range of shades.

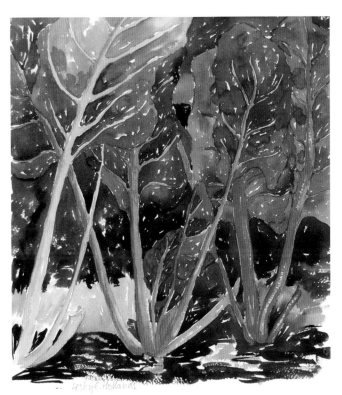

The dark earth makes the coloured stems seem even more brilliant.

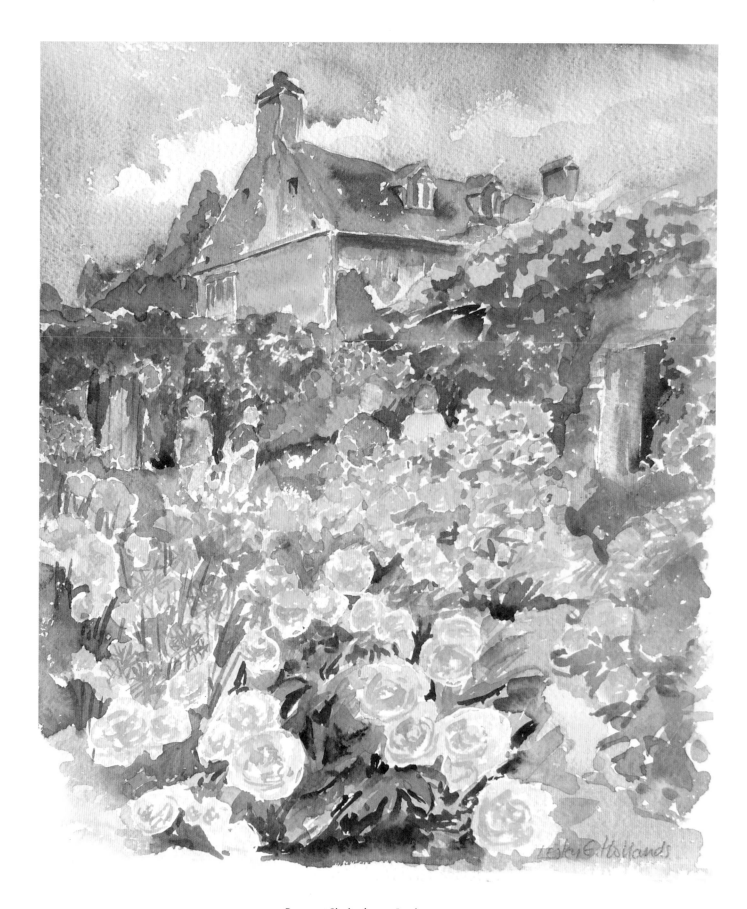

Roses at Sissinghurst Garden, Kent.

GARDEN SCENES

In this chapter we are going to look at broader views within the garden, incorporating buildings, statues, pathways and odd corners with something of interest to attract the artist and stimulate the imagination. Putting people into a composition, even if only in the distance, can add scale and interest, as does any living thing. A simple viewfinder, made from a piece of thin card or stiff paper with a rectangle cut from the centre is all that is needed to help separate a possible composition from its surroundings. Even using your hands to home in on an area can make seeing something that is a potential painting from among the distractions of its setting. A camera with a zoom lens can also do this.

A GARDEN SHED

This is an interesting project, which incorporates a bit of landscape as well as the shed and some of the things around and in front of it. The shed is a simple lean-to building made from weatherboarding, built up against another building made of brick, the whole lot being placed under an old and spreading oak. It was decided to exaggerate the size of the oak tree slightly to make the shed seem smaller and more picturesque. There was a lot of clutter and bits of junk outside the shed, which were not needed in the composition, but rather than spend the time clearing it up, artistic licence was used and the unwanted aspects were just ignored.

A quick sketch was made so that the composition could be seen on paper and some photographs taken for future reference. The drawing was adjusted until the proportion of tree to shed felt about right. The main trunk and larger branches of the

oak were drawn in, as were the broader areas of foliage. No fine detail was put into the tree in order to avoid making the tree too tight by just painting between the lines. The shed was drawn in with more care and some detail was added but again, not too much.

The colours in the composition work well with the

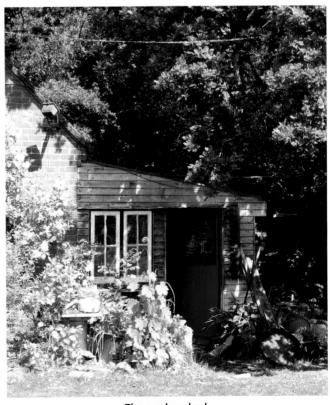

The garden shed.

First drawing with changed proportion.

Sky and first greens.

The building begins to appear.

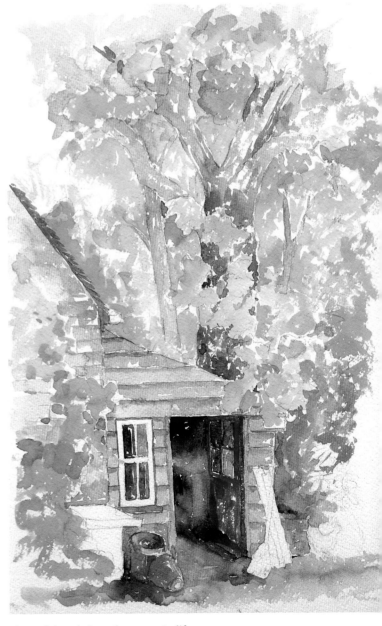

The red door brings the green to life.

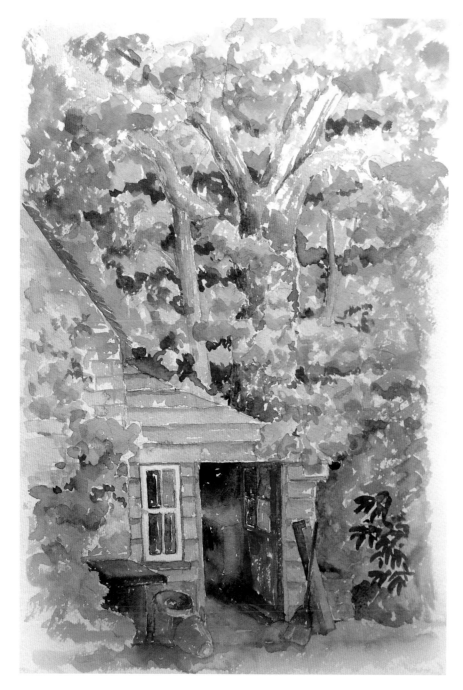

The oak tree seems to protect the shed.

grey/ochre of the tree trunk and the faded blue grey of the shed, contrasting with the red of the door and the warm reds in the bricks of the adjoining building. The light is also interesting with dappled shadows being cast on the shed and very dense shade behind the shed under the tree. The interior of the building is cool and dark with just a suggestion that there are things in it. There are also contrasting textures in the flat planks of wood used for the weatherboarding and the broken expanses of leaf framing the building.

It was decided that watercolour would best suit this composition as broken washes could be used to rapidly indicate the leaves and the trunk and branches of the tree as well as the foliage in the foreground.

Fabriano Artistico Rough 300gsm was used with the following watercolours: Cobalt Blue, French Ultramarine, Sap Green, Olive Green, Hooker's Green Dark, Winsor Yellow, Naples Yellow, Raw Sienna, Burnt Sienna, Permanent Carmine and Winsor Red. A number 10 synthetic sable brush was used for most of the painting with a number 6 used for the finer detail. By using large brushes throughout, the painting was kept relatively loose, capturing the late spring day and the sunshine.

There was some brilliant blue sky visible between the topmost branches of the tree and this was put in first using mainly

Cobalt Blue but with a little French Ultramarine added to darken some areas. Because the blue is easily turned from sky into leaves by adding washes of green and yellow it did not matter if there was too much blue at this stage.

A range of shades of green was mixed next, using Sap Green and Winsor Yellow and Hooker's Green Dark and Winsor Yellow. This gave a useful variety of those acidic greens so often seen in the first leaf growth of an English Spring. The greens were applied as areas of broken wash, leaving plenty of white showing and looking at the broad expanse of growth rather than individual leaves. If there is too much white it can easily be painted over but if you lose all the white paper it is difficult to get back. The plants and grass in the foreground were also put in, using slightly deeper shades in order to bring them towards you. Where the leaves are behind the shed the green has been painted up to the edge of the roof quite precisely and where they are in front the wash has broken across the edge of the weatherboarding. By doing this the shed feels more enclosed by the tree.

The buildings are the next areas to be painted. The soft colour of the faded weatherboarding is made by mixing Cobalt Blue with Raw Sienna and a touch of Winsor Red. Make the brush marks follow the line of the planks of wood and leave flecks of white showing, all of which help to make the front of the shed look flat and old. The adjoining brick building is indicated with some areas of warm red shades using Carmine or Winsor Red mixed with Raw Sienna. Again, the paint is applied with brush strokes that follow the general lines of the bricks but with no precise detail at this stage. The open door of the shed is painted with a deeper shade of red than the bricks and this colour is achieved by mixing Carmine with a little French Ultramarine. Having the door open gives an opportunity to make the shed look more substantial, leading the eye into the cool interior and giving a feeling of depth. Because both the shed and the brick building next to it are viewed from a low angle, none of the roof is visible. This can give a rather two-dimensional effect, which is counteracted by being able to see into the building through the open door.

Indigo is used for the windows and the interior, mixed with Burnt Sienna for the suggestion of the workbench. The glass of the window has some streaks of white paper left showing to give the impression that it is a transparent but reflective surface.

The huge oak tree is painted using a soft grey/green made from a mix of Raw Sienna and Olive Green. The beech tree in the background is greyer rather than green and is painted in a lighter shade so that it recedes. A general rule is that a stronger, warmer tone will come towards you and a cooler, lighter tone will recede.

Some of the foreground detail is put in now with the terracotta pots painted with a combination of Burnt Sienna and French Ultramarine. One of the tubs was in fact made from black plastic but artistic licence was used to turn it into an attractive terracotta container.

Some more colour is put into the foliage, using similar shades to those used on the trees, again with dragged brush stokes leaving flecks of light.

The next stage is to start getting more drama into the composition by putting some of the dense shadows in among the tree branches and foliage. This will help to make the tree look weightier and by contrast the shed more frail and enclosed.

A middle shade of green is washed in first to give more depth and variety to the foliage, being careful to retain areas of the original shades of green and some of the white. A darker green is then mixed by adding Indigo to Sap Green or Hooker's Green Dark. Olive Green is also used to extend the range of tones. Patchy areas of colour are applied with the edges representing the outline of groups of leaves. The dark areas are softened on some sides so that they do not look stuck on but are incorporated into the rest of the foliage. On the bottom right some different leaf shapes are added to give extra interest in this part of the foreground. The tree trunks and branches are made to look rounder and rougher by adding some darker shades to the shadow side of them. By using fine lines drawn in with a brush, an impression of the bark is given without it looking overdone.

The finishing touches are put in on the bench in the foreground and on the objects propped up. Shadow is added to the pots and the interior of the shed is adjusted slightly to give a slightly clearer suggestion that there is a workbench inside.

At one stage there had been a chicken drawn in the foreground but she seems to have disappeared.

The finished painting gives the feeling of an old shed built in the shade of the woods where perhaps the owner has just popped out for a moment.

WISTERIA AROUND A COTTAGE DOORWAY

This magnificent wisteria was seen, just by chance, in full bloom growing over a cottage in a Hampshire village. The scent was delicious. As there was no one there to ask permission to take a photograph a quick pencil sketch was made, concentrating on the wisteria and altering the position of the windows slightly, with the idea of developing a painting back in the studio. A few colour notes were made on a separate piece of paper to aid the visual memory.

The sketch was worked up into a fuller drawing making good use of the wonderful twisting trunk of the wisteria. The branches scramble across the front of the building with flowers

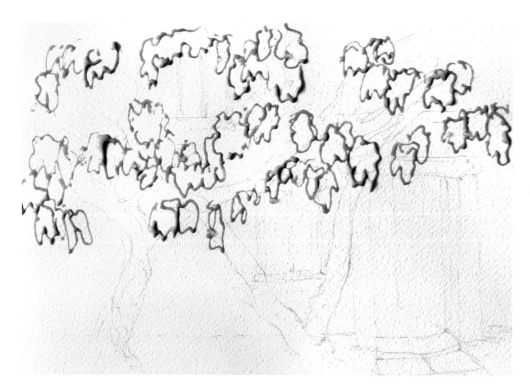

First stage with masking fluid protecting the flowers.

hanging down in front of the windows and the door, softening the hard edges of the building.

Fabriano Artistico 300gsm Rough paper was used for this painting with the following watercolours: Yellow Ochre, Raw Sienna, Burnt Umber, Permanent Rose, Cobalt Violet, Cobalt Blue, French Ultramarine, Indigo, Olive Green and Sap Green.

The colour of the stone was a warm honey shade which, if mixed with the purple of the flowers, would turn a muddy brown. In order to keep the clarity of the colour of the blooms, masking fluid was used to roughly outline the general area of the flowers. In this way the stonework can be laid in more freely without worrying about losing the white areas and consequently the freshness of the flowers. The easiest way to apply masking fluid in a flowing line is to use a bottle with a fine nozzle incorporated, preferably in a colour so that you can see where you have applied it. Schmincke make one in blue with a fine nozzle that gives an easily applied flowing line.

When using masking fluid it is important to make sure it is absolutely dry before you apply any paint. If your brush touches wet masking fluid, wash it out immediately because if it dries in the hairs your brush will be ruined. A rescue remedy, as a last resort, is to use washing up liquid and hot water to get it out.

The walls of the cottage are painted in using Raw Sienna and Yellow Ochre with a little Burnt Umber to vary the colour. The wall was darker around the main trunks of the wisteria so more Burnt Umber was added for these parts. The wall was built from blocks of stone but it would have been a bit fussy and tight to paint every block (the subject of the painting is the wisteria

after all), so a general impression was given by using horizontal brush marks, leaving lines and flecks of white which could have a suggestion of mortar added later.

The door frame and the window frames are painted using the same colour, as these are also built from stone. The light is coming from the right-hand side so a suggestion of shadow is given by darkening the areas away from the light. Further shadows cast by the wisteria are added later when the flowers are in. In this way you can make sure that the shadows correspond to the hanging flower heads making them look as though they are standing away from the wall.

The next stage is the main trunk of the wisteria. The bark is a beautiful soft grey/green/brown, gnarled and twisted around itself with age, giving an interesting knobbly surface. The colour is achieved by mixing some of the stone colour with a little Olive Green and where it is darker a touch of Burnt Umber or even some Permanent Mauve. The brush marks follow the growth pattern of the trunk and branches, which further accentuates the movement in the composition.

When this is complete and totally dry, the masking fluid can be removed. Roll it off with a clean finger to reveal the white paper underneath. If any of the paint is still wet it will smudge of course, which is why it is worth going away and doing something else for ten minutes or more before attempting the removal. A first broken wash of light purple is applied next. It is important to keep lots of white bits showing or you will lose the feeling of movement and delicacy in the blooms. Vary the colour as you go but do not let it get too dark at this stage. The

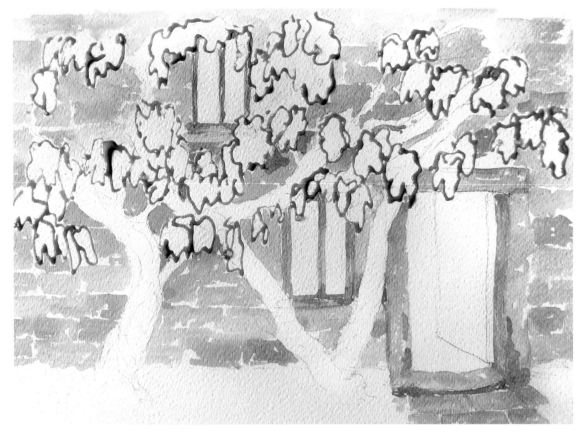

The honey-coloured stone is suggested.

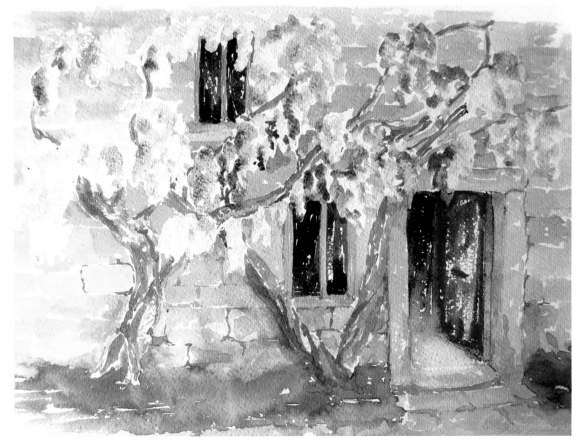

Masking fluid removed and flowers started.

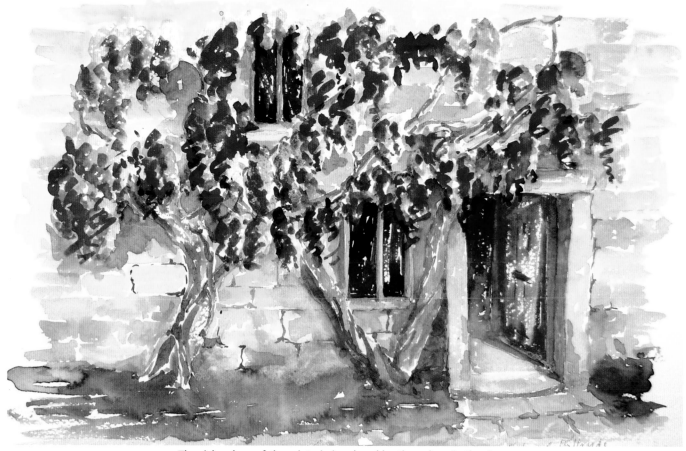

The rich colour of the wisteria is echoed by the colour in the door.

light is coming from the right-hand side so generally, any darker areas will be on the left. The door and windows are added now using Ultramarine mixed with flower purple for the door and Indigo and Permanent Mauve for the windows. The windows need to look as though they are glass and reflecting the light so keep lots of specks of white to capture this effect. Making some areas darker gives the impression that there is something just glimpsed through the glass and gives a suggestion of depth.

The open door is welcoming and, by using some of the same colour as the windows but more dilute, there is the suggestion of a cool room beyond. The back edge of the door has been allowed to dissolve into the interior giving a greater feeling of depth.

The walls of the house and the foreground need to be worked on next. Sap Green mixed with Olive Green and a little Burnt Umber in varying quantities gives a good range of shades for the grass. The back edge of the grass is allowed to run into the colour of the wall. This has the dual effect of pushing the back edge further away and making the wall look as though it is going down into the ground.

The wall needs just a suggestion of some of the stone blocks that it is built from. This is achieved by mixing some Burnt

Sienna with the colour used for the wall and putting in some fine, uneven and slightly broken lines to suggest the shapes of the blocks. It is an old building and nothing needs to look too precise and new. A little green added to some of the stone also helps to make it look old and mossy. The door frame and lintel are defined in a similar way.

It is now time to strengthen the colour on the flowers and add shadows where they are needed across the composition. Permanent Mauve works well with a little Permanent Rose added to warm the colour slightly. Both colours are transparent, which means that they will not look too heavy even if used at full strength. Using the tip of your brush, make some marks to indicate the shape of the blooms and give the feeling that they could be moving in a slight breeze. The darker colour is giving more definition and suggesting the shadows.

Shadows are also needed on the inside of the door and between the door and the trunk of the wisteria. The wisteria itself is also casting a shadow, which helps to make the plant look as though it is growing in front of the wall. Finally a little colour is run along the front to suggest a path.

The completed painting not only captures the feeling of age in both the building and the wisteria but also the freshness of new growth and the joy of another spring.

A SWATHE OF POPPIES

This wonderful splash of colour was seen at the Eden Project, in the Mediterranean garden. The Eden Project in St Austell, Cornwall, has a wonderful array of gardens both in the biospheres and in their surrounds where a wide variety of plants are grown using all sorts of designs and combinations.

The poppies are a wonderful, brilliant red and look so fragile with the papery petals held on slender stems growing among the grass. It was not possible to work *in situ* so photographs were taken and the painting constructed inside the studio.

Fabriano Artistico 300gsm Rough paper was used with the following colours: Quinacridone Red, Carmine, Vermillion Hue, Indian Yellow, Sap Green, Indigo and French Ultramarine.

The red of the poppies is what this painting is mostly about so it is important to keep the colour clear and bright. Green and red mixed make brown, so to avoid this, outline them in masking fluid to preserve the places where the poppy flowers will go. By doing this the foliage can be painted in quite freely with lively brush marks which capture the movement of the plants. The masking fluid must be completely dry before you start painting; if it is not then your brush may be ruined. If you do get masking fluid on a brush then the best way to get it off is to wash it in

warm soapy water before it has had a chance to dry. Several manufacturers make a masking fluid that comes in a tube with a fine nozzle, which makes drawing with the fluid very easy and means that you do not need to use a brush at all.

The lightest areas of foliage are washed in first with dragged brush marks, leaving lots of white paper showing. The centre of the composition is generally lighter than the outer edges, which helps to frame the poppies and give more of a feeling of depth to the painting. When the first wash is dry a second layer of slightly deeper green is applied using finer, mostly vertical, brush strokes. These marks begin to suggest the stems of the poppies and the leaves of the surrounding undergrowth.

A useful bright red for the poppies is either Quinacridone Red or Winsor Red. Some parts of the flowers appear more orange than red and this can be mixed using either of the reds combined with Indian Yellow or, if you prefer a ready-mixed colour, then Vermillion Hue is a useful shade. When painting in the poppy flowers the aim is to suggest the blooms rather than painting in each flower too tightly. By using a slightly impressionistic approach the petals are more likely to stay looking papery, delicate and fragile, which is what is needed. The lightest shade of each flower or group of flowers is painted in first. When this is dry a second brush mark is applied to each bloom, using a deeper shade to start suggesting the form of the flower

A swathe of poppies.

Masking fluid protecting the areas where the brilliant red will go.

Background greens washed in.

heads. A third stage of an even deeper colour gives the appearance of shadow and a three-dimensional effect. It is useful to leave small areas of white glinting through the reds to avoid making the petals look too solid and heavy.

When the red of the flowers is complete the foliage is built up with more vertical brush marks and some broader strokes to suggest different leaf shapes. A range of green shades is used for this including some more olive and yellow tones to give variety.

The finishing touch is to put in the very dark centres of the poppies. Indigo with a touch of Carmine is used for this as it gives a much richer, more velvety colour than black on its own would. A good alternative would be Blue Black or if you only have one black in your palette then add Indigo or French Ultramarine to it. The centres are seen from different angles and from different distances so they vary considerably in shape and size.

The finished painting captures the brilliant colour and fragility of the poppies and gives the feeling of a warm summer day.

Masking fluid removed and first stage of the poppies painted in.

The dark green in the background throws forward the brilliant colour in the poppies.

SISSINGHURST GARDEN

Sissinghurst Garden in Kent belongs to the National Trust and was once the home of Vita Sackville-West and her husband Harold Nicolson. Between them they created a magical garden with different 'rooms' each with a particular character and all beautiful. It is a structural garden and contrasts with the exuberant, dense planting all crammed together but controlled by the elegance and organization of the layout. It is a garden worth visiting at any time of year as there is always something interesting and unusual to see.

There were so many fascinating corners – old doorways, long views, beautiful planting, statues, river walks and a vegetable garden, not to mention the house and tower – that it was difficult to know where to begin. The garden is very popular and tends to get busy so there was no opportunity for more than a quick sketch *in situ* but plenty of openings for photographs. Having time, once back in the studio, to peruse the photographs, and to select some parts and enlarge others was a delight and a good many ideas for paintings could be gleaned from the process.

AN OPEN DOOR

The first composition chosen here is of an open doorway, framed by a *Magnolia grandiflora*, in an old wall with a view through to the pink bricks of the house. The sun shining through the doorway sends dappled shade onto the steps, illuminating some of the plants growing either side. The steps lead the eye into the composition and the glimpse of the house through the doorway, with its window and surrounding flowers and foliage, gives a focal point.

A sheet of primed oil painting paper was used for the composition as it gave the opportunity for changing the proportion of the painting if necessary. The following oil paints were used: Burnt Umber, Burnt Sienna, Cadmium Red Deep, Permanent Rose, Cerulean Blue, Cobalt Blue, French Ultramarine, Cadmium Yellow, Winsor Yellow, Yellow Ochre, Sap Green and Titanium White.

The composition has been sketched out first with a fine brush and then roughly blocked in with the appropriate colour for each area. The house wall is a beautiful soft shade of pink with areas of Yellow Ochre mixed with white. The top of this wall and the part seen through the doorway are generally lighter as they are catching the light. No detail is put into the wall yet, although the brush marks are generally worked in the direction that the bricks are laid. The rough shape of the magnolia trunk is indicated using Burnt Umber mixed with Sap

Green again making it lighter nearer the top where it is catching the light. The sky is painted with Cobalt Blue mixed with white.

The rough layout is then left to dry.

The next stage is to start putting detail into the door and steps. This area is important and needs to be painted with sensitivity and subtle colours. The strong diagonal band of sunlight falling across the door takes your eye up to the window in the house wall, which is just suggested at this stage. There needs to be enough detail here to describe the window but without it being so worked up that it comes too far forward in the composition. The door is made up of planks of wood that have been painted a soft grey green colour, which changes considerably depending on whether it is in sunlight or shadow.

There is a dark shrub growing behind the door on the right, which helps to indicate the space there. This is put in with some scumbled green and Burnt Umber allowing some of the soft pink of the bricks to show through.

The steps lead your eye through the door to the light beyond and need to be correctly drawn so that the perspective works. They are simply sketched in to begin with, with light and shade showing the rise of the steps. A few lines suggest the bricks from which they are built and the path in front is put in with soft shades of Yellow Ochre.

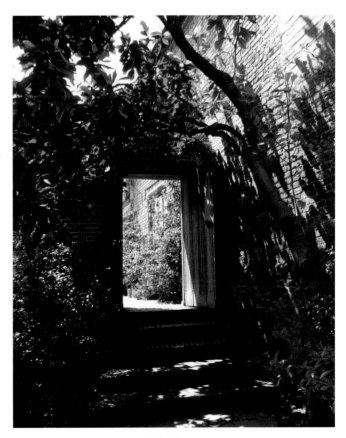

A shady doorway.

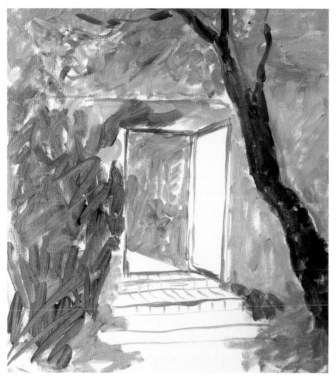

The first colours roughed in.

Some of the foliage of the rose growing round the window is painted using Cerulean Blue mixed with Winsor Yellow, which makes a really clear acidic green. The dark of the shadow on the rose foliage by the path gives a useful crisp edge to the light falling on the bottom of the door.

Once again the painting is left to dry. While the painting is drying it can be assessed to make sure that it is going in the right direction. On looking at it with a fresh eye a few mistakes are noticed: the angle of the top of the wall of the house is at too shallow an angle and needs to be made more acute to correct the perspective; the bricks of the step are also not at quite the right angle and need to be altered; the brush marks on the wall on the right are not helping to show the angle of the wall and are also not light enough at the top. It is useful to have seen and corrected these mistakes at this stage when they are very easily put right.

The sky is repainted and worked over the top edge of the wall to put the angle right using Titanium White, which is very opaque, mixed with Cobalt Blue. A chisel-ended brush is used to suggest, a little more clearly, the bricks in the wall on the right, lightening them nearer the top so they appear to be glowing in the sun. The steps are repainted, with the worn bricks put in, where hundreds of people have trodden, plus a wider range of subtle shades and a better line of perspective.

The composition is coming together now and is beginning to capture more the feeling of light and shade *(chiaroscuro)* that

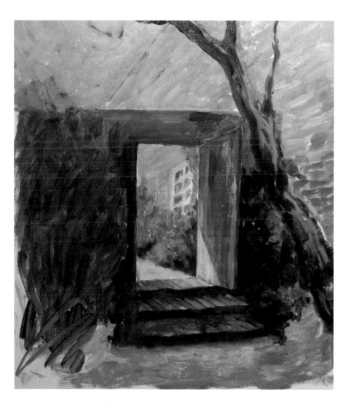

Light and shade are added.

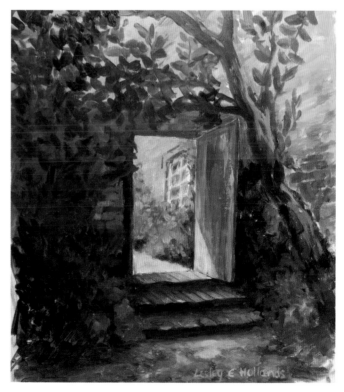

The light falling through the doorway leads your eye into the composition.

was so attractive in the first place.

More detail is added to the trunk and leaves of the magnolia and to the shrubs growing on either side of the steps. The undersides of the *Magnolia grandiflora* leaves are bronze in colour, linking them with the colour of the wall rather well. Some of the bricks in the wall to the left of the door are visible but, being in shadow, are much darker than the other bricks; these are painted in before the final leaves on the left-hand side are put in. The window needs more detail, so some shadow is put in to suggest that the window is set into the wall and the panes are darkened very slightly.

The finishing touches are to add some flowers to the rose growing round the window which is visible beyond the door. Also to make the path at the bottom of the steps more interesting by adding more colour and a suggestion of dappled shade and finally fill in the greenery above the doorway.

The finished painting captures the feeling of the door opening onto a sunlit courtyard with a cool shady garden in the foreground.

TERRACOTTA AND OLD BRICKS

This next painting is again from the garden at Sissinghurst. It is on a slightly smaller scale but the old terracotta pot and the very

Flowers and bricks are suggested.

Terracotta and old bricks.

The pot shape appears as the foliage is built up.

The grey of the stone complements the mauves in the flowers very well.

much older wall behind it have a warmth that is very attractive. The delicate mauve blooms of the Australian hibiscus, *Alylgyne huegelii* 'Santa Cruz', and the soft grey stone slabs that the pot is sitting on complete the composition.

A small piece of Fabriano Artistico 300gsm is used for this painting with the following watercolours: Winsor Violet, Cobalt Blue, French Ultramarine, Indigo, Yellow Ochre, Winsor Yellow,

Sap Green, Carmine, Burnt Sienna and Burnt Umber.

The pot is drawn out along with the lines of the paving slabs. The rest of the composition can be painted directly but the pot needs to have the correct ellipse and the slabs need to have the correct perspective for the painting to work. As the pot takes up as much space as the plant growing within, it is important that the drawing is sound and the painting of it is interesting.

The flowers are put in first so that their colour can be kept fresh and clean looking. Winsor Violet is too strong on its own so Cobalt Blue is mixed with it to create a lighter, more delicate shade of mauve.

The colours in the bricks are beautifully varied with soft shades of red, orange, yellow and brown. The wall to the right of the pot has a curved edge, rather than a sharp corner, which is indicated by gently bending the line of the bricks as they go around the side of the building. There are also some large blocks of creamy stone, which break up the bricks rather nicely. The bricks are painted in individually, taking some care to make sure that they follow the angles of the changing direction of the wall and that the perspective is at least roughly right. If you are concerned about the perspective then draw in a few guide lines to help you. The bricks are so old and worn that a bit of artistic fudging is quite acceptable and a little blurring of edges with a second wash can cover a multitude of mistakes.

The foliage is quite a blue/green in places but the lighter, more yellow tones are put in first, as the darker colour will go over the top. The leaves are quite serrated so small marks are used to suggest this.

The wall behind the plant is suggested with soft washes of colour but not too much detail, as it needs to be kept in the background. The terracotta pot is tackled next and is an important part of the composition as it takes up so much space. The subtle variations of colour and the light and shade must not be lost so an initial wash of warm red/brown is dragged across leaving flecks of light down the front of the pot. Experiment with different combinations of Burnt Sienna, Carmine, Yellow Ochre and French Ultramarine. While the first wash is still damp a second layer of deeper brown, mixed by adding French Ultramarine to the first colour, is run in on each side making sure that the edge is kept soft in order to indicate that the shadow is falling on a curved surface. A little more shadow is put in under the rim to make that area stand out.

The slabs of stone are painted in using Indigo mixed with Burnt Umber in a fairly dilute form. The colour is more intense further back in the shadows, so a stronger colour is used there. This colour is also run over the sides of the pot making the edges dissolve slightly and helping to connect the pot with its surroundings. Flecks of light are left on the ground in front of the pot to stop the grey slabs becoming too dominant.

More colour is now put into the flowers, using a deeper shade of mauve with a fine brush, to suggest a little detail in the petals. The leaves have some of the darker blue/green added to both the foliage and the spaces between the foliage to give them more definition and make them stand out more.

Finally a wash of dilute French Ultramarine is run in across the wall behind the foliage.

This is a pleasing small study, which has kept the balance between the rather large terracotta pot and the plant.

THE ROSE GARDEN AT SISSINGHURST

This next composition is from a photograph taken in the rose garden at Sissinghurst where the scent held within the old brick walls on that warm summer's day was glorious. The composition is slightly exaggerated to make more of the rose blooms in the foreground, using them to lead your eye into the painting and up to the cottage in the background. A few people are included to add interest and scale.

The house is drawn in with some of the adjoining old brick walls and a suggestion of the foliage growing on them. The roses are not drawn in at this stage since masking fluid will be used later to position them and allow the foliage to be painted freely without risk of losing the pink shades of the flowers.

Fabriano Artistico Rough extra white paper is used in 300gsm weight with the following watercolours: French Ultramarine, Cobalt Blue, Sap Green, Hooker's Green Dark, Winsor Yellow, Indian Yellow, Raw Sienna, Permanent Rose and Carmine.

The sky is painted in first using French Ultramarine, which granulates nicely leaving a gently textured finish. The paint is dragged across the rough surface so that the areas of white cloud can be left as dry paper. The mass of sharp green foliage growing on top of the wall is painted in using Cobalt Blue and Winsor Yellow.

The flowers are outlined in masking fluid applied with a tube with a nozzle on the end, which makes it very easy to draw. Rather than drawing in too many individual flowers, which might look somewhat bitty, try to see how the flowers group together forming swathes of blooms. The flowers at the front are enlarged slightly to give a greater feeling of depth to the composition and to balance the weight of the building in the background.

The masking fluid is left to dry completely before continuing, to avoid any risk of contaminating the brush with still wet fluid. If this does happen, wash the brush out with warm soapy water immediately.

The house roof and walls are quite a similar colour but it is important to look for the differences; the roof has some darker streaks on it and is generally not as warm a shade as the walls. Raw Sienna and Carmine mixed are used for the walls and a little French Ultramarine added for parts of the roof.

The wall of the garden is a deeper shade again so the same colour, but with less water, is used here with more French Ultramarine for the shadowed parts. Making the wall darker also helps to bring it forward: a warmer, stronger colour comes towards you and a cooler, lighter colour recedes.

More of the foliage right across the garden is now added, using a range of lighter fresher greens. The figures have a little detail put in with some colour on their clothing and hair. One

The rose garden at Sissinghurst.

The composition is planned out.

The warm brick of the building is put in without too much detail.

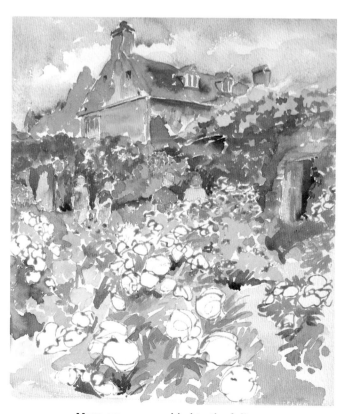

More greens are added to the foliage.

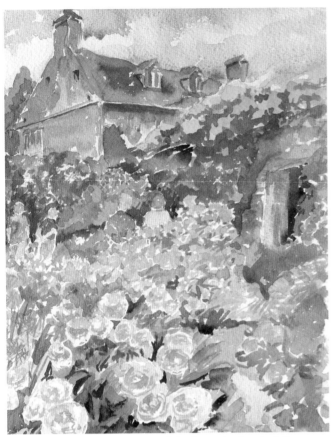

The roses carry your eye right from the front of the composition up to the house.

T-shirt is painted red just to make it stand out slightly more and add a tiny splash of bright colour to the composition.

The gravel path, which winds through the garden, has a warm pink tinge, which links up nicely with the walls of the garden and the building behind, subtly connecting the foreground with the background.

Before removing the masking fluid some small parts of deep green shadow are painted in to add emphasis to the roses.

When all of the paint is completely dry the masking fluid is rubbed off revealing the pristine white areas where the pink roses are going to go. The shapes that are exposed are not necessarily the right shapes and will need to be adjusted, not only by painting in the flowers but also by bringing in the green around them to change and improve their shapes.

The roses create a pleasing connection with the middle of the painting, leading your eye into where the figures are standing and then onto the doors in the walls and then the house. It would be easy to overdo the rose blooms, making them too detailed and fussy. As the whole painting is pretty freely painted it would be inappropriate to make the roses too meticulous; all they need is more colour on the foreground ones applied in such a way as to suggest the layers of petals that are characteristic of this particular variety of rose. To get this effect the paint

is dragged across each flower in a rough semi-circle, leaving flecks of white showing. Dilute Permanent Rose is used and any necessary softening of the edges must be done before the paint is dry as this colour is truly permanent. When the flowers are in then the foliage is worked up with more darks worked into the light greens, giving the impression of leaf shapes. There is a clump of spiky, lime green alliums to the left of the roses which set off the soft pinks and gentle shapes of the roses to perfection. The strong, straight stems of the alliums add another contrast to the more softly flowing areas of the painting. A little shadow on the path and a touch more detail to the shadows on the house completes the painting.

This painting works on a number of counts: the roses, being slightly exaggerated, lead your eye into the painting; the figures give a sense of scale and add human interest without being too obvious and the whole feel of the painting is that of a warm summer's day, which it was.

STATUE AMONGST *ALCHEMILLA MOLLIS*

In the garden at Sissinghurst there are many lovely statues positioned so that they can be seen at the end of a long walk or

Sunlit statue.

The statue is roughly sketched in.

The dark foliage makes the statue stand out.

come upon unexpectedly as you turn a corner. This particular piece of sculpture was standing against a dark yew hedge with a froth of *Alchemilla mollis* growing in front. The deep green of the yew dramatically set off the pale stone of the statue and the lime green of the low-growing plants at the base gave another wonderful contrast.

Oils were chosen for this composition so that the very strong dark colours could be achieved without them becoming too heavy. Painting the statue could be quite a challenge so oils, with their flexibility of being able to paint light over dark, were deemed a better choice.

A small canvas with white primer was used with the following oil colours: Sap Green, Burnt Umber, Yellow Ochre, Win-

sor Yellow, Cerulean Blue, French Ultramarine and Titanium White.

The statue was roughed in first using a grey mixed from Yellow Ochre, Cobalt Blue and White. There are patches of green where lichen is growing and parts that were more ochre than grey so all of these colours were used. No real detail was put in at this stage but the proportions and the stance of the statue needed to be caught.

The yew hedge was a wonderfully dark green, close clipped so only a little texture and variation of colour showed. Sap Green mixed with French Ultramarine was used for the bulk of the hedge with touches of Burnt Umber added in places to give variety. The darkness of the hedge can be used to go over the

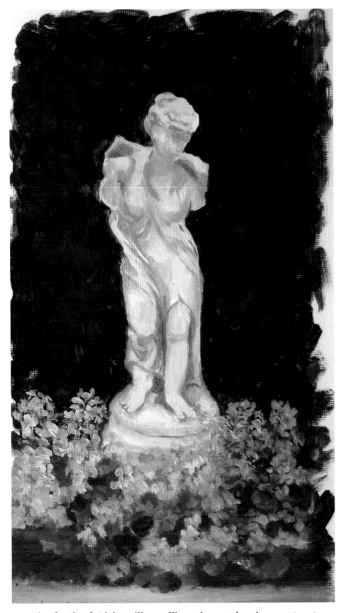

**The froth of *Alchemilla mollis* makes a pleasing contrast
to the figure.**

outline of the statue and it will be redrawn where necessary.

In front of the sculpture is a brilliant froth of lime green
Alchemilla mollis, which is roughed in using Cerulean Blue
mixed with Winsor Yellow. The broad leaves of the plant, which
are a softer blue/green, set off the fizz of the flowers to perfec-
tion. Cobalt Blue mixed with Yellow Ochre makes a blue/green
almost like Terre Vert, which is very useful for leaves of this type.
The yew hedge is worked on with the brush marks made to go
in a more generally horizontal direction with just the slightest
suggestion of light catching some parts. This is enough to lift
the intense dark of the hedge without bringing it forward or
making it too important within the composition.

More detail is put into the statue keeping the marks soft,

almost blurred, in order to maintain the feeling of age and
weathering of the stone. The head of the statue is too large but
this is easily remedied by painting over the outer edge and mak-
ing it smaller. The right knee is too low and the left thigh too
wide, so these again are corrected.

Small marks of acidic green are dotted into the *Alchemilla
mollis* with white added to the colour for where the light is
catching the plants on the left hand side. More detail of light,
shade and shape are put into the leaves, although still keeping
the whole appearance fairly soft and loose.

The statue is standing in a border with mown grass in front
of it. At one point it seemed as though the grassy area was not
going to be needed but as the painting progressed it was decid-
ed that the flat area of bright green grass set off the sculpture
with its dark background rather well, and gave an extra feeling
of depth to the painting.

The completed painting successfully catches the feeling of
the softly lit, old stone statue and the bright contrasting froth of
the *Alchemilla mollis*.

ASLEEP IN THE SHADE

This photograph was taken one warm summer's afternoon in a
garden that had been opened for the National Gardens Scheme.
The National Gardens Scheme is a wonderful organization that
promotes the opening of private gardens to the public in aid of
a wide range of charities. There is a small charge for entry and
often plants for sale as well as delicious refreshments. You can
find a list of all the gardens and their opening times in the NGS
Yellow Book (see Further Information at the back of the book).

The elderly gentleman in the photograph had partaken of

Asleep in the shade.

95

Initial sketch in pencil.

some of the excellent tea and cake that had been on offer and had fallen asleep in a shady spot. The figure, even though it is tucked away in among the plants, was going to be the focal point of the composition so the surroundings have been simplified slightly. The pathway takes your eye into the painting and to where the figure is sitting and the two tubs add interest to the foreground. The third tub seemed unnecessary so it was omitted and the pot to the left of the figure looked too high so it was moved down and some colour added to the contents.

Fabriano Artistico 300gsm was used with the following watercolours: Sap Green, French Ultramarine, Cobalt Blue, Cerulean Blue, Indigo, Indian Yellow, Winsor Yellow, Raw Sienna and Permanent Rose.

The figure is drawn out first so that the position and stance are correct. The gentleman's head is tipped right forward onto his chest so very little of his face is visible. To get the angle of the head, look at where the shoulders come in relation to it. A common mistake is to make the shoulders too low, which then gives

The figure is put in first.

the impression that the head is much more upright. The way the head fits into the hat is also important; drawing the top of the head and then fitting the hat around it can make this easier. The path and pots are also drawn in along with the line of the top of the hedge. Everything else can be put in freely and directly with a brush.

The figure is catching the light so the Cerulean Blue that is used for his shirt is diluted a little for the area that is in the sun. A slightly deeper shade is used to draw in the creases in the arms and where there is a stronger shadow by the canvas satchel that he is holding. The trousers and hat are painted using Raw Sienna mixed with a little blue to darken the colour. Again, a more dilute version of the colour is used for the light areas. The dark hatband is useful as it helps to accentuate the curve of the head. The face and hands are painted using Raw Sienna with a touch of Permanent Rose and an even smaller amount of French Ultramarine. The face has no real detail, just a suggestion of light on the left-hand side. Too much detail in such a small area can look

Foliage in a range of colours is added next.

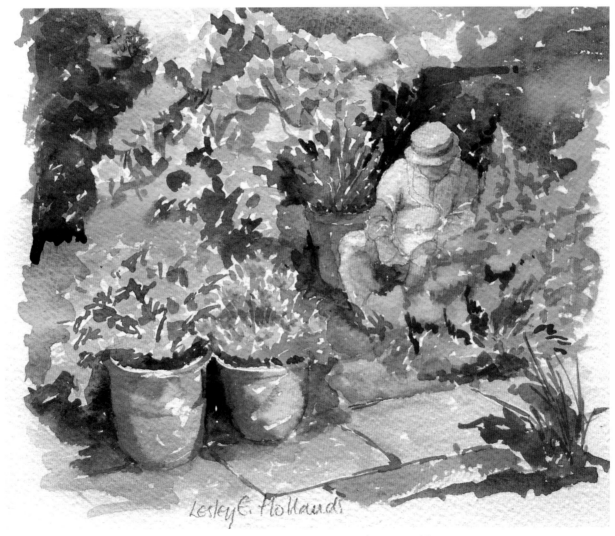

Foreground detail takes your eye into the composition.

clumsy and it is better to let the eye of the viewer fill it in.

The two flowerpots and the path, which leads your eye into where the figure is sitting, go in next. As they are so near the front the pots need to have some interesting colour on them together with light and shade. Permanent Rose and Raw Sienna are used for the lighter areas with French Ultramarine added for the darker areas. The path is mostly Raw Sienna with a little green or red added to give variety. The path is a light shade as it is catching the sun and the gentle glow of the colour brings the stone slabs to the fore.

The area behind the figure is made up of a dark yew hedge, which frames the sleeping man very well, bringing out the light falling across his shoulder and knee and accentuating the tilt of the hat. Beyond the hedge are some lighter areas of foliage and small patches of sky seen through the trees, all of which are suggested quite loosely, allowing the colours to run gently into each other.

The yellow and orange flowers in the foreground tubs go in next along with the pink flowering climber further back. These are put in quite simply without much detail at all at this stage. The tub next to the figure has some red foliage painted in (although this was not there in reality) as a little red in a landscape helps brings it to life. More light green foliage is added on the right-hand side with dragged brush marks, leaving flecks of light, which give highlights and contrast to this area.

The foliage continues to be built up using a range of greens and still not a lot of detail. The figure is the focal point of the composition and if there is too much detail in the rest of the painting it can detract from the main subject.

Once the rest of the foliage has been suggested, prop the painting up and stand back from it so that you can assess what else needs to be done. It was decided after a little thought that more detail and a darker colour were needed in the foreground on the right. By putting in some plants here with a deep green and some spiky shapes, it gives the painting a greater feeling of depth because this area has come towards you. The path is also brought forwards with some extra detail put in, the gaps between the slabs painted in and some shadow run across. The various flowers need a suggestion of detail so a second shade is put on each area which is just enough to give the feeling of light and shade and make the flowers appear more three-dimensional.

A finishing touch is to put some shadow on the pot next to the sleeping figure and darken the hedge behind him.

The finished painting has caught the stance of the dozing figure and the feeling of a warm summer's afternoon, without spelling it all out in too much detail.

SUNLIT FIGURES BENEATH THE TREES

This is another painting worked from a photograph taken in the garden opened as part of the National Gardens Scheme. The figures were enjoying a rest and a chat on some comfortable chairs that had been placed in the dappled shade of the over-hanging tree. To one side is a stack of wood, propped up in readiness for the next winter's fires, making some interesting shapes and useful, contrasting, vertical lines. It was almost like a stage set with the figures lit by the sun but in part silhouette with the light sky beyond, framed by the dark branches of the old tree, all of which gave a sense of quiet drama.

A piece of primed oil painting paper was used for this piece of work with the following oil colours: Sap Green, Olive Green, Burnt Umber, Cerulean Blue, Cobalt Blue, French Ultramarine, Cadmium, Yellow Deep, Winsor Yellow and Yellow Ochre.

Before starting on the painting some pencil sketches were done of the figures to make it easier when it came to the painting. A figure sitting with crossed legs can be quite difficult to get right so some practice is always useful.

The scene was sketched in with a brush and some Olive Green paint, paying particular attention to the size of the figures; they needed to look as though they were comfortably framed by the branches of the tree but far enough into the painting to be catching the light. The big tree branches are put in and a suggestion of where the shadows are going to go. By sketching in lightly like this, it makes it easy to change things and improve the composition once it begins to appear on the paper.

The chairs were set at an angle with the figures facing the sun, which made them appear in semi-silhouette. To make the

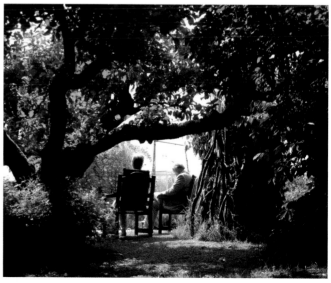

Two figures under the trees.

The composition is sketched out with a brush.

Basic colours are blocked in.

Darks are added.

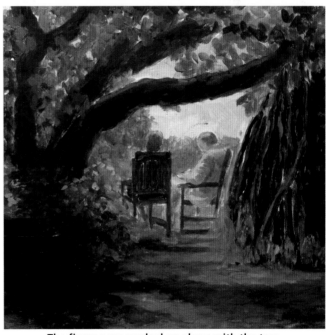

The figures are worked up along with the tree.

figures appear to be sitting in the chairs and conversing with each other, it is important to get the angles and the sizes of both the people and the chairs right. Looking at the heads and where they come in relation to each other helps, as does observing where the backs and feet of the chairs come. The figure on the left is slightly nearer to the foreground so appears a little larger. The way that the two people overlap is also important for the composition, as it unites them and makes a stronger shape.

Once the basic drawing is complete then the sky and light-est areas of foliage are roughed in. The sky is a pale blue made from Cobalt and Titanium White and more of it painted than can actually be seen, so that when the foliage is painted in, small flecks of sky are visible between the leaves. The lightest foliage is painted in using yellow, which will be glazed over with transparent shades to turn it green later.

The shadows cast across the grass by the tree are put in with a range of shades of green, and the stack of wood on the right-hand side is indicated in deeper greens. Getting the right shade

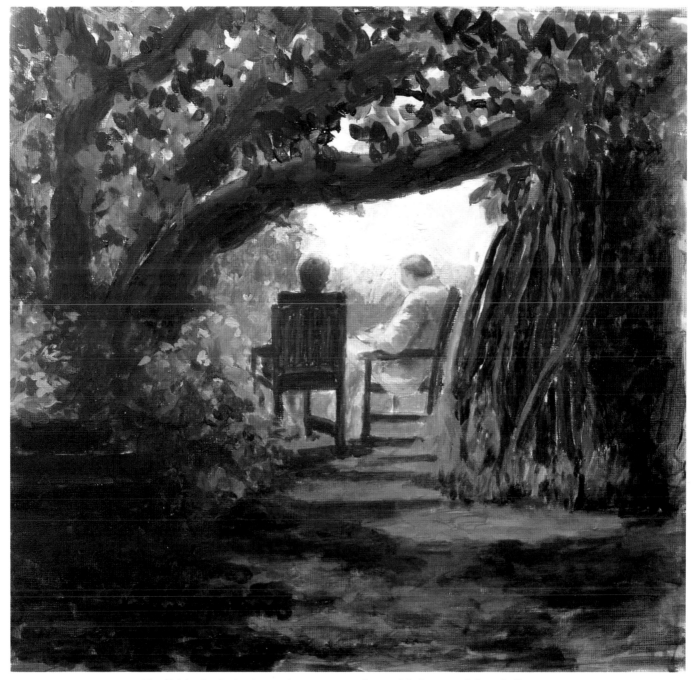

The finished painting has a pleasant atmosphere with the peaceful sunlit figures.

of green can be difficult and if you find it a real problem then it is worth investing in a few more ready-mixed greens. Experiment with the various shades of green, blue and yellow that you have in your paint box and try out different combinations and proportions of colour. Don't forget that black mixed with Lemon Yellow can make olive green and that adding a small amount of red to a green can soften it; too much of course and you will turn it brown.

The painting continues to be built up with darker shades

and a glaze of bright green is run across the yellow areas. By using a glaze, which is a transparent colour mixed to a thin consistency, you can achieve a depth and brilliance of colour, which can otherwise be difficult to achieve. If the glaze of colour has darkened the underlayer of paint too much then wipe it away with a soft cloth, trying to leave just a little paint behind. You can increase the transparency and flow of a colour by adding Liquin to it (see Chapter1).

The very dark tree trunks are painted using a mixture of

Burnt Umber, Sap Green and French Ultramarine. The brush marks are painted along the trunks as opposed to across in order to give a suggestion of the rough texture of the bark. Some of the darker leaves around and above the tree are also painted in at this stage.

The painting is now left to dry before going on to further build up the glazes and start work on the figures.

Once the painting is dry then the very dark shadow across the grass is broken up and lightened slightly with more thin layers of paint. The left foreground is also darkened, which starts to make the composition come to life with the figures beginning to look as though they are sitting in a pool of light while all around them is shadow. A suggestion of the leaves on the tree and surrounding shrubs is put in with some more deliberate and careful brush marks. The stack of wood on the right has more darks painted between the upright branches along with some light and shade to make them appear more three-dimensional.

The figures are now painted first of all with fairly simple areas of light and shade. The man sitting on the right has more light on him and therefore will have more visible detail but it is best to go slowly and keep the first stages uncomplicated. If you spend a lot of time on the detail before making sure that the basics are right you may find it all needs to be changed; this is not only very disappointing but there can be a strong temptation to leave it as it is. The other figure is almost in silhouette but the small touches of light on the top of the head and back of the chair are very important, as this is what is going to make the figure look three-dimensional and not just a cut out.

When the first layer of paint on the figures is dry and you are sure that what you have painted is right then more detail can be added. By letting the first layer dry, subsequent paint can be wiped off if needs be without losing the basic structure. There are some useful bits of light and shade on the jacket especially on the arm and across the back. The light on the shoulders indicates that the figure is leaning forwards slightly with his head bent and looking at something resting in his lap. The other figure has her head turned slightly towards her companion; this is shown by the light on the head and its angle and shape.

More darks are added to the tree and thin layers of green used to tone down the lightest greens in the foreground. In order to get the sense of the figures being in full sun all the other lit parts of the painting need to be less bright.

The painting at its present stage is very green so in order to relieve this some pink and mauve flowers are added to the plants growing at the base of the tree. There were some poppies growing in the flowerbed beyond and between the seated figures but these seemed too intrusive so were left out.

The painting is now nearly finished so it is propped up and left for a while before deciding if any alterations are needed. On looking at it with a fresh eye it was decided that the man's head was slightly too large so this was altered quite simply by painting over it with some sky colour. The tree foliage also did not seem quite dense or dark enough so more deep greens were added to correct this. Finally a few more flowers were added to both the left-and-right hand sides, to relieve the mass of green a little more.

This was quite a challenging painting to do, with the amount of green and the figures to cope with, but the finished composition seems to catch the feeling of the sunlit glade and the figures appear to be sitting there enjoying the warmth.

Watering cans.

CHAPTER 6

DETAILS IN THE GARDEN

In this chapter some of the more intimate parts of the garden are going to be used as subject matter. There are often lots of small corners, unintentional still-life groups, interesting surfaces and other odds and ends that make excellent subject matter for painting just waiting to be noticed. A small viewfinder, made by cutting a rectangle in a piece of stiff paper or card is a useful tool to help you see these possible paintings. By looking through the viewfinder you can cut out surrounding areas and focus on the bit that you want to paint. This works well for large scenes as well as the small ones.

Looking at things from a different viewpoint can also open up ideas for what to paint. A group of daisies growing in the lawn, when seen from above, does not look very inspiring, but crouch down and get really close up and the whole thing changes. If you are taking photographs from very close it is worth using the macro setting on your camera (if there is one). The effects of light on small areas can make a big difference and here a camera is essential for capturing that fleeting moment.

In this first project two different approaches to painting are going to be used for the same subject matter. The calendula flower was in full sun and glowed in the strong light. It was difficult to get a properly crisp image at first because there was a slight breeze, which moved the flower every time the camera clicked. A windbreak was set up and finally a good sharp photograph was achieved. A blurred photograph could have been used and in some cases having the image out of focus can be an advantage. If you are trying to do a very loose painting from a photograph, then using an image that does not have a lot of detail but gives you the broad areas of colours and general shapes can help enormously.

CALENDULA

In both paintings the same colours are used, and a heavyweight paper with a rough surface. The rough texture makes it much easier to drag the paint and keep the flecks of light, which are so important when you are working with such strong colours.

The following watercolours were used: Indian Yellow, Winsor Yellow, Winsor Red, Carmine, Alizarin Crimson and Indigo.

The first of the two paintings here is the slightly tighter one. The calendula flower has been drawn out with some care, looking not only at the shape of the petals but the spaces between them. By observing the negative spaces you are more likely to get an accurate and interesting drawing.

The paint is put out on a large mixing palette – a dinner plate works well, so that there is plenty of room to mix colours without them all running together. The lightest part of the flower is put in first using a number 10 brush. Indian Yellow is the main colour but some parts are lighter than this, so Winsor Yellow is used as well. The large brush allows you to drag the paint, leaving areas of dry paper that stay white. If you find dragging difficult then practise on a spare piece of paper, which must be of the same type as the paper you are using for the actual painting as different papers behave differently. Where the flower is in shadow the petals are a deeper shade of orange so here some Winsor Red is added to the Indian Yellow. The centre of the flower is left as a white space.

The first layer of petals is left to dry so that the colour does not run into the next layer. More petals are put in all round, keeping the colours varied but generally darker on the left-hand side. The top layer of petals is casting a shadow on those below,

Brilliant orange calendula flower.

First stage with a range of oranges.

Petals are built up with more colour.

which is useful for defining the edges where necessary. The outermost layers are important as it is going to give you the shape of the flower against the dark background. The petals have a very characteristic shape at the tip, which is worth taking the trouble to get right.

The centre of the flower is dark and has an uneven, knobbly surface. There are some small specks of yellow and orange where pollen is caught, which help to break up the dark colour. These lighter shades can be put in first and the dark painted round it or they can be put in afterwards using an opaque colour such as Cadmium Yellow.

Some of the petals need further definition and this is achieved by using the shadows. Try to avoid outlining a complete petal as this can look very stiff but use a broken line along just part of the edge. The petals on the shadow side of the flower blend into each other and this effect can be achieved by either running more colour over them to pull them together or by using a wet brush to soften some of the edges.

Prop your work up now and stand back from it. It should now look brilliant in colour and appear rounded in shape with the impression of layered petals. This is the time to put more definition in if needed or further soften edges.

The final part is to put in the background. The colour behind the flower is very dark, which helps to make the bloom stand out and glow brilliantly. A pale background would tone down the whole composition and the painting would lose much of its drama. Here Indigo has been used in various degrees of intensity and some of the edges of the petals on the shadow side of the flower have been allowed to run into the background. The paint has been applied to a wetted surface so that the colour will run just where the paper is wet and be kept under control. If you work with the paper flat there should be no problem with manipulating the paint around the petals, where you want them to stay crisp.

If you find using such a strong colour rather daunting and think that a paler colour would work just as well, try it out first before committing yourself. Take some small pieces of paper of the same type as you have used for the painting and put a colour on each one. Place these coloured scraps against the painting and see how they look. By doing this you can judge whether they will work for you without risking spoiling your painting. If you decide on a dark colour aim to get the colour right first go, rather than building it up in layers. By doing this you are less likely to lose all the flecks of light, and this would

The dark background makes the orange glow.

make the colour look very heavy and overpowering.

The finished painting is wonderfully dramatic and colourful and really captures the essence of the calendula flower.

LOOSE CALENDULA

The second version of this subject is much looser and wetter in approach and because of this it is advisable to use a very heavyweight paper with a rough surface, minimum of 300gsm but preferably heavier. Stretch the paper or use paper that comes on a glued block so that the surface does not cockle as you work.

The same colours are used as in the previous piece and once again should be put out on as large a mixing palette as you can find. An even larger brush is useful, a size 14 plus, or a really big Chinese brush that will hold lots of pigment but still come to a good point.

Working flat, wet the paper to begin with in roughly the shape of the flower, leaving areas of dry paper and then drop in the yellow paint. Drag the paint out with the brush so that you are leaving marks that are something like the petal shape with-

out being too distinct. The paint will run everywhere but do not worry about that at this stage. Work in some of the darker colour and again do not worry that it runs together with the first colours. Make sure that some white areas are left showing and, if the paint seems to be about to cover the whole sheet of paper, blot back some of it with a paper towel.

Leave it to dry. Drying may take some time but do not be tempted to rush it by using a hair dryer as this will move the paint, stir it together and consequently you will lose some of the interesting effects. Some parts may have produced what are called 'cauliflowers' which are not to everyone's taste but again do not fiddle with it at this point. There will be lots of time for adjustments and alterations at later stages.

When the paint is dry or very nearly dry start putting in the next layer of petals. Although this is a loose painting using very fluid paint you do not have to rush it by working faster than you feel comfortable with. You can be quite considered with your brush marks and lay them in thoughtfully making each mark count. Once again the colour is deeper on the left-hand side and the petals there are less defined. The yellow on the right needs more orange in it and the edges of the petals are suggested with more overlapping brush strokes.

Wet into wet start.

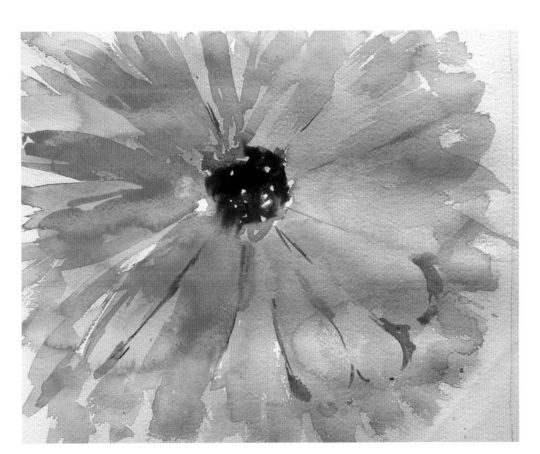

More colour plus the centre added.

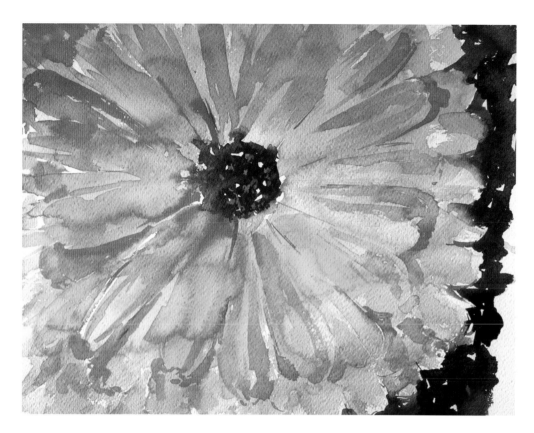

The dark background sets off the brilliant colours and makes the painting glow.

Stand back from the painting frequently so that you can assess its progress but do not be tempted to prop it up before it is properly dry or your hard work will end up at the bottom of the paper.

Now take a slightly smaller brush with a good point and use it to draw in some detail. Look for the lines and edges created by the overlapping petals and where there are cast shadows. Using shades that are a level or two deeper than the areas you are about to work on, put in small amounts of detail a little at a time. If you put in too much detail you will lose the lovely loose feel of the painting. Should any part become too tight this can be easily remedied by taking a damp brush and softening the lines and the edges. You can also wet and blot out areas if they have gone too far too fast.

The dark centre is put in using a mixture of Carmine, Indigo and Indian Yellow. Wet the centre and drop the colour in so that it flows unevenly and leaves specks of white. Let some of the colour run into the petals on the darker side of the flower so you have a variety of marks around the outside of the centre. Carry on building up the layers of petals and the shadows.

The final part is the small amount of dark background. With this composition a mixture of Indigo and Carmine is used. The Indigo is put in first and the Carmine dropped into it while it is still wet. Soften some of the edges of the petals, allowing the colours to run together to give a blurred and indistinct edge in some places.

Let the whole painting dry and then decide whether it needs any more definition in the petals or further detail in the centre. Do not put in any more fiddly bits unless you are absolutely sure that the painting needs it. It is better to wait a day or two before adding any last touches rather than making it too tight by going back in too quickly.

The finished painting has a fluid drama with brilliant, luminous colour, which really stands out well.

COSMOS

The next painting is again a close up of a flower, this time a cosmos (or Mexican aster) called 'Seashells'. Oil paints are used, which give a different result again from the previous two paintings. American artist Georgia O'Keeffe (1887–1986) did a number of large-scale paintings of close ups of flowers which are very dramatic and well worth looking up.

A white primed board is used with the following Alkyd oil colours: Permanent Rose, Cadmium Yellow Deep, Winsor Yellow, Titanium White and French Ultramarine Blue.

The flower petals have an edge of strong pink colour, which gently dissolves into pale pink and then to white. The outline is drawn onto the white board with a small, well-pointed brush and the colour is then pulled out with another brush dipped into a little white spirit. The paint will flow and run, somewhat like watercolour, and if it goes too far it can be blotted back with

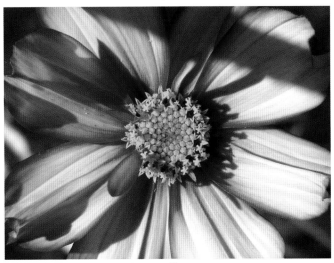

Cosmos flower.

Outlines drawn in with a brush.

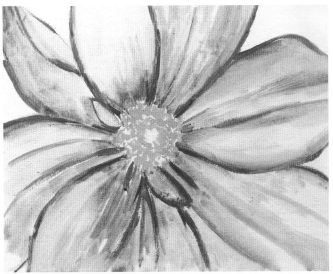

Pinks and mauves added.

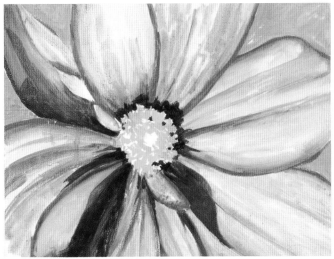

Shadows and some background go in next.

some rag or a paper towel.

The centre of the flower is made up of star-like forms, which hold the pollen. The outer part is a deep yellow, which changes to a sharp green as it goes towards the centre. Indian Yellow is used for the outer edge, mixed with a little Winsor Yellow where it is lighter, and small brush marks are used to indicate the broken surface.

When the drawing of the petals, with their softened edges, is complete the painting is left to dry. By using Alkyd paints the waiting time is much shorter than with standard oil paints.

The petals are built up using very subtly-changing shades of pink. There are delicate lines running through the petals from the centre and these are just suggested at this stage. The pink edging looks very much like a simple outline to begin with but when observed closely lots of slight variations of colour and width can be seen. Some of the edges need to be made stronger and other parts softer, gently fading them into their surroundings. A good way of achieving this is to take a small soft brush and mix lots of small quantities of different shades of pink through to delicate mauves on your palette, which are then ready to pick up and use immediately. Have a number of brushes on the go at once if you have them as it helps to keep the colours separate. Then, looking carefully at each section, paint what you see there. Because the painting is only of the flowerhead it is important to get the intricate subtleties of the bloom in order to make the painting worth more than a single glance.

Shadows play a significant part in the composition because they indicate where things are in relation to each other. Shadows also indicate the form, or shape, of the petals and can make the whole image stand out from the board and look three-dimensional. The shadows are quite blue in some places and more mauve or violet in others and also vary considerably in

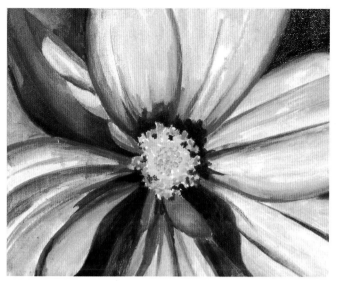

More shadows and a darker background give some dramatic contrasts.

Snowdrops.

intensity. It is important to use your observational skills to see and put down these finer points.

Some colour is put into the small amount of background that is visible. A warm yellow is used to begin with, which is then darkened in parts as the painting progresses.

When you feel that the painting is almost finished set it to one side for a while and then look at it with a fresh eye. Ask yourself the following questions: does the flower make a pleasing shape on the board? Do the edges of the petals stand out enough without looking too harsh? Is there enough subtlety in the variation of colour? Do any of the shadows need to be made darker or lighter and are they describing the form of the flower?

Remedy any areas that need it. If some parts of the painting need only a very delicate change of colour, using a glaze can work well. The painting must be dry to begin with, then thin layers of transparent colours can be applied and wiped back to leave a very slight change in shade where needed. These thin layers can continue to be built up until the desired result has been achieved.

The finished painting stands out well, looks three-dimensional but not too obvious in colour or handling.

EARLY SNOWDROPS

This small study was made from some snowdrops that had the courage to show their heads above the snow in the late winter. It was a heart-warming sight and an indication that spring was on its way. It was very quickly and simply painted with the minimum of colour. The leaves were put in first using Sap Green

mixed with French Ultramarine; they are almost a single brushstroke each. A little variation of colour was added for interest with Yellow Ochre on some of the tips and a touch of Winsor Yellow down the sides of one or two leaves. The flowers were drawn lightly to get their positions right and then indicated with a very pale green or blue. The stems were the same green as the leaves but with some Indian Yellow added. Finally some colour was put into the snow in shades of blue and mauve, which helped to show up the delicate white blooms. It makes a charming study.

WISTERIA

Wisteria in full bloom is a lovely sight and the scent is delicious. The plant can live for many years and as it grows it develops an interesting trunk, which twists around itself for support, and creates an almost sculptural effect. This in itself can make an excellent subject for a painting and would lend itself to a slightly abstract approach.

In this next project it is the detail of the blossom that takes centre stage along with some of the long sweeping stems, which give an added structure to the composition. It was decided that a very loose approach would be the most appropriate for this painting, keeping the fresh blowy feel of the long racemes moving in the breeze.

As quite a lot of water is going to be used it is advisable either to stretch some paper or use a glued pad, the latter being much the easier option.

A few pencil lines are put in to place the blooms and get a

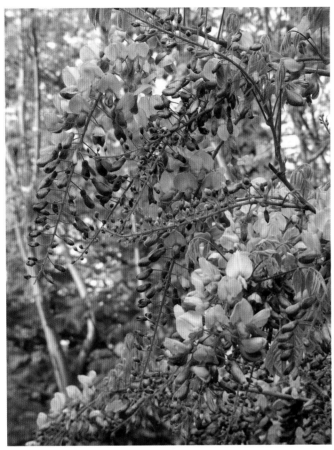

Wisteria.

Flowers are loosely suggested.

Bright spring green is used for the background.

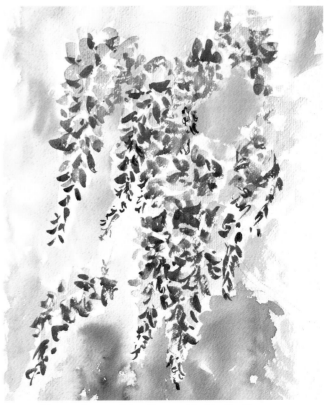

More colour and detail are added to the flowers.

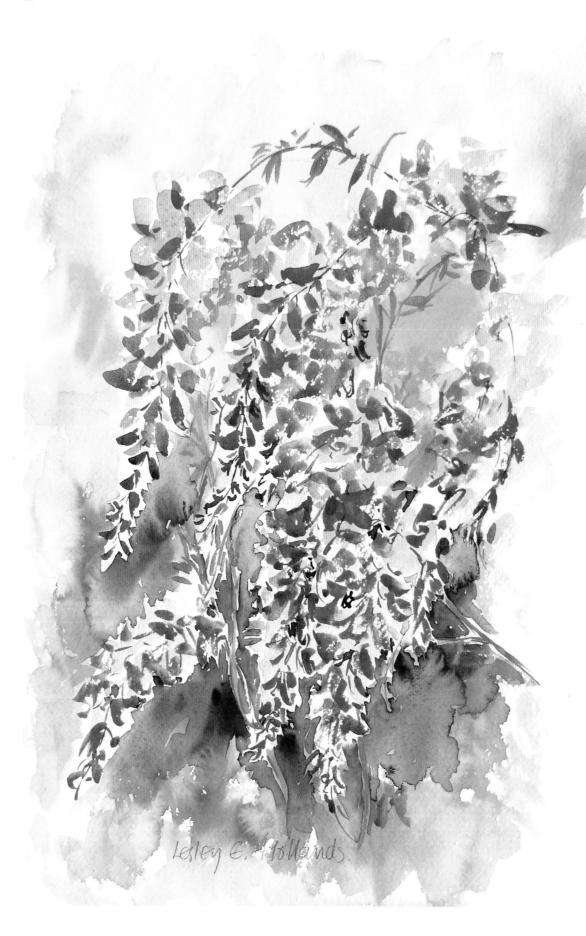

The finished painting full of fresh spring colour.

rough idea of the layout and composition. No detail is needed at this stage and in fact if it were drawn out too completely then the tendency would be to fill in the drawing rather than let the paint flow freely.

A glued pad of Fabriano Artistico Rough 300gsm was used with the following watercolours: Permanent Rose, Winsor Yellow, Naples Yellow, Yellow Ochre, Cobalt Blue, French Ultramarine, Ultramarine Violet and Sap Green. A number 14 brush with a good point was used for the whole painting.

Once the few guide lines have been put in with a pencil the first broken wash of the lightest blossom colour is dragged across the main areas of the flowers. To get a broken wash use the side of your brush rather than the tip. Practise on a spare piece of paper if you are feeling less than confident. The rough surface of the paper will also help achieve the uneven wash that you are aiming for. Vary your colour a little to give added interest and leave plenty of spaces within the areas of wash to allow for the green background to go in later.

A background has not been put in first with this composition because it is important to keep the lovely clear purple shades of the flowers. Purple going over a green background would go brown and lose its freshness.

Once the first stage of the flowers is dry some bright yellowy green is mixed to go in the background. To begin with the wash is put around the flowers, leaving some extra space to allow for expansion of the blooms and the suggestion of more flowers in the background. There are two ways of doing this, both of which need the paper you are working on to be laid flat. One method is to use wet paint and drag it around the areas where you want it, keeping a paper towel handy to blot back any parts that have gone too far. This method can give you hard edges, which will need to be softened with a damp brush before they have dried. The other method, which is probably easier, is to wet the areas where you want the paint to go with clean water and then drop your paint into this. The paint will only run as far as the edge of the wetted area and you can then manipulate the edges by dragging them out with your paintbrush or blotting them back with a paper towel. A combination of soft and hard edges is needed here, with soft edges receding and hard edges coming towards you. This combination will give a sense of depth to your painting.

The next stage is to build up the colour on the flowers without making them look too solid. Wisteria is related to the pea family (its Latin name is *Leguminosae*) so the flowers have a distinct resemblance to pea flowers with the characteristic fan shaped upper petal and slipper-like lower section. The lower part of the flower is darker than the upper and the more tightly closed the flower the darker the colour. On this particular wisteria the colour of the buds is much redder than even the partially opened flowers. Manipulating the brush by pressing

down to give a broader stroke and lifting up to give a narrower one works well here. Vary the colour and make the marks more precise where there are tight buds. In this way you are introducing subtle variations throughout the painting and giving a greater feeling of depth and movement.

The final part of the painting is to introduce a greater degree of contrast by putting some much darker colour into the background and some suggestion of the stems and branches of the plant to add structure.

The green is a deeper shade lower down and this colour is achieved by mixing French Ultramarine with Sap Green. Small areas of dark are carefully painted between some of the flower heads, which gives the mauve a greater vibrancy. As you move up the painting add more Sap Green to your mixture and finally some Winsor Yellow. There should be no hard edges between each shade so be ready with a clean brush to soften any areas that need it.

The branches are painted in with a mixture of Naples Yellow and Yellow Ochre, with a touch of red added to warm the colour slightly. Naples Yellow is a more opaque pigment, which enables you to paint over the background. The stems and branches snake through the composition, joining the flowers up and giving a lovely sense of movement. A few of the new leaves are indicated with single brush strokes using the same colour as the stems, which add the finishing touch.

The finished painting captures the movement of the long heads of the wisteria flowers and gives a real sense of a warm spring day.

DANDELIONS AND DAISIES

This little painting was suggested when lying on the grass on a summer's day and noticing these rather unassuming little flowers close at hand. The group of daisies with the bright yellow of the dandelions growing near to them made a very cheerful composition and one that might easily be overlooked. The lawn is made up of a wide variety of plants so there were lots of different leaf shapes and colours; one of the few times when a weedy lawn could be considered an advantage.

The white daisies were quickly sketched in first so that the white shapes were not lost. The composition seemed to need an extra something in the top left to balance it so another dandelion was added, which took the yellow from the row in the front through the painting.

A small piece of Bockingford paper 300gsm was used for this painting with the following watercolours: Indian Yellow, Winsor Yellow, Sap Green, French Ultramarine, Crimson and Titanium White.

Dandelions and daisies.

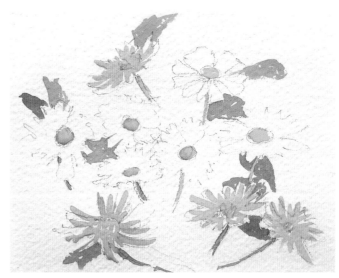

The flowers are set out on the page.

Background leaves give the flowers more definition.

More detail in the background completes the painting.

The warm yellow of the dandelions' petals was put in first, followed by the cooler yellow of the centres of the daisies, which also needed a touch of green around the outside edge of the centre. Some of the lighter greens in the foliage were also put in at this stage using brush marks that resembled the various leaf shapes. The dandelions have red stems, which are painted using a mixture of Carmine and Sap Green.

More details are added into the growth around the flowers, again using a range of greens and suggesting the leaf shapes without being too fussy about being exact.

The next stage is to put the very dark greens in plus the shades of brown from the weeds just going over. By placing the darks thoughtfully you can use them to make the flowers stand out more where you want this.

The painting was then put to one side for a while and on returning to it some final adjustments were made. On looking at it from a distance the browns in the background were standing out too much so these were toned down and made into deep greens in places. The shapes of the daisies had got lost slightly so Titanium White, which is a very opaque watercolour, was used to redraw some of the petals.

The finished painting, although it is little more than a quick sketch, has a charming simplicity about it, which goes to show that even the humblest of plants can make useful subject matter.

VIEW THROUGH A GRAPE-VINE IN LATE SPRING

While sitting under the grape-vine one beautiful, bright, late spring day, with the sun shining through the early leaves, the following composition suggested itself. The sky was a brilliant

Vine leaves in the sun.

The sky is washed in on top of the drawing.

blue and the leaves were the acidic green of early growth. Where the leaves overlapped, dense areas of shadows were formed creating all sorts of interesting shapes. The main stems of the vine made a strong network of overlapping lines giving a structure to the composition and contrasting well with the leaves. Some of the spiralling tendrils were visible, which gave another sort of interesting shape. The main colour of the composition was green, which, without another colour to relieve it, could be monotonous. Fortunately some of the leaf stems had a distinctly red tinge to them, which was all that was needed to bring the colours to life.

A rough watercolour paper was used for this painting so that some texture could be achieved particularly with the first wash. Fabriano Artistico 300gsm paper with the following colours was chosen: Cobalt Blue, French Ultramarine, Indigo, Sap Green, Hooker's Green Deep, Winsor Yellow, Cadmium Yellow, Winsor Red and Burnt Umber.

The leaves were drawn out first along with the main stems. This was done so that some areas of leaf could be left unpainted when the first wash was applied in order for a very bright, light green to be achieved. Cobalt Blue with a touch of French Ultramarine was used for the sky. French Ultramarine granulates to give an interesting but not too intrusive texture when mixed with the Cobalt. A completely flat wash could have been used here but by varying it slightly a suggestion of movement and light cloud in the sky was achieved without it being overpowering. Areas of leaf were left either uncovered or with a very light wash.

When the blue was dry the first brilliant shade of green for the lightest areas was painted in. Sap Green and Winsor Yellow make a very acidic colour, which works well. While this first layer of green is still damp a second layer is washed in over new areas of the painting plus some of the bright green. Thus with just

The first leaves are painted with a range of greens and yellows.

More darks are added.

The stems complete the painting and give some structure with their straight lines.

two layers of colour plus the blue a range of greens can be created. By putting on the next layer before the first is completely dry a softer effect is achieved. Some parts can be made more definite later if that seems appropriate.

The next stage gives greater definition and depth to the composition by adding in the darker leaves. A number of leaves are overlapping and strange, half-leaf shapes are created against the light. French Ultramarine and Burnt Umber are mixed with either Sap or Hooker's Green to give a really intense colour and this is used carefully to show these interesting shapes. The darkest areas are to the left and bottom of the composition. By concentrating the depth of shadow here, this enhances the feeling of the sun shining through the leaves and the fact that you are looking up towards the light.

The thinner stems connecting the leaves to the branches have quite a lot of red in them. These small lines of red are very important in the painting as they relieve the green and add touches of warmth to what would otherwise be a very cool composition. If you have painted over an area where the red is to go then mix Cadmium Yellow with Winsor Red; this will give you an opaque colour, which will block out pretty much anything that is underneath. The cadmium colours are all very opaque and need to be used with care as they block out all the light from your paper; because of this, although the colour can be strong and bright, it also has a certain deadness to it.

The dark stems, which will give contrast and structure to the painting, are put in next. The stems and branches are a dark brown with hints of green in them. A mixture of Burnt Umber and French Ultramarine gives a lovely rich brown which can be made lighter by adding yellow, or turned into a different shade of brown by adding green. There is light and shade on the branches, which needs to be suggested and the surface is slightly rough and uneven. The textured surface can be suggested by using quite a dry brush and dragging the paint so that it catches the surface of the paper. By running a darker shade in for the shadow, before the first line of paint is quite dry, a rounded appearance to the branches can be achieved.

At this stage it is a good idea to step back from the painting, preferably leaving it for a while before going back to put in the finishing touches. On later assessing the painting it was decided that the bottom left-hand corner was not dark enough and the stems passing behind the leaves should be shown by putting in some darker green lines. The spiralling tendrils also needed to be painted in and a little more red put onto some of the stems.

The finished painting is quite simple in many ways but gives a pleasing suggestion of the sun shining through the young leaves.

A GROUP OF COSMOS

This group of cosmos (also known as Mexican asters) with their feathery leaves were seen, lit up by the sun against the dark of a conifer hedge. The dark shadow of the background accentuated their delicate colour and the apparent fragility of their blooms. Cosmos are a lovely summer flower to have in the garden; they are very accommodating, easy to grow and will flower for months just as long as they are dead-headed. They come in all sorts of colours and different heights so it is simple to find one to suit your garden.

COSMOS IN WATERCOLOUR

This photograph is used twice to give two very different paintings. The first is a watercolour, worked in a fairly free way with a slightly unusual composition in as much as it does not use all that is there or the whole sheet of paper. (The second, described later, is in oils.)

Fabriano Artistico 300gsm has been used for this piece with the following watercolours: Permanent Rose, Cobalt Blue, Indigo, Sap Green, Indian Yellow, Winsor Yellow and Cadmium Yellow.

The delicate flowers are put in first, using the minimum of colour and very loose brush marks to indicate where the flowers are. The flowers appear as different sizes, partly due to perspective but also to the angle that each flower is seen at. The colour on the nearest blooms is slightly stronger than on those further back, which helps with the tonal recession; the distant flowers have more blue on them which, being a cooler colour, helps as well.

The foliage is very feathery and a bright, sharp green. Fine brush strokes with a green made from a mixture of Winsor Yellow and Sap Green are used to indicate the leaves. The marks are crossed and go in all directions to give a lively delicate effect. There are some parts that have a warmer colour and Indian Yellow is used here, again with fine feathery marks.

To further break up the foliage area some of the darks are put in next. Mixed together, Indigo and Sap Green make a lovely rich colour which works well here. Small marks are put in among the bright greens and yellows with a darker colour further back in the composition. The dark colour will show up the

Cosmos in the sunshine.

The flowers are delicately but loosely painted.

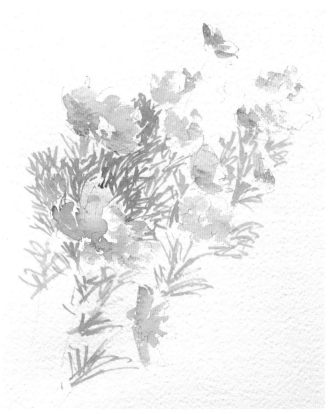

Feathery leaves are added.

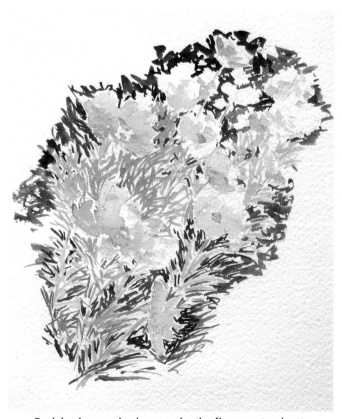

Dark background colours make the flowers stand out.

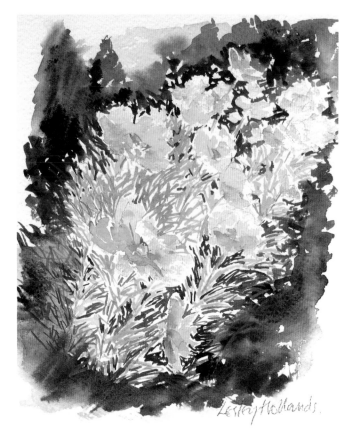

A suggestion of distant trees and some more dark greens
complete the painting.

light flowers, so needs to be painted in with care. A bit of extra space around each bloom is a useful thing to have; too much space can easily be removed later, but putting white back in is far more difficult.

Stand back from your work now and assess the overall composition and the shape that the painting makes on the paper. At this stage it looks almost like a bunch of flowers rather than a group of flowers growing in the open. To correct this, more dark needs to be put in all around using washes of colour, rather than the small marks previously used for the foliage. A suggestion of sky is put in at the top using Cobalt Blue and a hint of tree shapes in the distance helps to give depth to the composition without being too intrusive.

The foliage now needs to be taken out and over some of the dark green on both sides; Cadmium Yellow is used for this as it is so opaque and covers pretty much anything. The finishing touch is to put a little more colour on the flowers with some more Permanent Rose on the foreground blooms and a little Cobalt Blue on the distant ones.

The finished painting is unusual in its design but captures the delicacy of the flowers without being wishy-washy.

COSMOS IN OIL

The next painting, which uses the same photograph as a starting point, is quite different in a number of ways; it is painted in oils, the colour is built up in glazes from dark to light to begin with and the lights are painted in with opaque colour when the composition is nearly complete.

A white oil-painting board is used with the following Alkyd oil colours: Permanent Rose, Cobalt Blue, Cerulean Blue, Sap Green, Winsor Yellow, Indian Yellow and Indigo.

The broad areas of light and shade are washed across the board leaving some small flecks of the white board showing. The edges of the light yellow area in the middle of the composition are deliberately left uneven and broken up. By doing this the next stage, when the two colours are overlapped and linked together more, is easier to accomplish. Some small patches of Cobalt Blue are painted in where the sky is seen through the trees in the distance.

There is no real detail at this stage and the whole painting is just a very general impression of what can be seen in the photograph.

The painting is now left to dry fully before the next stage.

The feathery foliage is an important part of the composition as it helps to give the flowers the feeling of delicacy and fragility that is so necessary to the success of the painting. A brush that comes to a good point is vital; one of the synthetic sables can work well and is inexpensive. The fine lines of the foliage are drawn across the yellow area in the centre of the composition and the surrounding darker green parts. The marks cross over each other and vary in tone and colour, ranging from light to dark green and light to dark yellow. By varying the colours and tones a feeling of dappled sunlight is suggested.

The sky has more light blue added to it with small broken brush marks and the trees in the distance are bulked up with more light and shade and suggestion of shape. The painting is still very fluid at this stage, with things implied rather than spelt out.

Once again the painting is left to dry completely.

If you are happy with the work on the leaves and background and feel that the paint is implying enough then go on to the flowers. Once again the blooms are going to be suggested rather than precisely defined. The flowers are shades of pink, and Permanent Rose works well here, either full strength, diluted or with white added. The shadows on the flowers are delicate shades of blue, violet or mauve. Look for the general shape of the petals and the spaces between the petals and the different flower heads. Using quite thick paint and deliberate brush marks, start placing the flowers in the composition. The flowers further back appear smaller and tend to be more in shadow. The foreground blooms have stronger colour and just a little bit more detail on them and are larger.

By getting the colour and size right you will be using perspective and tonal recession to give the composition a feeling of depth and distance.

The background greens are sketched in first.

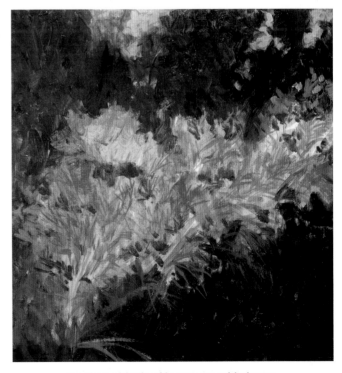

Feathery details of leaves are added next.

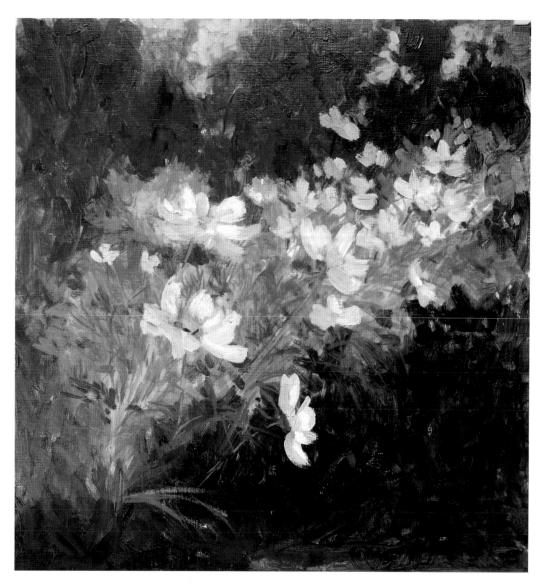

Flowers are painted on top in a range of delicate pinks.

At this stage it is better to put too little rather than too much into the flowers. Over-painting will make them appear heavy rather than delicate blossoms blowing in the summer breeze. When you feel the painting is nearly complete, prop it up and leave it for a while before assessing the general effect and whether any more needs to be done.

Here it was decided that some even stronger colour in the foreground flowers would be useful together with some more yellow in their centres. The left-hand side seemed slightly empty so a couple more small blooms were tucked in and finally one or two more stems were added.

The finished composition has a freshness and delicacy that is very pleasing. Even with the strong dark colours, the painting does not seem heavy and the flowers could almost be swaying in the wind.

MUSHROOMS

This group of mushrooms was seen growing on a friend's lawn and a number of photographs were taken from differing viewpoints. The chosen photograph was selected because the low angle gave a more intimate view and a stronger composition with only the four mushrooms on view. The long blades of grass gave an added dimension and the contrast of the straight stems worked well against the rounded caps of the fungi. This is a simple composition, painted on a small scale, which did not take long to complete; it was more a capturing of a moment than a weighty piece of work.

The mushrooms have an interesting shape so were drawn in with a pencil first of all.

An offcut from a larger sheet of Bockingford 300gsm paper was used with the following watercolours: Yellow Ochre, Carmine, Sap Green, French Ultramarine, Winsor Yellow, Indian

Mushrooms in the grass.

Delicate shades of brown are used for the caps.

Greens are put in with a broken wash.

Stems and darker green go in next.

Yellow and Indigo.

A wash of a warm honey brown, mixed from Yellow Ochre and Carmine, was painted onto the caps of the mushrooms, starting at the top where the colour is deepest and dragging the paint down so it became gradually lighter. Where the undersides of the mushrooms are seen, the colour is darker with a hint of blue since they are in shadow and are picking up some reflected green from the grass.

A broken wash of bright green, dragged horizontally across the page, goes in next with a band of darker green softly blending into the lighter, representing some distant trees at the top. When the paint is dry another more broken wash of darker green is applied with some of the brush marks going vertically as well as horizontally. The stems of the mushrooms are darkened and made to look rounded with a hint of shadow down

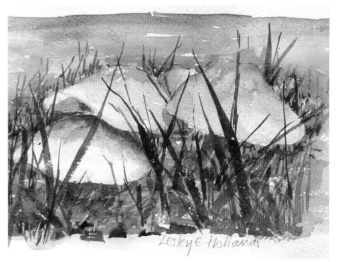

Grass growing in front of the mushrooms connects them to their surroundings.

one side.

The blades of grass go in next using different widths of brush stroke and varying shades of green and a reddish brown. The brown in some of the grass stems connects the colour of the surroundings with the warm shade of the mushrooms and makes the composition more interesting. One or two areas of dark are pushed in under the fungi giving an impression of soil showing and shadows cast.

This is a simple painting, but fun to do.

ROSE HIPS

Rosa rugosa is a beautiful rose and very tolerant of its situation and degree of neglect. It flowers freely throughout the summer with lots of richly scented blooms and in the autumn large,

deep red hips are produced, which make a welcome splash of colour during the winter months. Its only drawback is that it is very prickly but this can be an advantage if it is used as a hedge to keep things out of the garden.

A small group of hips was chosen for this next painting viewed from low down so that some sky was seen behind. It was a sunny day so there were some useful strong shadows and clear highlights on the glossy surfaces of the rose hips.

A small, white primed canvas was used for the painting with the following oil colours: Cobalt Blue, French Ultramarine, Cadmium Red Deep, Winsor Yellow, Indian Yellow, Sap Green and Titanium White.

The bright red of the hips was sketched in first with some Cobalt Blue mixed with white for the background. The blue was deliberately varied in tone to give, even at this early stage, the suggestion that there were other things growing beyond the rose bush. There were some interesting effects of light and

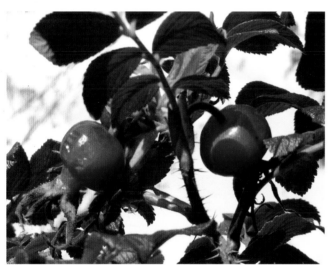

Rosa rugosa hips.

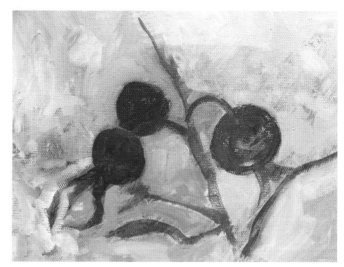

A blue background is scumbled on and the hips painted on top.

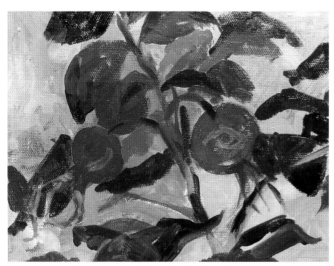

Leaves are built up in shades of green.

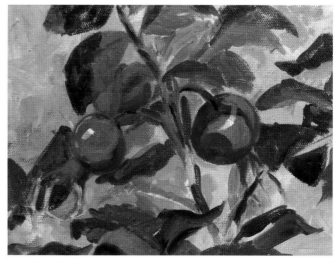

The hips are made to look round and glossy with the addition of shadows and highlights.

shade on the stems and leaves of the rose as well as curved shadows and highlights on the hips. These were roughly painted in using Sap Green mixed with either Winsor Yellow or French Ultramarine. The painting is kept quite loose and free at this stage with no real detail yet.

More shadow and structure is added to the leaves, and the curved shadow on the hips, which help to show their beautifully rounded shape, is painted in. The colour of the shadow is a deep red made by mixing Cadmium Red Deep with French Ultramarine Blue. There are also some lighter patches of orange on the hips, which are also painted in now.

More colour is added into the background using blue and white with a little deep red added to give a slightly purple tinge. A little detail is added to the leaves with a suggestion of light and shade along with some more yellows and greens going onto the stems.

The final touch is the highlight on the hips. It is very easy to overdo this by making the highlight too white and too large, which makes it look as though it is stuck on rather than being the natural sheen of the skin. A brush mark of a pink shade is applied first, making it curved to follow the surface of the hip. When this has dried a little, or if you cannot wait, then with a very steady hand place a small mark of white on top. If it looks too stark gently pull out the edges to soften it and blend it in with the pink shade.

Now leave it for a while before deciding whether the rose hips stand out enough and look rounded and whether the background needs any more in it to suggest foliage, as well as sky beyond the rose.

This is a relatively simple composition but has enough variety of colour and suggestion of depth to give it interest.

WATERING CANS

These two watering cans were sitting under a tap against an old brick wall in one of the gardens at Sissinghurst. They made a pleasing group with the cool grey of the metal contrasting nicely with the warm bricks and red flowers behind them. They were facing away from each other to begin with but the composition seemed to work better with them both facing the same way so they were moved before being photographed.

A small, white primed canvas was used for this painting with the following oil paints: Cerulean Blue, French Ultramarine, Indian Yellow, Yellow Ochre, Cadmium Red Deep, Hooker's Green Dark and Titanium White.

The canvas is left white so that small, unpainted light areas give a sparkle to the painting. The composition is drawn out first so that the line of the bricks and the shape of the watering cans

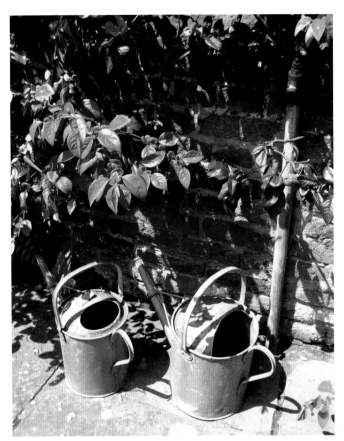

Watering cans at Sissinghurst.

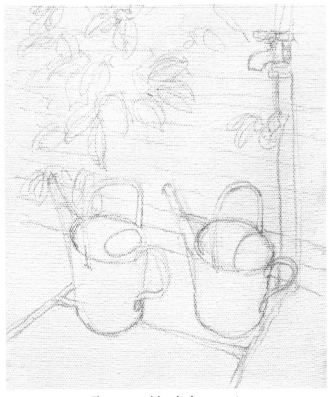

The composition is drawn out.

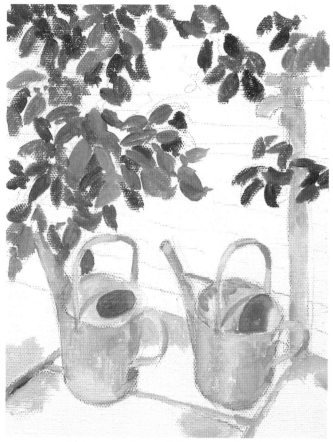

The cans and some foliage are painted.

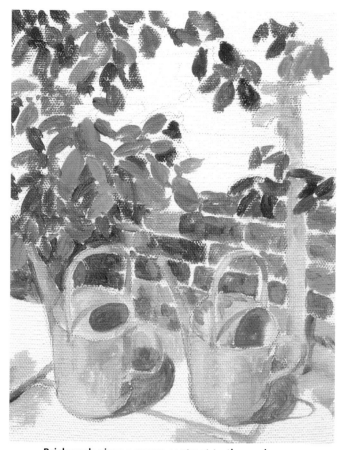

Brickwork gives a warm contrast to the cool greys.

can be put in correctly. The pipe with the tap connected to it was not very visible in the photograph but has been made more of a feature in the composition as it gives a reason for the watering cans to be there and also provides a useful contrasting straight vertical line.

The foliage is painted in first and as this is going to be quite a quick painting and there will not be time to allow layers of paint to dry, the brick wall behind the leaves is not put in at first because the red colour might blend in with the green, creating brown where it is not wanted. One brush mark can create the shape of an individual leaf, so the foliage can be painted in quite freely so long as a variety of colour is used and the leaves are different sizes and growing in different directions.

The watering cans and the water pipe go in next. The grey of the cans can be mixed from Cerulean Blue and Yellow Ochre. There are some areas of pale Yellow Ochre where the light is catching the metal at the front, which helps to make them look round. The subtle range of shades of grey and cream together with the dark shadowed interior makes the watering cans interesting to paint and enables them to stand well within the composition. There are some similar colours on the stone paving slabs and the metal water pipe, which helps to pull the compo-

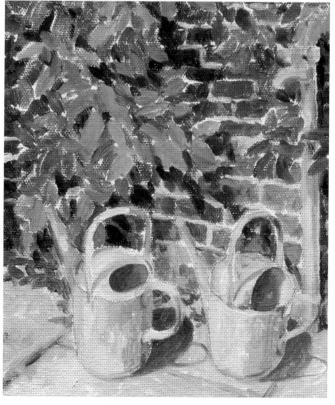

A simple but pleasing composition.

sition together. The shadow on the inside of the watering cans is mixed from French Ultramarine and Yellow Ochre. It is useful to note that the colour is slightly lighter nearer to the front of the opening, getting darker as it goes further in as this stops the shadowed interior from looking like an oval shape stuck on.

The bricks are a lovely range of shades of warm pink, red and orange and, where they are in shadow, almost purple. The mortar between the bricks is a creamy colour with slightly uneven lines. To begin with, the mortar is left as white canvas so that the cream colour can be used to adjust the size and shape of the bricks, if that is necessary, at a later stage. The bricks on the left are mostly in shadow so are generally darker and have less detail on them, whereas where the sun is catching them the colour is soft but warmer and brighter.

The stone paving slabs have quite a range of colours on them including a very soft pale pink, which picks up and links with the colour of the bricks rather nicely. Even the narrow spaces between the slabs have an array of shades in them, all of which help to make the painting more interesting.

The finishing touch is to put in any further shadows cast by the plant that are necessary plus a little more colour into some of the leaves where they need a little more definition.

The finished work has a quiet charm and shows that even the most humble of objects can make an interesting and attractive painting.

PINK AGAINST GREY

This painting is of a close-up of a seaside garden. The large pebbles were piled up and all sorts of plants, tolerant of salty sea breezes were grown among them. The brilliant pink of these *Lampranthus spectabilis* with their fleshy, succulent-type leaves looked magnificent against the grey and white of the stones.

The composition was sketched out first and a few alterations made to how it looked. In reality the pink flowers were clumped together on the right-hand side but it was felt that by putting in a few extra, looking as though they were growing further into and along the stones, the composition would be improved. Further along in the pile of rocks were a number of stones that had lines of a different colour running through them, making them look almost as though they had been tied up with string. As the garden was a private one it seemed wrong to reorganize it to include the more interesting pebbles so these were just added in on paper where it seemed appropriate.

Bockingford 300gsm Rough was used for this painting with the following watercolours: Permanent Rose, Sap Green, Indian Yellow, Naples Yellow, Winsor Yellow, Raw Sienna, French Ultramarine and Cobalt Blue.

Flowers by the sea.

Bright pinks and purples are painted in first.

Greens go in next.

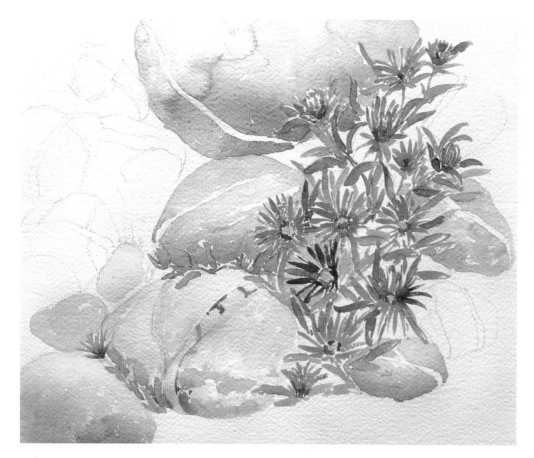

The stones range from yellow to grey.

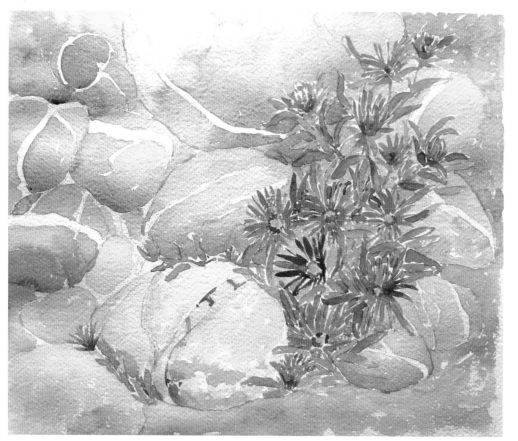

Shadows make the composition complete.

The flowers were painted in first as they are the most important part of the composition and need to be kept looking clean and brilliant in colour. Where the flowers were in shadow a little French Ultramarine was added to the Rose to darken it slightly. It is important to notice the variations in the flowers and the way that they face in different directions, overlap and are at various stages of growth from tight bud to fully out. By observing and using the variations you will make the painting more vibrant and interesting.

When the flower colours are dry the leaves are put in. The leaves are very rounded and fleshy and with a tangled growth that scrambles through the rocks, finding small amounts of water and nourishment; they are many shades of green and yellow. To make them look rounded a single brush mark is used for each one, with some brush strokes dragged to leave flecks of white and while others are given a second brush stroke, with a deeper colour, run down one side. Getting the subtle variety of colour as well as the different directions of growth is important if you are to capture that scrambling effect.

The stones are quite an array of colours, some quite a warm pink or yellow and some a cool grey. The lines running through them are usually a light-coloured material but even this has variety. The grey tones are mixed from combinations of Cobalt Blue and Raw Sienna. Naples Yellow can also make a pleasing soft grey but it is more opaque. The Cobalt granulates slightly, which helps to suggest the grainy surface of some of the stones. Look for the variety of colour in each stone rather than just painting it one shade as this adds to the subtle complexity of the work. It is important that the stones are interesting but not overpowering as they take up a lot of space in the composition. In front of the stones there was a flat area with very fine gravel or coarse sand and this is painted using Raw Sienna mixed with Cobalt for some parts and Permanent Rose for others.

The composition is coming together and the balance of pebbles, stones and plant works well, but the whole painting is very flat at this stage because there are no shadows. It was a brilliant sunny day and the shadows were clear cut and showed the shapes of the stones very plainly. There were also some dark shadows between the stones and behind the plant, which helped to make the flowers stand out. There is a range of colours in the shadows, which change depending on what colour stone they are falling on. Generally a shadow is a darker shade of whatever it is on. If you see shadows as purely grey, then try to see colour in them by asking yourself which shade of grey they appear to be, are they a warm pink or mauve tone or a cool blue or green shade. Here a blue/grey has been mixed from Cobalt and Raw Sienna or Naples Yellow, which gives a cool shadow. The warmer tones have been made by combining French Ultramarine with Carmine or Permanent Rose. Try out different shades on a spare piece of paper and hold them against the shadow that you are trying to match them to; this will help train your eye to see the colours that are there.

Some final touches of a deep blue/green are painted into the small spaces between the flowers and leaves, which give a useful contrast to the brilliant pink blooms, making them really glow and stand out.

The finished painting works on a number of levels: the hot pink of the flowers contrasts well with the cool colour in the stones; the spiky flowers and leaves stand out against the rounded rocks and the feel of the sprawling flowers and the piled up stones is pleasing and attractive.

HIDING AMONG THE HELLEBORES

These gnomes were discovered hiding in the grass of a garden in Christchurch along with twenty or so others. Some were barely recognizable as gnomes but others had achieved an interesting patina which made them a possible subject for a painting. To paint just the gnomes was not very inspiring but to place a gnome and a goose in among some hellebores, where they were partly hidden, added an amusing aspect to what would otherwise be a fairly standard flower painting. The gnomes were positioned so that they were mostly obscured by the hellebores and surrounding plants. This made the composition more about the flowers than the gnomes.

A sheet of primed oil painting paper was used with the following oil paints: French Ultramarine, Permanent Rose, Cadmium Red Deep, Hooker's Green Dark, Winsor Yellow and Titanium White.

Garden gnomes.

The group was drawn out first; making sure that the plants covered quite a lot of the gnomes but allowing enough of them to be seen for them to be recognizable as concrete statues. Extra flowers were added plus some buds to make a more interesting and full composition.

The hellebore flowers and buds were blocked in first using French Ultramarine mixed with Permanent Rose and white. The gnome was also roughly painted without much detail at this stage.

To give the impression of being low to the ground and looking up, some sky was painted in at the top of the group and a suggestion of foliage put in around and above the gnomes. The hellebore leaves were put in with more detail so that they looked nearer to the viewer. The goose had some light and shade added and its eye and beak painted in. The gnome's face also had detail added to it.

The centre of the hellebore has some interesting, hanging, pale yellow stamens which were added, giving more of a three-dimensional feel to the flowers. Stems and an extra bud, to break up the shape of the goose, were put in and the whole painting then was put to one side to assess its progress.

After leaving it for a while and looking at it with a fresh eye it was decided that the foliage was generally too dark and the flowers needed more detail in order to bring them forwards. The area behind the goose looked rather empty and a little flat.

More yellow was added to the leaves generally and the veining on the helleborus was emphasized with some green and darker purple. A suggestion of flowers growing behind the goose completed the composition.

The finished painting is not to be taken too seriously. It was a curiosity and a challenge, as much as anything, but it is good to try different things occasionally, even if you then decide that you never need to paint them again.

First stage blocked in.

More detail added.

An amusing composition.

Statue and reflection.

WATER

Water is probably one of the most difficult things to capture well in a painting. There are so many aspects to take into account, even when dealing with still water in a pond or lake. Not only do you have to paint what is floating on the water but also what is growing in the water, often partly submerged, as well as reflections of what is around the water. Then there are further challenges when attempting to reproduce moving water; ripples and reflections, light catching the movement of a current, weeds undulating in the flow and so on. There is a lot to take on board and one good way of tackling it is to make choices about what to include and what to leave out. Looking at how other painters have dealt with the problems can also help; Monet's *Water Lilies* is an obvious one, but there are many other artists whose work is well worth getting inspiration from. Have a look on the internet – there is an amazing array of paintings that include water.

The smaller compositions containing water in close-up can also make interesting paintings: a drop of water on a leaf can look stunning; a puddle with the reflection of its surroundings; a bird bath with or without an accompanying bird are all appealing subjects.

WATER LILY

If you have not tried painting water before this makes a good first subject because it is small and relatively simple. It was painted from a photograph since it was too hot to work outside on that particular day. Unfortunately one of the flowers was tipped on its side, which did not look very comfortable and the bud that was needed to replace it was on the other side of the pond. However, there is a lot you can do with artistic licence and some reorganization on paper.

The brilliant pink, fully open lily was the focal point of the painting but it needed something else to balance it, so the opening bud was drawn in on the left. The leaves were also slightly rearranged to improve the symmetry of the composition. Once the organization of the painting seemed right, the excess lines were rubbed out and the work started.

Fabriano Artistico Extra White Rough 300gsm was used for this piece with the following limited palette of watercolours: Permanent Rose, Hooker's Green Dark, French Ultramarine and

Water lilies.

The composition is drawn out.

Indian Yellow.

The lily was painted first, using pure Permanent Rose which was dragged up each petal so that the colour was graded from dark to light, bottom to top, with some small flecks of white paper left showing. Some petals were darker than others and a second layer of colour was added to these. The leaves went in next using Hooker's Green Dark mixed with Indian Yellow, which gives a good range of shades. Some of the edges were changing colour so a little Permanent Rose was added to the mixed green for these parts. Each leaf had quite a range of subtle colours on it which, as they form a relatively large part of the painting, was important not to miss. The centre of the flower was just showing the tips of its yellow stamens and these were painted with straight Indian Yellow.

In the photograph there were lots of reflections of the reeds that were growing out of sight around the edge of the pond and it is at this stage that a decision needs to be made as to how much, if any, of these reflections are to go in. Without them the painting might seem a little dull and with them it could equally become too fussy, so a delicate balance has to be reached. In a situation like this where there are choices to be made, the slow and steady method is the best. By doing a little at a time and reviewing the result it should be possible to avoid any serious mishaps.

The painting needs some darks in it to set off the colour in the flower and make the pink really sing out. There is a deep red reflection of the flower in the water immediately below it so this is painted in using Permanent Rose mixed with Hooker's Green. There are some deep shadows around some of the leaves, which are painted in using the same two colours but with a predominance of Hooker's Green. The painting is starting to look livelier with these contrasting colours and it is now time to tackle the water.

The water has quite a lot of blue in it but with some areas having a greener tinge. Very dilute French Ultramarine mixed with just a touch of Permanent Rose and Hooker's Green give a good shade for the mainly blue areas. The balance is tipped towards green by using dilute Hooker's Green with a very small amount of the other two colours for the remaining parts. The colour is washed across the leaves where they are under the water and the submerged edges blurred slightly. The paint is dragged in places, which leaves flecks of white paper suggesting the reflected light on the water.

Now the decision has to be made as to whether the reflections of the reeds are going to work or not.

Having put the painting to one side for a while and thought about it, the reeds seemed to be a necessary part of the composition. In order to prevent them from being too dominant, a lighter shade was used to paint them. A combination of Hooker's Green and French Ultramarine worked well and the reflections were taken across the leaves where they were submerged, which increased the illusion that they were under water. The

Pinks and greens make a pleasing combination.

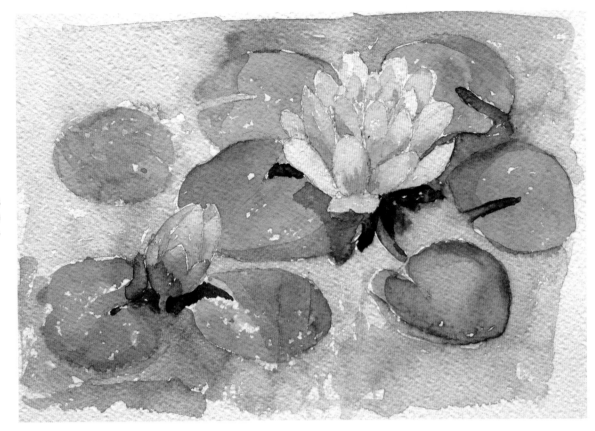

The shadows and reflections give the suggestion of water.

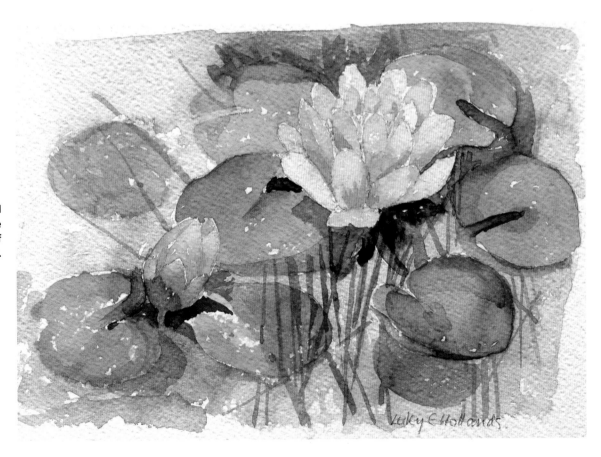

leaves themselves cast a reflection and the bud has a little red beneath it, which links with its other, darker shadow.

The reflections could possibly have been made darker but as the painting seemed to work as it was they were left as the paler shade. The finished painting is small but has a charm and simplicity that is pleasing.

BRIDGE AT WEST DEAN

This painting is of a charming rustic bridge built from local flint, which spans the stream in West Dean Gardens near Chichester in West Sussex. There are a number of bridges at West Dean, all of which are interesting but this one showed the clearest reflections in the water.

A small piece of Fabriano Artistico 300gsm was used for this painting with the following watercolours: Hooker's Green Dark, French Ultramarine, Indian Yellow and Permanent Rose.

The scene is sketched out first and the bridge is slightly simplified as it is a small painting and a lot of detail would have made it too busy. When the drawing has as much in as is needed to support the painting without it becoming a 'painting by numbers', the first washes of colour are added.

The bridge is painted in using a range of greys and soft greens with just the suggestion of the shapes of the flints that it is built from. Broad areas of green are put into the background and along the bank of the stream and behind the large beech tree growing on the left-hand side. Once these initial washes are dry then some of the reflections of the bridge are painted along with some more foliage suggested in the background. The whole painting is kept fairly loose at this stage.

The tree trunks are built up with shades of grey and olive green with an indication of light and shade and the remaining reflections are put in.

When all this is completely dry the water is going to be painted in. The colour for the water has to be transparent or else all the work that has been put in with the reflections will be covered over and lost. The water appears quite dark but there is a lot of variation in colour and tone. Hooker's Green mixed with French Ultramarine is used and a flat wash is laid across where the water is. This needs to be done with care and light horizontal strokes dragged across, leaving flecks of light and not disturbing the under painting too much. If it has got too dark then a damp brush to loosen the paint and a piece of tissue to blot back will correct this; alternatively white can be replaced by using Titanium White which is totally opaque.

The finishing touch here is to paint in some of the floating waterweed and add a little touch of red to the flowers just to lift the overall green of the composition.

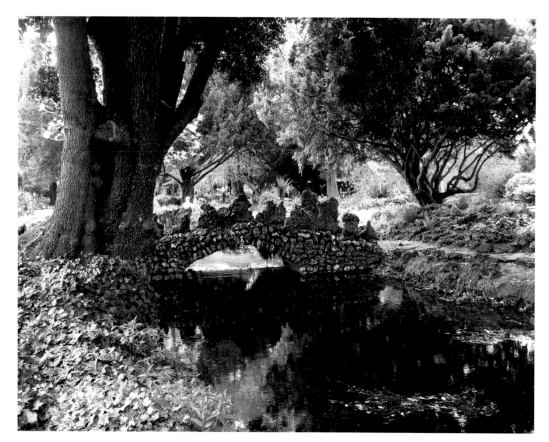

The stream at West Dean.

Background and bridge are painted in.

Trees and foliage are added with the reflection.

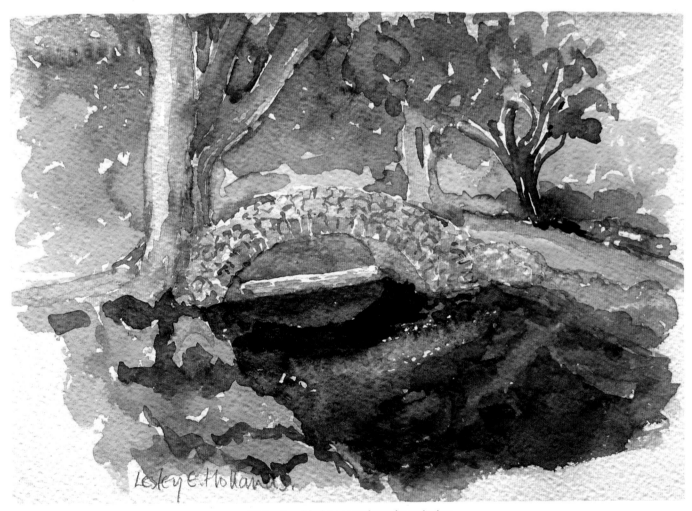

Water is added to complete the painting.

THE OLD MILL GARDENS

This next painting is going to tackle the water in a slightly different way. The millstream was flowing slowly and the surface of the water was rippled, distorting the reflection of the building. To get the appearance of the ripples, the water is going to be painted with small horizontal brush marks. The composition is drawn out first so that the building and the angle of the mill-race are right.

Fabriano Artistico Rough Extra White 300gsm was used with the following watercolours: French Ultramarine Blue, Indigo, Burnt Sienna, Burnt Umber, Hooker's Green Dark and Winsor Yellow.

The sky was painted in first with a broken wash using dilute French Ultramarine, which granulates nicely. If you are painting a sky behind a complicated shape like a building, then you may find it easier to turn the paper upside down and paint from the edge of the roof downwards; the paint will then flow away from the intricate shape and is less problematic to manipulate around the fiddly bits.

The dark windowpanes were put in using Indigo and a brush with a good point so that the white window frames could be left as unpainted paper.

The roof has a first, dry wash of Burnt Sienna dragged across, leaving quite a lot of white. The brush marks are dragged horizontally so that any lines that appear follow the lines of the tiles. The tiles are too small to need any real detail

but manipulating the paint in this way is just enough to give the impression that they are there. A second layer is applied, when the first is dry, of Burnt Umber mixed with a little blue to darken it. Again the brush marks are laid in horizontally.

The wooden weather boarding is stained black on the mill but is painted with Indigo as this is a more subtle colour and is not as overpowering as neat black. The strips of wood are painted with a fine brush in horizontal lines so any small gaps can represent the overlapping of the boards.

The surrounding foliage goes in next using shades of bright green and sharp yellow. These lighter colours will be built up and overlaid with deeper shades of green as the painting develops. The willow on the right-hand side has vertical lines of a mid-tone green, which will cover over the roof. Where there are spaces between the hanging branches of the willow, small flecks of tile colour are added. Below the willow is a small tree with some deep red blossom; this is tucked in partly behind the willow and partly across the mill, which gives a feeling of depth and breaks up the end of the building nicely.

There are a number of figures walking in the garden on the left-hand side but just two are put in to give a sense of scale to the composition. One is given a crimson jumper in order to carry the red from the tree on the right across the painting. Neither figure stands out too much; they are there to be discovered after the eye has been taken into the composition via the water, then the mill, followed by the surrounding greenery – and finally the people are noticed.

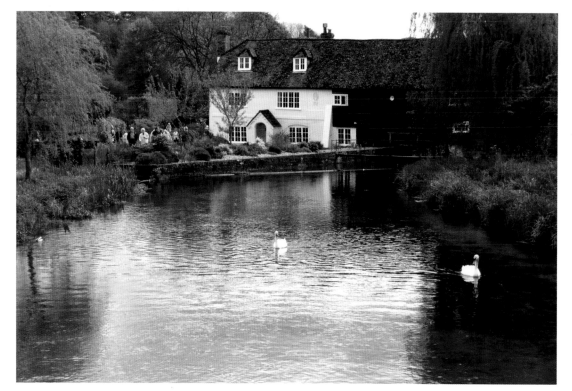

The old mill.

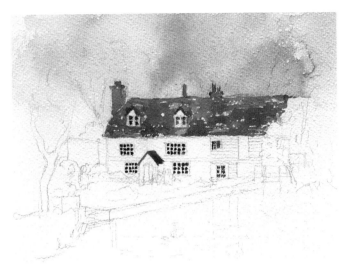

Sky and building are painted first.

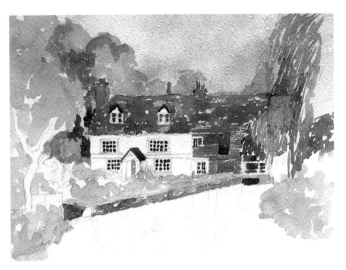

Surrounding garden goes in next.

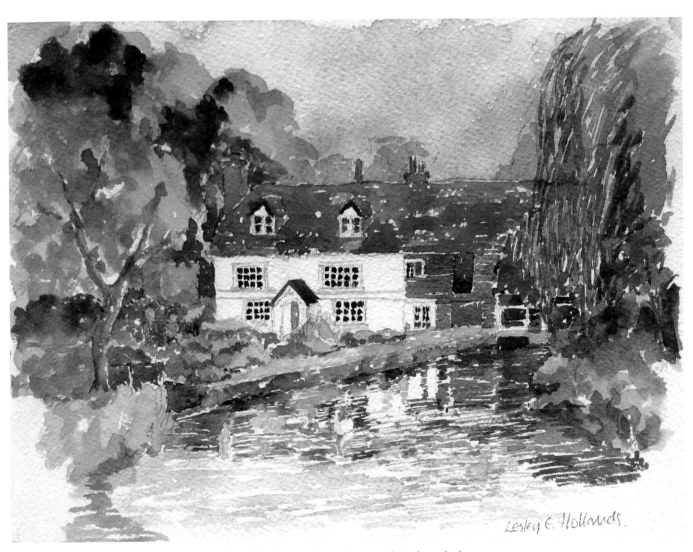

The reflections in the water complete the painting.

Darks are added to the growth around the mill and along the bank of the millrace, which help to define the building and the course of the water. When all the darks are in, plus some extra detail of light and shade on the tree on the left, the reflections can be put in.

Where the white building is reflected, the paper is going to be left unpainted, so it can help to put in some light pencil marks to act as guidelines so that these areas are not lost. Starting at the top, nearest to the building, the dark reflections of the wood are painted in using narrow horizontal lines. This part of the water is also in shadow so there is less light falling on the water and it is all generally deeper in tone. Working down the water, there are more colours where trees and other foliage are reflected. Where the roof is mirrored in the water there are more ripples so that the shape of the roof is largely lost and it is only the colour that shows it is there. The little bit of red from the

blossom on the trees on the right takes the colour through the painting, connecting with the figure on the other side.

There are two swans swimming on the water but only one is going to be put in to avoid the scene looking too much like a chocolate box. The swan is just suggested and can barely be seen so it is another element of the composition for the viewer to discover after looking at the painting for a while.

The final part of the reflection is the sky, which has shades of blue plus green and quite a lot of white where the ripples are. Once all is painted in, the composition needs to be assessed to make sure that the water looks like water with a reflection of the mill in it and the balance of colour, light and shade feel right. The finished painting has caught the feeling of the gently rippling water and the white of the mill creates a pleasing contrast with the dark trees behind.

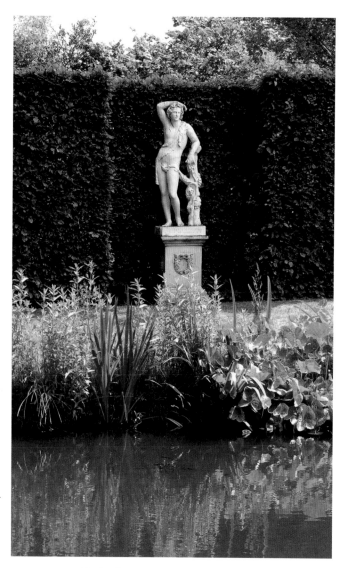

Sissinghurst statue with reflections.

The statue is outlined by the yew hedge.

STATUE AND REFLECTION

This next piece uses a wet into wet technique for painting the reflection in the water. This is a quick and simple way of creating a blurred reflection but the amount of water used and how wet the paper is when you drop in the colour needs to be well judged. A small piece of Bockingford Rough 300gsm was used with the following watercolours: Sap Green, Winsor Yellow, French Ultramarine, Indigo, Naples Yellow and Burnt Umber.

The statue is lightly drawn out with very little detail, as this is going to be a rather impressionistic painting.

A dark green is mixed from a combination of Sap Green and Indigo and this is painted in immediately behind the statue, which defines its shape beautifully. The leaf growth of the hedge is generally horizontal so the brush marks are made to follow this direction with spaces left for some lighter colour.

The statue is a very pale honey-coloured stone with a hint of green where moss has started to grow. Dilute Naples Yellow works well with the addition of a little blue for shadows and the mossy bits.

The sky is painted with dilute Ultramarine and the flat foreground grass is washed in using Sap Green mixed with Winsor Yellow. Some of the sharper green areas in and above the hedge are also painted with this colour while still leaving small patches of white paper. The remaining darks in the hedge are painted, then the bank along the edge of the water. Here some browns and more sludgy greens are added, using Burnt Umber mixed with Sap Green.

A little detail with the upright leaves of the water plants brings the edge of the riverbank into focus and gives a feeling of depth to the composition.

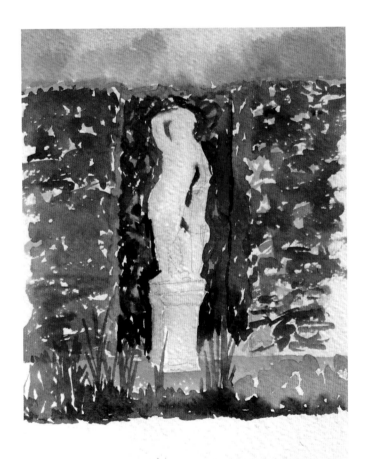

Detail is added to the statue and its surroundings.

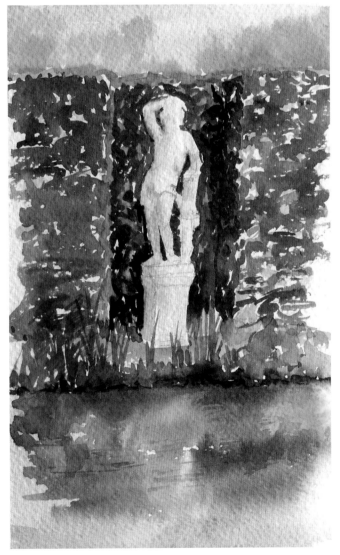

A watery reflection is added.

When everything is painted, the river can be started. A wash of clean water is run across the front of the painting and when it is still damp but not sodden the colours of the statue and surrounding greenery are dropped in. Do not forget that there is foreshortening in the reflection, which is what makes it look as though the statue is going down into the water and not resting on top. The colour will run so keep the paper flat. As the colours dry they will become lighter so another layer of paint may be needed to give a little extra definition in places. There are some ripples on the water, which was very slow moving, and these can be added, using fine lines of a deeper colour, when the paper is nearly dry. If the ripples stand out too much then wet and blot them gently.

The finished reflection has a very soft effect and looks as though it is sinking down into the water.

RAINDROPS ON *ALCHEMILLA MOLLIS*

Droplets of water are very difficult to paint but if you can bring it off they can look charming and quietly impressive.

The leaves of *Alchemillia mollis* seem to attract drops of water and when the sun catches them they flash and sparkle like jewels.

A small piece of Bockingford NOT 300gsm was used for this study with the following watercolours: Cobalt Blue, Hooker's Green Dark, Yellow Ochre, Indigo, Burnt Umber and Titanium White.

The main leaf was drawn out first with the chosen raindrops. The serrated edge of the leaf was put in later using the brush so only the general, slightly simplified shape was drawn. There were a lot of water droplets on the leaf, more than was wanted for this particular study, so only enough to make a good composition were selected. The drops were different sizes and shapes and spaced out fairly randomly. As there was a lot of background still showing, a suggestion of other leaves growing behind the main one was added.

The largest leaves were painted early on; carefully going round the water drops, leaving these as white paper and pulling the paint out to create the uneven serrated edge. Make sure that the pencil marks are not too heavy before you paint or you may find that they show through and cannot be rubbed out as they are fixed by the paint. A range of shades of soft blue/green was used to stop the leaf looking flat.

Once the leaves are dry a dark background of Indigo and Sap Green is put in which really makes the leaves stand out in quite a dramatic way. Some Burnt Umber is added to parts of the dark area to give a suggestion of other things growing there and to relieve the predominance of green. The main leaf has some patches of brown on it and Burnt Umber is used for these as well.

The white shapes of the raindrops are now painted in using a very pale green with a small strip of white left where the water is catching the light. It is very important to make sure that the colour used to fill in the raindrop shapes is lighter than the leaf that it is resting on. If the water is darker than the leaf, it will look solid and more like a beetle than a transparent drop of liquid. When the light colour is dry a line of shadow is run down the side of the drop away from the light. This is also left to dry. There

Drawing of raindrops on *Alchemilla mollis*.

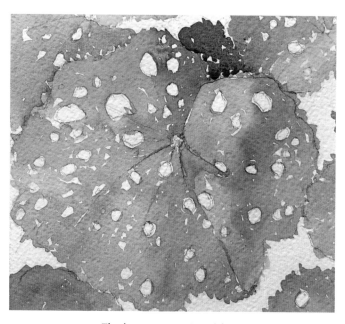

The leaves are painted first.

is also a shadow cast by the droplet on the leaf and this is painted in with a deeper green than the shadow on the water itself. If the light has been lost, which can easily happen as it is such a small area, paint it back in with Titanium White. Titanium White is a very opaque watercolour, far more so than Chinese White and tends to be rather thick, so stands up on the surface of the paper. To avoid this raised appearance dilute the paint just enough to get it to flow without making it so thin that it does not cover what it needs to. Test it on a spare piece of paper, which has some colour on it, before trying it on the water drops.

The raindrops should now look as though they are rounded and sitting on the surface of the leaf, glinting in the sunlight.

This is an interesting challenge to try and if successful can look very attractive.

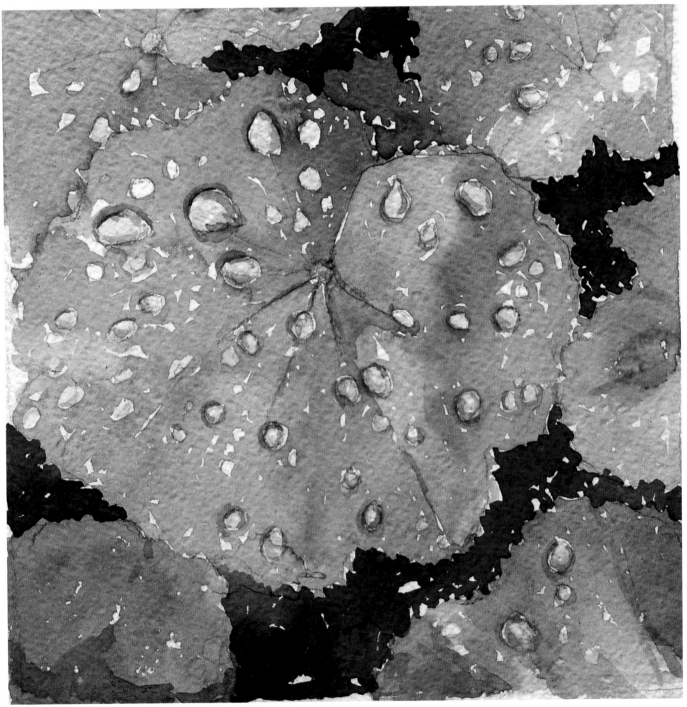

Background and shadows on the raindrops complete the painting.

GOLDFISH SWIMMING IN A POND

It is quite difficult to photograph fish in a pond, especially one where the water is a bit green. This next painting is an amalgamation of three photographs taken at different times in different places.

The combination of the red gold of the fish, the deep pink of the water lilies and the crimson of the *Gunnera* stems made a pleasing composition enhanced by the upright stems of the reeds and the rounded pebbles in the foreground.

A white primed canvas was used for the painting with the following oil colours: Cadmium Yellow, Winsor Yellow, Cadmium Red Deep, Hooker's Green Dark, French Ultramarine Blue, Cobalt Blue and Titanium White.

The composition is sketched out and the main areas of pond and background foliage are blocked in. There is quite a variety of colours in the water depending on how deep the pond is, what is growing in it and what is reflected on it, so it is important to observe the differences.

The foreground edge of pebbles, with their varied shapes and sizes, introduces some useful pink and cream shades as well as cooler tones of grey and blue. Their rounded shapes contrast with the straighter lines of the reeds and add interest to the foreground of the painting without detracting from the fish, which

are the main subject of the composition.

The reeds, fish and water lilies are painted next, again looking for the variation in colour and shape. The fish are just suggested so that the feeling that they are moving and are under the water is kept. The water will be painted over them with dragged marks, indicating that the fish are moving just below the surface and in some places are breaking through. The *Gunnera* stems, which are a form of giant, inedible rhubarb, have a crimson tinge, which is darker than the fish so sits nicely in the background. The lilies are another shade of pink, which makes a useful link in the composition between the pale pinks of the pebbles in the foreground, the red and orange of the fish and the crimson of the *Gunnera*.

Now that the basic painting is in and the composition feels quite balanced some more detail can be added. The painting is quite impressionistic so too much detail is to be avoided. The water needs to be darker, especially at the front, so some deep blue is washed across the surface, which suggests reflected sky. The fish have some of the watercolour taken across them and are also given a touch of brighter colour on their backs. The darker water comes towards you and makes the fish stand out more and look extra brilliant.

The lilies have another layer of darker colour put on their nearside, which makes them look more three-dimensional and

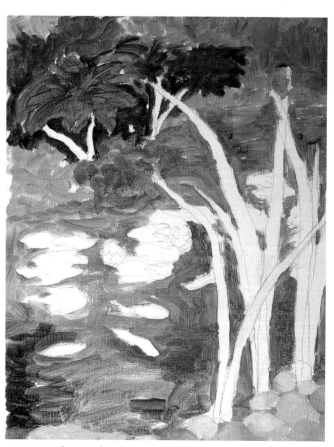

The pond and surroundings are sketched in.

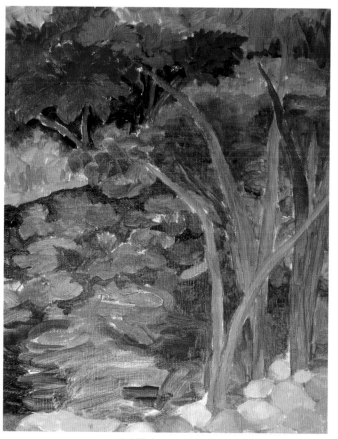

Goldfish are added.

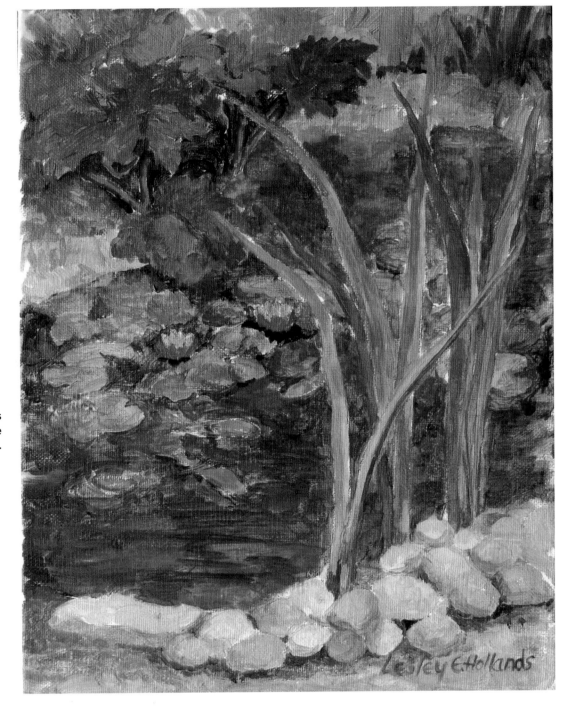

Detail in the stones completes the foreground.

the reeds in the foreground have a second band of colour run down some of the leaves to give extra interest.

Finally the pebbles have a blue shadow tucked between them to define their shapes and give them a slightly sharper edge and the *Gunnera* stems are darkened on one side where they are shadowed by the leaves, which push them further into the background.

The finished painting catches the movement of the fish and

has enough in it to make an interesting composition. One thing that might improve it slightly is to put another *Gunnera* stem in, as an odd number is somehow more pleasing then an even one. Water adds another dimension to a painting; it is quite possible to achieve this impression if you remember to break it down into what you see reflected on it, what is growing in it and what is underneath.

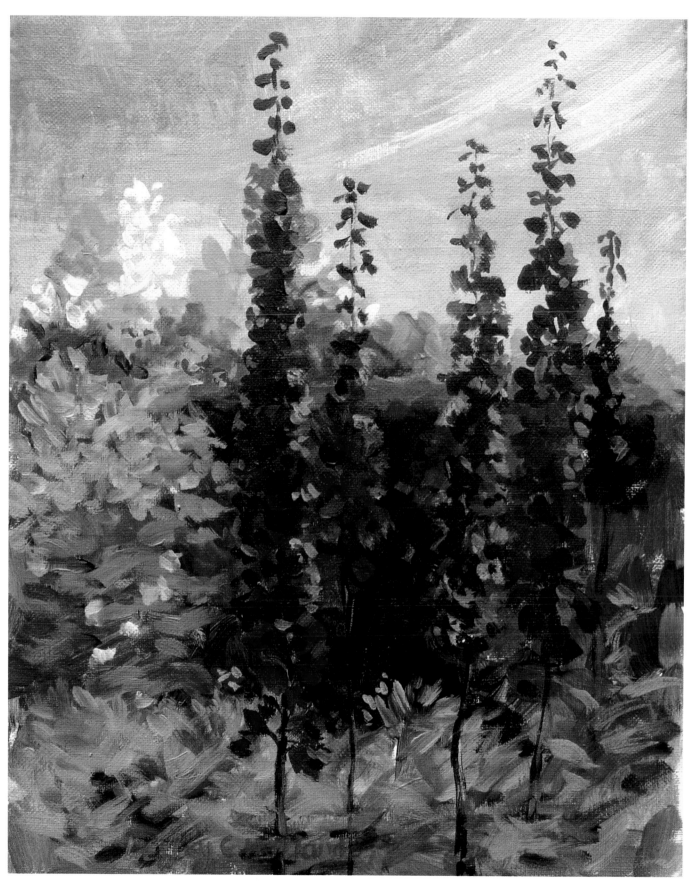

A stand of delphiniums.

DEVELOPING A FREER STYLE

In this final chapter we are going to look at some more relaxed approaches to painting your garden. There are lots of things that lend themselves to a looser approach, flowers in particular, but also some less obvious subjects such as more formal gardens, baskets of fruit, doorways, buildings and benches, to name but a few.

Taking a close-up view can create some interesting compositions, as can distorting the viewpoint and changing the angle of vision. Playing with angles, looking for rhythms and patterns within a possible painting, can also open up new ideas and approaches.

GERANIUMS

The first painting takes a loose approach to a fairly standard composition. The pot of geraniums had been brought into the porch to give it some protection from the increasingly cold nights. The brilliant orange of the flowers glowed against the shadows of the porch and where the leaves were out of the sun they appeared very dark, which made the blooms seem even brighter. It is a simple painting but painted with freedom and bold colour looks quite dramatic.

Fabriano Artistico Rough 300gsm was used with the fol-

Brilliant colour framed by the window.

Flowers and first leaves loosely painted in.

145

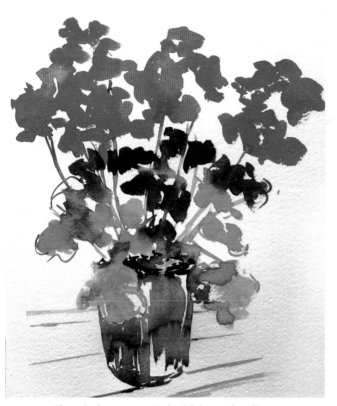

The window suggested with just a few lines.

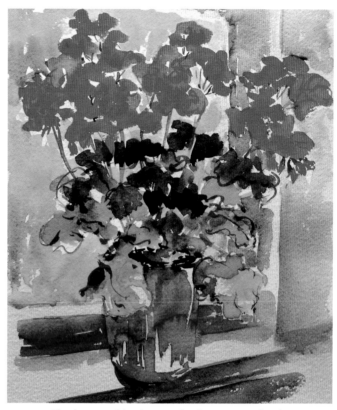

Shadows and background colour create depth.

lowing watercolours: Winsor Red, Winsor Yellow, Sap Green, French Ultramarine and Indigo.

As the whole idea was to keep the painting very loose and free there was no drawing. If you don't have the confidence to paint the pot without some guidelines then draw that in lightly but leave the rest out.

The flowers are painted in first so that their colour can be kept vibrant and fresh without any contamination from the surrounding colours. Winsor Red mixed with varying amounts of Winsor Yellow is used for most of the blooms. Winsor Red on its own will be used to give more definition later. The paint is used fairly wet so that it will flow but it is important to get the general shape of the clusters of flowers and avoid making it look like a solid lump of colour. Look at the outline and the spaces between.

The leaves are suggested, first with Winsor Yellow mixed with a little Sap Green and then built up with Sap Green combined with French Ultramarine to make a really dark green. Again look for the spaces between the leaves and their different shapes and sizes. Using a fairly large brush (a number 10 or 12) helps to keep the marks fluid and unfussy. The stems are put in using various greens and some of the orange.

Allow this to dry before going on to put in the flowerpot.

The flowerpot colour is mixed from Winsor Red, Winsor Yellow and French Ultramarine. Different combinations of these colours will give you all the shades that you need for the pot. The lightest colour is dragged down the side that is catching the light leaving some white paper showing and the darker colour is run in next to it, so the colours blend together. As the colours dried they formed what is called a cauliflower. Sometimes this hard-edged shape can be very intrusive but here it seemed to fit in and if anything make the plastic pot look more interesting, so it was left. If you get a cauliflower where you don't want it, it is usually possible, by taking a damp brush to soften the edge and dissolve the line. It is only if you have used a permanent colour and allowed it to dry that you will not be able to do this. The earth in the pot is a very dark brown, which is made by mixing Indigo with Sap Green. Small areas of white are left among the dark brown to stop it looking too solid and heavy.

The windowsill and the frame behind it go in next. They are painted in freehand, as a slightly wobbly line looks more interesting than one that is dead straight. There is quite a lot of reflected colour on the white paintwork so the lines are painted in using diluted orange, green or blue as appropriate. If the lines have gone in at the wrong angle or look too heavy then wash them out before they have dried and when the paper has dried

re-do them. If you need to, then some light pencil guidelines could be put in.

The shadows on the window frame range from purple through to orange depending on what is reflecting colour near to it. Behind the pot, a mixture of French Ultramarine and Winsor Red have been used to give a soft purple, which has been tipped more towards a blue green as it goes behind the leaves on the right. At the top more red has been introduced, as there is a lot of colour reflected by the flowers. Below the plant a darker and greener shade is used, which defines the window ledge and suggests that it is jutting out from the wall.

The garden outside the window is full of light and greenery and this is suggested with flowing areas of light and a mid-tone green put in with a large brush and fairly wet paint.

The flowers now need a little extra definition and this is given by drawing in some suggested petal shapes with a fine-pointed brush and pure Winsor Red. A similar technique is used on the leaves and drawing lively, darker lines both on and around them makes the most of their wonderfully frilly shapes.

The finishing touch is to put a little darker shadow by the pot where it is resting on the window ledge and to add one or two buds to the flowers.

The finished painting is fresh and lively with wonderfully vibrant colours.

PLUMS

These wonderfully rich-coloured plums were picked one autumn day and put into a trug where they were left out in the rain. The shiny fruits, with their colours enhanced by the water seemed an ideal subject for a painting. They could have been used in the container, which would have made a more traditional composition but here they are used on their own, giving the feeling of glorious abundance.

Bockingford 300gsm was used for this painting with the following watercolours: Indigo, Cobalt Blue, Indian Yellow, Winsor Red, Carmine and Sap Green.

The plums are drawn out first to get the appearance of the tumbled heap of fruit. Extra stems are put in, facing in all directions, to give more movement to the composition. The plums came in all sizes and were seen from different angles and it is important to notice the variations and the spaces between the fruits.

The first stage of painting is the yellow since it is the lightest colour, and the small amounts of green go in next. The brush marks follow the contours of the fruit; enhancing their rounded shapes and making them look more three-dimensional.

Reds are now run into the yellows with the paint dragged round the fruits leaving white areas for the shine. The deepest

Glossy plums.

Drawing with first shades of yellow.

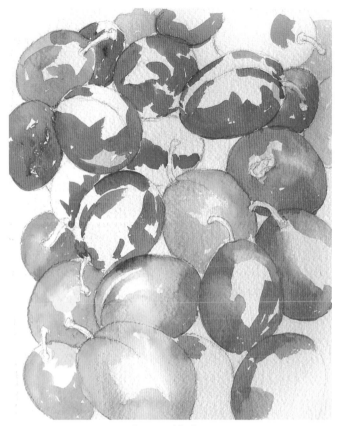

Reds are added next.

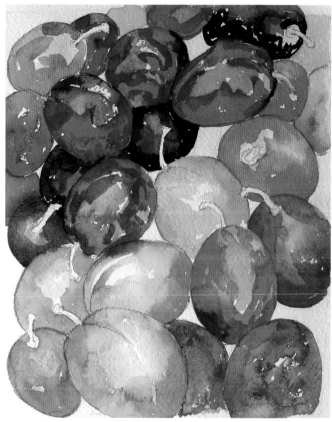

Deep blues and purples build up the colour.

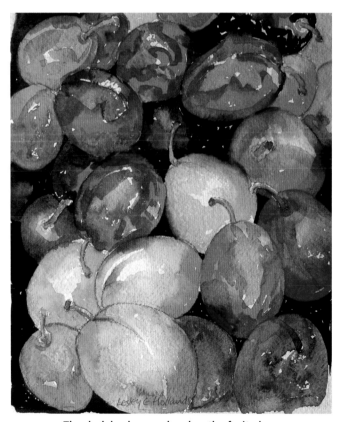

The dark background makes the fruit glow.

areas of red use Carmine, which is then lightened with the addition of Winsor Red. This becomes lighter and more orange when it goes over the yellow, which has already been put down. Hard edges are softened where needed by running a damp brush over them to pull the colour out. Quite a lot of white paper is still left showing at this stage.

The plums have a most attractive bloom on them, which is partly Cobalt Blue and partly shades of purple. These colours are washed on next with the lightest areas being Cobalt and the rest blending from pale purple, made by mixing Carmine with Ultramarine, through to the deepest shades mixed from Indigo and Carmine. These deep colours make the lighter reds and oranges glow by contrast.

The spaces between the fruits are very dark indeed and these are painted with an intense mixture of mainly Indigo but with a little Carmine added. The dark background gives very precise edges to the plums but this is not always the best thing to have as it makes them look rather as though they have been cut out. To avoid this, the edges of some of the fruit are allowed to run and bleed into surrounding areas, which gives a softer, slightly blurred effect. This works best with the fruits that are further down in the pile and helps to make them look as though they are overlapped by the plums on top, giving the whole

composition a greater feeling of depth.

The final touch is to paint the stems in shades of green with their little brown bumps on the ends.

The finished composition works well and has a glorious feeling of exuberance exuding from the rich colours and the heaped up abundance of fruit.

CALENDULAS

This group of brilliantly coloured calendulas were growing in a Shropshire garden as part of a wild flower meadow, which had been planted for a rustic summer wedding. There were birds-eye speedwell and corn cockles amongst the blooms, the blues of which contrasted well with all the orange. The grouping of the flowers naturally leads your eye into the composition and the distant background is deliberately left blurred and out of focus.

A Fabriano Artistico Rough paper was used for this painting with the following watercolours: Indian Yellow, Winsor Red, Sap Green, French Ultramarine, Indigo, Cobalt Blue and Titanium White.

The orange of the calendulas is roughly brushed in first using a large, number 12 brush. The paint is dragged in order to leave flecks of white paper and the marks are approximately flower shaped and get smaller as they go further back. Indian Yellow is used for this first layer.

Green stems in various shades are put in, making the lines of the stalks bend in different directions, giving a sense of movement to the flowers. Narrow leaves are put in, making them larger and more distinct at the front and growing smaller as they go further back in the composition.

The painting is left to dry before a second layer of Indian Yellow mixed with Winsor Red is applied using a slightly smaller brush with a good point. The spikiness of the flowers is now suggested with short, almost scribbled brush marks. These marks also indicate the shadow side of the blooms and help to make them look three-dimensional without being too detailed.

To make the flowers really glow there needs to be a strong contrasting colour set against them. The spaces between the plants are quite small and intricate and to fill them in neatly

Calendulas.

Flowers and stems are loosely washed in.

Deeper orange and some leaves are added.

Dark green in the background makes the flowers stand out.

would go against the free and vigorous approach of the rest of the painting. In order to put the darks in the background without becoming tight the painting needs to be laid flat and plenty of strong dark colour mixed from Indigo and Sap Green be made ready. The spaces between the plants are then roughly wetted with clean water and the dark green dropped into the wet areas so that it flows and runs only where the paper is moist. As long as you keep your paper flat the paint will not run all over the painting but will spread out in a controlled way, leaving some interesting variations in colour and texture, but without being too neat.

As you work up the painting, add some yellow to the green to lighten it slightly as this will help the background at the top to recede.

The light areas of the stems and leaves now need to be connected more to the dark background. This is done by using some mid-tone greens and a pointed brush to draw in, quite vigorously, some fine, and generally vertical lines right across the painting.

The final touch is to suggest the tiny blue flowers of the birds-eye speedwell which were growing right through this clump of calendulas. Cobalt Blue, which is semi-opaque, is used with the addition of some Titanium White to increase the opacity and lighten it. Some of the flowers were more mauve, so a little Winsor Red was added to the mixture for these. The flowers were painted in using small horizontal marks, which got smaller as they went further back.

The finished painting is lively, colourful and vigorous.

BLOSSOM AGAINST THE SKY

This winter flowering tree looked stunning against the cold blue sky. The pink of the flowers accentuated the hint of mauve in the sky and the fragile branches made lacy patterns against the clouds.

It was decided to use oil paints for this particular work as it makes it so much easier to paint light against dark.

A white primed canvas and Alkyd oil paint in the following colours was used for this painting: Cobalt Blue, French Ultra-

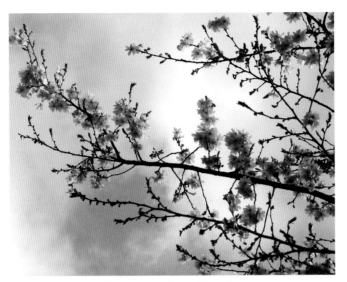

Blossom against a blue sky.

The sky and clouds are scumbled in.

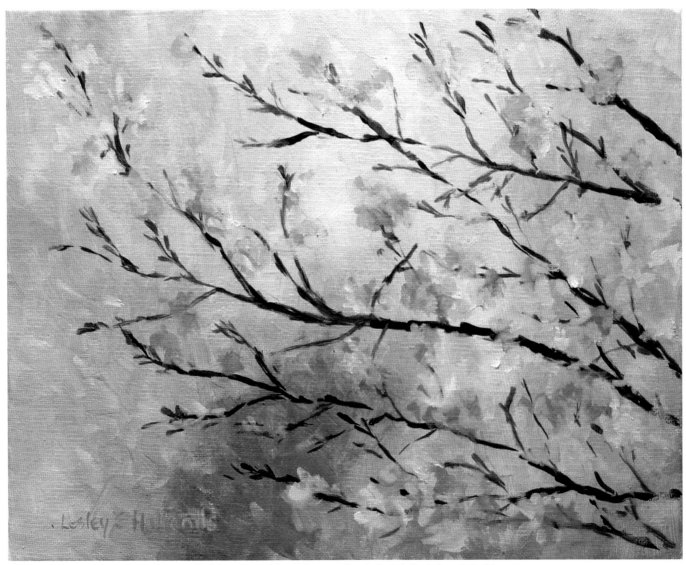

The blossom and branches are freely but delicately painted in.

marine, Permanent Rose, Hooker's Green Dark and Titanium White.

Alkyd paints were used because of their speed of drying and Liquin was added to make the drying time even shorter.

The sky is scumbled in first, using the Cobalt Blue on its own for the deepest sky colour, white and a tiny amount of red being added for the clouds. The brush marks are very visible to begin with as the colours are laid in and scrubbed together at the joins and the composition is worked out directly onto the canvas.

The first layer of paint is left to dry. Alkyd paint with the addition of Liquin can be dry enough to continue working on in less than an hour if the pigment is not laid on too thickly and the canvas is put in a warm airy place.

The second layer of colour is used to tease out any edges that are too abrupt and smooth out brush marks where they might be too intrusive. This is a quickly executed and freely-painted work so it would be wrong to try and make the sky too smooth and tidy.

The tree branches are slender and delicate with small side shoots and buds as well as the fully-opened flowers. In order to keep this fragile appearance it is important not to paint these parts in too heavily. Broken lines and paler colours help with the illusion of delicacy. Although the branches are seen against the light and so appear quite dark, there still needs to be some interesting colour in them. Permanent Rose with Hooker's Green Dark and a little French Ultramarine make a good rich shade that is dark but subtle. Where the branches thin towards their tips a little white is added to lighten the colour slightly. A brush called a Cat Tongue Filbert is a useful shape to use here because it will give a narrow line and a broader one in the same stroke depending on how it is twisted and the amount of pressure employed in making the mark.

This stage of the painting is now left to dry completely to avoid any mixing of the colour with the pale shades of the blossom.

The blossom varies in shade from intense pink through pale pink to a soft mauve. The paint is going to be applied quite freely, suggesting the delicate petals, barely attached to the branches and ready to be blown from the tree at any moment. The paint needs to be applied thickly enough for it to cover the branches where it needs to. Titanium White is a very opaque colour and will block out pretty much anything that is underneath it. The mauve, which is used for the blossom where it is in shadow, is mixed from a combination of Cobalt Blue and Permanent Rose with a little white added. The blossom gets smaller the further out along the branch it is so more delicate brush marks are needed for this. Some petals were blowing in the wind but because they were similar in colour to the sky and nearly transparent, could hardly be seen. Putting in a few, just visible at a second look, adds a feeling of movement that is there

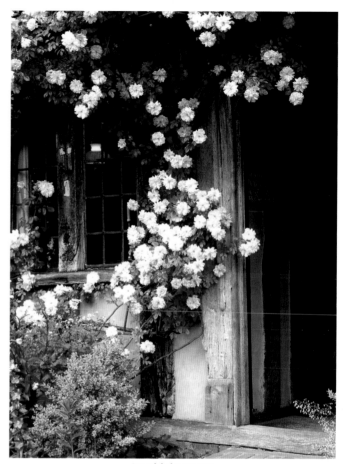

An old doorway.

but not too obvious.

The finished painting has the feeling of a cold spring day with the promise of warmth to come.

THE OLD COTTAGE DOORWAY

This wonderful old timber-framed building had a lovely soft yellow rose growing around the open doorway which complemented the grey of the timbers and the warm pinks of the bricks beautifully. This could be a fussy and over-detailed painting but the following work is going to keep it simple, direct and fresh.

A limited range of colours was used to keep the composition unified. Fabriano Artistico Rough 300gsm was used with the following watercolours: Cobalt Blue, French Ultramarine, Winsor Yellow, Yellow Ochre and Carmine.

The door and the window next to it are sketched out very lightly, just to give some guidelines and get the proportions right. The walls had a pale colour wash on them and dilute Yellow Ochre was used here. Inside the door were some flagstones, which appeared quite pink as did the old bricks that

Bricks and foliage are painted first.

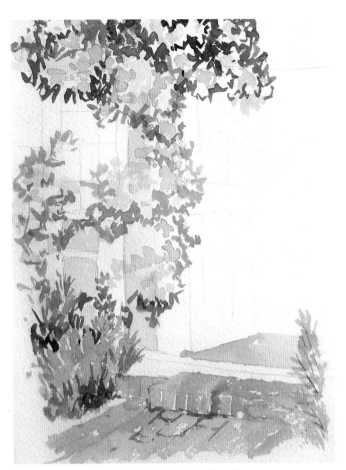

More detail is added to the plants.

formed the step and edging to the pathway. Yellow Ochre and Carmine were used for these areas with the addition of a very little French Ultramarine for the bricks, which have a purple tinge to them.

The roses are a gentle apricot colour with a deeper yellow where they are less open and a hint of pink in places. The flowers are suggested with dragged brush marks in the approximate shapes of the clusters of blooms.

Shades of green are made from Cobalt Blue and Yellow Ochre, which give a soft colour suitable for the lighter areas of foliage. These parts are painted with a sketchy, almost scribbled mark, which suggests the leaves without actually defining them. Where the rose is growing in the shadow above the door a darker green is used to indicate this. There are some shrubs growing by the path on both sides of the door and these are sketched in with some of the lighter greens. The grass, growing between the bricks of the path, helps to define their shape without having to put in too much detail.

The open doorway with its deep shadows and the dark of the window are going to add depth, contrast and interest to the composition. The door is painted first with a mid-tone blue grey mixed from Cobalt Blue and a touch of Yellow Ochre. The brush

strokes are dragged in vertically so that any flecks of white left showing will follow the lines of the panelling. The far edge of the open door dissolves into the cool shadows of the old house, suggesting a space beyond what can be seen. A dark colour is mixed from French Ultramarine and Carmine with a little Yellow Ochre added to prevent the colour from becoming too purple. The darkest interior space is painted first working back towards the inner edge of the door. The inside edge of the door only needs to be very vaguely suggested with no real definition. Letting the colours run together and become blurred works well.

The dark panes of glass in the window are painted in with French Ultramarine mixed with just enough Carmine to darken the colour without making it purple. The window bars are left as white paper and the glass has streaks of white left showing, which suggest shine and reflections.

The roses now need to be brought forward slightly so some darker colours are added. More pink was used because this made the flowers stand out against the old walls without making them look too stark. If too much of the white has been lost then some Titanium White paint can be dragged across a number of the blooms to redefine them.

153

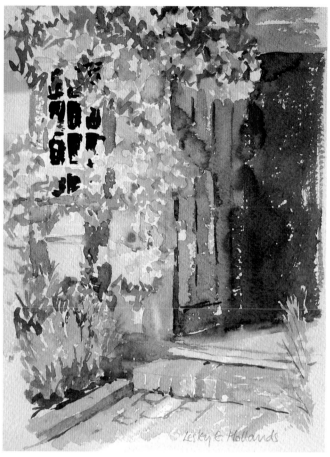

The cool interior is suggested through the open door.

Alkyd oil paints were used with Liquin added to speed up the drying time even more and a small white primed canvas. The following colours were used: French Ultramarine, Cobalt Blue, Hooker's Green Dark, Winsor Violet, Cadmium Red Deep, Permanent Rose, Winsor Yellow and Titanium White.

The basic proportions of the painting are blocked in first. The sky is a mixture of French Ultramarine and White with a little Permanent Rose added for parts of it. The mauve/blue connects well with the delphiniums, which will go in on top. The hedge is the darkest part of the painting and Hooker's Green Dark with French Ultramarine is used to achieve the intense shade of green required. Behind the hedge are some lighter-leaved shrubs and small trees. These are painted in with loose brush marks of Hooker's Green and Winsor Yellow. All the foliage is quite roughly and vigorously put in so that the brush marks show, suggesting the texture of the growth. The foreground plants are a brighter, lighter green and a stronger version of the distant foliage is used for this area with larger brush marks.

The painting is now left to dry so that the next layer does not stir up the first.

There are some red roses growing behind the delphiniums and pink ones climbing up through the shrub on the left. The

The window bars have a very light Cobalt Blue washed across them, just to take off the starkness of the white.

As a finishing touch, some red flowers were added to the shrubbery by the path at the front, to lead your eye into the composition.

The finished painting, with its softly dissolving colours, has captured the feeling of age in the old cottage doorway.

A STAND OF DELPHINIUMS

This composition lends itself to a free approach with the wonderfully intense blue spikes of the delphiniums soaring up above the hedge behind. There was a house beyond the hedge but it was decided to leave this out in case it distracted slightly from the flowers, which are the main point of the composition, and there was enough interest in the surrounding shrubs to make it unnecessary.

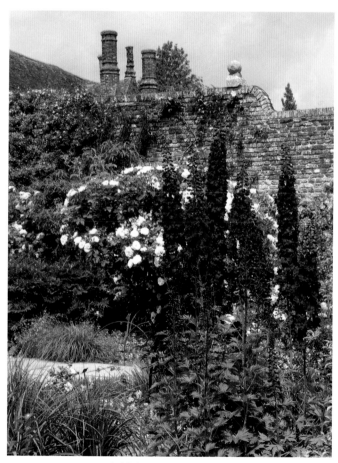

Delphiniums at Sissinghurst.

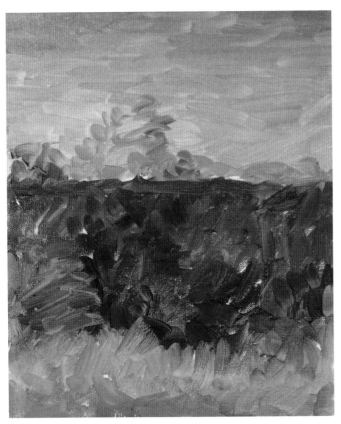

Sky and hedge are roughed in. Deeper orange and some leaves are added.

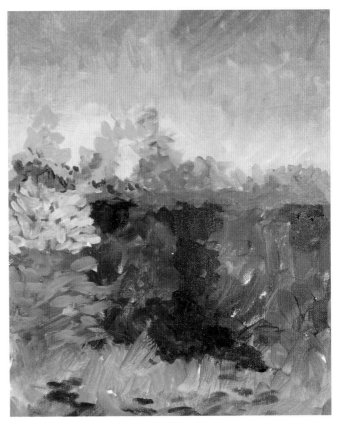

More detail is added.

shrub is painted first using the green of the foreground with added white to create a chalky shade. The brush marks are directional and suggest the way in which the plant is growing but without any real detail. More weight is given to the plants growing beyond the hedge and the foreground has some added darks put in with horizontal brush strokes. The outline of the plants growing at the front is improved by being made less straight and more interesting.

Once more the painting is left to dry completely. It is important that the delphiniums can be painted in on top without losing the clarity of their colour. If the purple were to mix with the green underneath it would become a rather muddy shade.

Before the delphiniums are painted in, the sky is adjusted. It looks a little flat and uninteresting and, although it does not need to be a mass of clouds that fight with the flowers, it does need something. Some lines of white are streaked in running at an angle across the blue. These lines are then washed in and dragged with a dry brush to give a suggestion of wisps of high cloud caught by the wind.

The delphinium spikes are quite dense, almost too much so for the painting, so a little artistic licence is used and the outline of the flowers is opened up a little. A mid-tone is laid in first using a mixture of French Ultramarine and Winsor Violet with a

Tall spikes of delphiniums complete the painting.

little White added. It is important to vary the brush strokes and the spacing and size of the flowers on each stem. If this is not done then the fragility of the spikes will be lost and the flowers will look far less interesting.

A second layer of a lighter shade is now added where the flowers are catching the light. Delicate brush strokes are needed here and little flicks of colour suggesting the small petals work best.

Lastly the darks are added. Each flower on the spikes has a darker middle and some of the flowers are in deep shadow. French Ultramarine, Winsor Violet and Winsor Red Dark are mixed to achieve the deep, rich shade needed here. It is better to put too little rather than too much of the dark in to begin with. If in doubt, stop and step away from the painting before going on.

The roses now have another shade of red or pink put on them and the foliage at the bottom has a little more definition added with some lighter colour and broader brush marks.

The finished painting has caught the feel of the hot summer's day and the delphiniums look majestic against the dark of the hedge and the light of the sky. It could possibly have had the house in the background but as this was a quick and freely executed painting it was decided to stick with the original decision.

LOOKING AHEAD

This final painting is not a direct painting of a garden but it is a composition that looks forward to the next growing and painting season. It is something that can be set up during those gloomy winter months when getting into the garden seems a long way off. It is the planning that takes place now and the dreaming of colourful beds and borders, overflowing vegetable patches and bursting fruit cages that can keep the spirits up during the short dark days.

Ordering seeds, perhaps choosing a few new varieties as well as the old tried and tested favourites, can be a very pleasant way of spending some time. This still life was inspired by that activity and the following painting ensued.

The old clay flowerpots have a patina and colouring that the plastic varieties never achieve. The pots are set up with a favourite trowel and some packs of seeds on a simple piece of white paper. The composition is drawn out on a piece of Bockingford 300gsm paper and the following watercolours were used: Burnt Sienna, Indian Yellow, Winsor Yellow, French Ultramarine, Cobalt Blue, Hooker's Green Dark and Carmine.

The flowerpots are painted in first using some rich red/browns with touches of blue added to darken them. There are hints of green on the surface in places where moss is starting to grow and lighter, more orange tones where the pots are catching the light.

The seed packets, with their pictures of what will hopefully grow from them, are colourful and fun to paint. The peas, carrots and cucumbers are loosely painted in without too much detail at this stage. They only need enough visual information for the viewer to see what they are.

The trowel has a wooden handle, which has gone grey with age, and has a strip of leather running through a hole in the end to hang it up by. The stainless steel part of it has stayed pretty

Seeds and pots.

Rich shades of terracotta go in first.

The seed packets add colour.

bright even though it has often been left uncared for outside. Cobalt Blue and Winsor Yellow makes a good steel colour with the addition of French Ultramarine where it is in the shadow. A suggestion of the writing on the seed packs is useful and can be indicated with some squiggly lines for the smaller print and something a little more legible for the larger.

The shadows are now added, which help to show that the objects are three-dimensional and sitting on a flat surface. Dilute French Ultramarine, with a little Hooker's Green added, is a good colour as it links up with the colour on the seed packets and is not too intrusive.

A suggestion of background is put in with a broken wash using more blue. The back edge of the table is softened so that it does not divide the composition but gives an indication of depth and distance.

The finished painting looks forward to warmer weather and days to be enjoyed in the garden.

The trowel and background wash complete the painting.

FURTHER INFORMATION

There are lots of places to look for inspiration when you have exhausted the resources of your own garden. Here are a few suggestions that hopefully will give you some stimulation and encouragement.

There are suggestions of gardens to visit but the other way of finding more things to paint in your own garden is to do some redesigning and look at new ways of putting plants together. Placing some more unusual things in your garden to add focal points could be good for your garden as well as your painting. There are lots of books available on garden design and the best thing to do is to go to your library and see what they have before buying anything. Just looking in a good bookshop and flicking through the pages of a publication is also well worth doing before deciding to spend hard cash on a publication.

Keep a look out in junk shops and car boot sales for unusual bits of old garden equipment which can be artistically displayed and used for a still life in the garden. Bits of statuary can look very stylish and if you cannot afford the real thing or even a concrete copy, then garden centres will often sell off damaged pieces for a very reasonable price. Displaying the sculpture among the greenery and disguising any knocks or missing bits can be great fun to do and can give a lift to a gloomy corner or enhance a sunny spot.

Hilliers' Garden Centres have a number of publications which are practical and down to earth. They deal with the design of your garden and the planting, both of which can be very useful in giving you ideas for even small changes.

WEBSITES

The National Trust has many wonderful gardens open to the public. If there are lots within reach for you, it is well worth becoming a member. They are usually quite happy for photographs to be taken in the garden but not in the houses. If you want to paint *in situ* it is best to contact the property first to make sure this is acceptable. Some gardens are very busy and have narrow pathways so people stopping to paint can clog up the flow of visitors.
www.nationaltrust.org.uk

National Gardens Scheme, sometimes referred to as The Yellow Book has 3,700 gardens open in England and Wales all in aid of charity.
www.ngs.org.uk

Gardens of Scotland is another charitable organization with a Yellow Book and hundreds of gardens open to the public.
www.gardensofscotland.org

Highgrove, Residence of HRH Prince of Wales, Gloucestershire. This is a stunning garden with lots of unusual and beautiful planting plus interesting sculpture and buildings. Unfortunately you are not allowed to take photographs and are escorted round the garden by a guide. You need to book in advance and have proof of identity but it is well worth the effort to get there.
www.princeofwales.gov.uk

For gardens to visit in general plus gardening advice:
www.gardenseeker.com

For more information and examples of paintings by the author please visit: www.lesleyhollands.co.uk

GARDENS

Gardens belonging to the Royal Horticultural Society are well worth visiting. They have several gardens in different parts of the country:

Harlow Carr near Harrogate, North Yorkshire
Hyde Hall near Chelmsford, Essex
Rosemoor, Devon
Wisley, Surrey

The flowers shows are a useful source of inspiration:
Chelsea, which can be overcrowded
Hampton Court Palace, which has a larger site so more room for everyone with a pleasantly relaxed feel
Malvern Spring and Autumn shows are informative and welcoming.

Information about all of the Royal Horticultural Society gardens and shows, along with gardening advice can be found at:
www.rhs.org.uk

For gardens open to the public in the USA and other parts of the world, the following is a useful site:
www.gardenvisit.com

BOOKS

The following useful book, still available through Amazon, is the catalogue of the exhibition of the same name which was on at Tate Modern a while ago. It shows lots of different approaches to painting gardens from a range of artists: *The Art of the Garden* by Martin Postle, Stephen Daniels and Nicholas Alfrey. Published by Tate Modern

For some visual inspiration and to help you take good photographs to work from, the following books could be useful: *The Art of Flowers and Garden Photography* by Clive Nichols. Published by The Royal Horticultural Society, similarly *The Art of Garden Photography* by Ian Adams.

INDEX